Counterparts

Form and Emotion in Photographs

Weston J. Naef, Curator
Department of Prints and Photographs

◆

Documentation by Joan Morgan
Research Assistant, Department of Prints and Photographs

◆

THE METROPOLITAN MUSEUM OF ART · NEW YORK

E. P. DUTTON

This book was published in connection with the exhibition
Counterparts

The exhibition and this publication have been made possible by
Warner Communications Inc.

THE METROPOLITAN MUSEUM OF ART, NEW YORK
February 26 — May 9, 1982

CONTEMPORARY ARTS CENTER, CINCINNATI
May 20 — July 2, 1982

DALLAS MUSEUM OF FINE ARTS
August 4 — September 13, 1982

SAN FRANCISCO MUSEUM OF MODERN ART
November 19, 1982 — January 9, 1983

CORCORAN GALLERY OF ART, WASHINGTON, D.C.
February 22 — April 18, 1983

PUBLISHED BY
The Metropolitan Museum of Art, New York
Bradford D. Kelleher, Publisher
John P. O'Neill, Editor in Chief
Leon King, Amy Horbar, Editors

On the jacket:
Couple d'amoureux dans un petit café, quartier Italie
by Brassaï, Pl. 52.

Contents

FOREWORD · 6
Philippe de Montebello

ACKNOWLEDGMENTS · 7
Weston J. Naef

PREFACE · 8

TEXT AND PLATES · 14

NOTES · 140

BIBLIOGRAPHY · 143

· CHRONOLOGIES ·
Joan Morgan

· INDEX OF PHOTOGRAPHERS ·

Foreword

THE EXHIBITION *Counterparts* and its accompanying publication were conceived by Weston J. Naef, Curator in the Department of Prints and Photographs. Not only do the selection and the installation of the photographs on display attest to a discerning eye and a well-grounded knowledge, but also they reflect The Metropolitan Museum of Art's active interest in this area of collecting. Although the Museum's initial involvement with exhibitions of photography occurred as long ago as the tenure of its first director, Luigi Palma di Cesnola, who organized a presentation of American photographs for Turin's International Exposition of Modern Decorative Arts in 1902, it was not until 1933 and the major gift of the Alfred Stieglitz Collection that the Metropolitan's nuclear collection of photographs was substantially augmented by a donation that in effect made the acquisition of photographs an imperative for the Museum. The Metropolitan's holdings grew steadily, but a systematic acquisitions program was not developed until 1976, when Warner Communications Inc. contributed substantial funds for this purpose to the Museum.

In 1981, Warner Communications Inc. donated to the Metropolitan those books and prints of Victorian photographs from the Robert O. Dougan Collection that had been on loan at the Museum since 1976. It has also provided significant financial support for a special purchase fund for the Department of Prints and Photographs and for contributions to purchases made by private collectors for the Museum. In addition, Warner Communications Inc. has subsidized this current exhibition and this handsome, interpretive publication.

On behalf of the Museum I wish to express our deep gratitude to Steven J. Ross, Chairman of Warner Communications Inc., who had the vision to provide corporate grants for the purchase of works of art. I also want to give special thanks to Weston J. Naef for mounting the exhibition; to Joan Morgan, Research Assistant in the Department of Prints and Photographs; to Leon King, the editor of this book; and to all the Museum staff who were involved in this project.

PHILIPPE DE MONTEBELLO
Director, The Metropolitan Museum of Art

Acknowledgments

MANY PEOPLE have influenced the contents of this publication and the collection of photographs that provided the background for it, a few of whom must be singled out for mention. Emanuel Gerard and Roger Smith of Warner Communications Inc. displayed enlightened leadership by embracing a program of funding that involved the acquisition of works of art for the permanent collection as well as the more traditional means of corporate sponsorship, the temporary traveling exhibition. Corporate sponsorship of temporary exhibitions has come to be expected, but the foresight to see value beyond the present instant has added an important dimension to the relationship between museums and their corporate benefactors. I wish to thank Mary McCarthy, Director of Contributions, and Virginia Brieant, Director of Contributions to the Arts.

Joan Morgan, who came to the Museum's Department of Prints and Photographs as a volunteer, proved to be indispensable and was soon engaged as general research assistant. For both her insights and her dedication to the guiding idea of the exhibition and the book, I am deeply grateful. I am thankful to Colta Ives, Curator in Charge, Department of Prints and Photographs, whose inspiration prompted many of the acquisitions, to David Kiehl and to Joan Ades, and to my other departmental colleagues for their continual helpfulness: Nancy Devine, Elizabeth Wyckoff, Edmond Stack, and Max Berman. Outside the department James Pilgrim, Carol Cardon, Tanya Maggos, John Buchanan, Herbert Moskowitz, Laura Grimes, Nina Maruca, Linda Sylling, John Funt, Christos Giftos, Helen Otis, Carlo Coccaro, Doris Halle, and Bruce Wineberg all devoted time in significant ways. I wish particularly to acknowledge the solicitous editorial efforts on behalf of this publication by John P. O'Neill, Leon King, Joan Holt, Amy Horbar, Elizabeth Pollock, and Henry von Brachel. Eleanor Morris Caponigro deserves high praise for creating a design of grace and clarity.

Behind this undertaking stand two groups without whom the project could not have been realized. Dealers and other vendors of photographs constituting new additions to the permanent collection displayed chivalrous patience while purchase decisions were being reached. The photographers whose work has been recently acquired by purchase but omitted from the exhibition deserve particular acknowledgment since that work established the context from which the objects in the exhibition were selected. Of the photographers whose work is included in the exhibition but not reproduced in the publication, I beg indulgence and understanding of how an idea can exceed the size of its container.

My wife, Mary Meanor Naef, experienced the pains of authorship without the ultimate rewards, and to her I owe the deepest thanks.

WESTON J. NAEF
Curator, Department of Prints and Photographs

Preface

IN ONE WAY or another the long shadow behind this undertaking is that of the first collector of photographs as art in America, Alfred Stieglitz, whose taste was eclectic and sometimes self-contradictory and who was uniquely responsible for the existence of a collection of photographs at the Metropolitan Museum. His indirect influence may still be observed radiating outward like the ripples raised by a pebble cast into a still pond.

Stieglitz's collection of photographs had pockets so rich they may never be surpassed, including works by Edward Steichen, Paul Strand, and Charles Sheeler. It also had gaps. The process of filling the gaps began in the 1940s and 1950s when A. Hyatt Mayor acquired works by many nineteenth-century pioneers for whom Stieglitz had little or no concern, including W. H. F. Talbot, D. O. Hill, Robert Adamson, and Julia Margaret Cameron. Mayor also added at this time certain of his important younger contemporaries, including Walker Evans and Edward Weston.

The growth of the collection since 1975 has taken into consideration the fact that Stieglitz and his immediate curatorial successors paid little or no attention to American photographs of the nineteenth century. The collection has grown recently by the addition of works by J. W. Black, John A. Whipple, Carleton E. Watkins, and Maxime Du Camp. The greatest challenge has been to find younger photographers whose accomplishment or promise caused their work to fit comfortably within the collection as it has evolved to this point. The continuing influence of Stieglitz is manifest in the selection of young photographers whose work represents a contemporary approach to particular concerns already defined by a picture or artist in the permanent collection.

◆ ◆ ◆

The format of this book—placing side by side two or three photographs that are presented as having some special visual relationship to each other—evolved from Stieglitz's fondness for making comparisons between the artists and photographers who were his friends. My purpose is to elongate Stieglitz's principle of equivalency to encompass paired photographs that may become formal and emotional equivalents of each other.

Among the ideas guiding the essays herein is that picture language is not identical to word language and, moreover, that art stated perfectly in visual language resists restatement in words. Little attempt has been made to arrive at one-to-one verbal equivalents of the images. The photographs have been treated as though they were in themselves forces so deeply natural in character that they can be perceived and experienced but not fully known. If the undertaking has a thesis, it is that parallel to comparative anatomy and comparative zoology are comparative art history and a comparative

history of photography. When two photographs are set side by side, they are seen differently from when displayed singly, and what they have to tell us about each other can be told in visual language alone.

In placing a photograph by Stieglitz (*Pl. 1*) beside one by Harry Callahan (*Pl. 2*), a question is being asked and information is being given. The observer is being asked to look at, and to savor, the photographs for whatever responses they may trigger in the imagination. He is being informed directly and indirectly. The indirect information is that works of this kind did not heretofore exist in the collection. Neither Stieglitz's near-snapshot style nor Callahan's many studies of his wife, Eleanor (work that is lineally descended from Stieglitz), were previously represented in the permanent collection.

The most important reason these two photographs are paired is because they demonstrate equal mastery of the most fundamental vocabulary of the language of the photograph—in particular, the symbiotic relationship between the photograph and the meaningful instant in time. Stieglitz and Callahan both make instants meaningful without reliance on expediencies of any kind; they sculpt directly with their eyes. They often represent single moments devoid of the customary signals of arrested motion. Stieglitz's Margaret Prosser is a figure modeled in light; the photograph embodies contrasts of mass versus pattern and transparent brightness versus transparent darkness like sculpture in sunlight. *Margaret Prosser* is a photographic equivalent of deeply felt personal regard by the photographer for his subject and an equivalent of abstractly modeled plastic form. Callahan's *Eleanor* is a similarly felt statement about his model, but it is rendered with the cooler detachment of one who sculpts in low relief with great precision, using light as if it were a modeling tool to delineate edges and shadows. The pair is felt to represent equal levels of composition and design, qualities that endear both pictures to observers sensitive to properties of form that are uniquely photographic. How does the capacity to appreciate such works of art come about?

It would be a mistake to assume that the process of understanding is purely rational; it is largely intuitive. Intuition was the single most powerful force motivating the photographers who made the images. It was also the most powerful force in selecting the sets of comparisons to be presented here and in composing the accompanying texts. The contents of the book may be said to be the result of taste, which is used here as a synonym for intuition. We recognize taste as the faculty photographers exercise in selecting their subjects and taste as something exercised by the person who selected the photographs; but by admitting taste we also admit fashion, and being in fashion risks soon being out of fashion both for the photographer and for the curator.

9

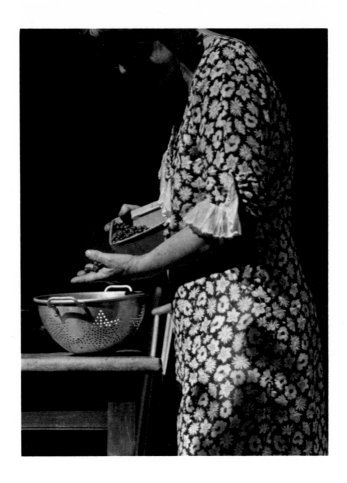

Alfred Stieglitz
American, 1864–1946

Margaret Prosser Sorting Blueberries, Lake George
Gelatin silver, 1936

4½ x 3⅜ inches · 11.4 x 8.5 cm
1976.569
Warner Communications Inc. Purchase Fund, 1976

[PLATE 1]

To understand this manner of looking at photographs, let us think about arithmetic. When two numbers are added, we all know that the sum can never be greater than that of the individual parts. In arithmetic, two plus two can never be six—or so we are told. Businessmen who form large enterprises and physicists have showed that in certain rare instances two plus two can equal six when matter, and not numbers, is involved. For example, scientists have demonstrated that when certain atoms are fused,

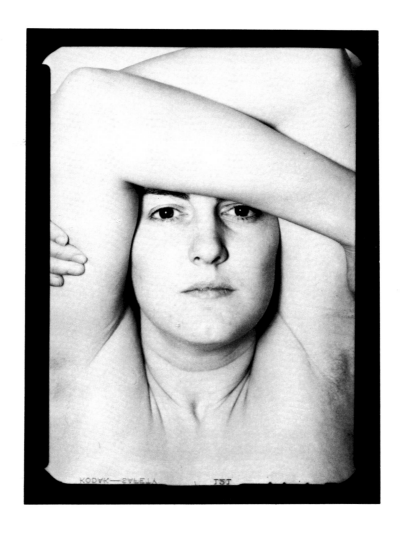

Harry Callahan
American, born 1912

Eleanor
Gelatin silver, 1980 from negative of about 1947
4⁹/₁₆ x 3⁵/₃₂ inches • 11.65 x 8.35 cm
1981.1072
Purchase, Warner Communications Inc. Gift
and matching funds from the National Endowment for the Arts, 1981

[PLATE 2]

more energy is released than was required to initiate the fusion. This book and the exhibition upon which it is based involve similar anomalies. Their purpose is to test whether two plus two can equal six in visual language.

Art historians and art theorists have long advised that two pictures could never be placed side by side without altering the ways both are seen. Typifying this is the attitude of Professor Daniel Varney Thompson of Yale University, who was so deeply con-

vinced that every work was created independently and must be studied alone that he made it a policy to project only one slide at a time in his lectures.[1] Museum people, however, are confronted with walls and space, not an empty screen. The curator's craft is manifest in rooms that usually must, of necessity, contain more than one work at a time. A fundamental decision when installing an exhibition is which objects will go beside which. Every time a show is installed, new relationships are created. The customary goal of the curator is to make the comparisons so subliminal that the observer is barely aware that one work is influencing the others around it. The objective in this book and the exhibition on which it is based is the exact opposite. The photographs have been consciously arranged in pairs or triplets to test the hypothesis that pictures can say as much about each other as a thousand words.

To establish such a system is to court failure and stir a feeling similar to what the mathematician Pierre de Fermat must have felt when his famous "last theorem" was articulated. Reading a treatise by Diophantus, one of his illustrious Greek predecessors, Fermat focused upon the mathematician's equation that described what happens when two numbers are multiplied by themselves and then added together ($a^2 + b^2$). In the margin of his copy of the treatise Fermat noted that he had devised a marvelous proof for the ancient problem. To the frustration and anger of several generations of mathematicians, Fermat's note ended with the message that the book's margin was too small to contain his proof.[2]

The texts following the sets of photographs here are like theorems for which final proofs are lacking. In some instances the proofs simply do not exist, and in other cases the space allocated is simply insufficient for the texts to do justice either to the images or to the interpretational problems that have been posed.

Text and Plates

Perception of an Object casts
Precise the Object's loss—
Perception in itself a Gain
EMILY DICKINSON

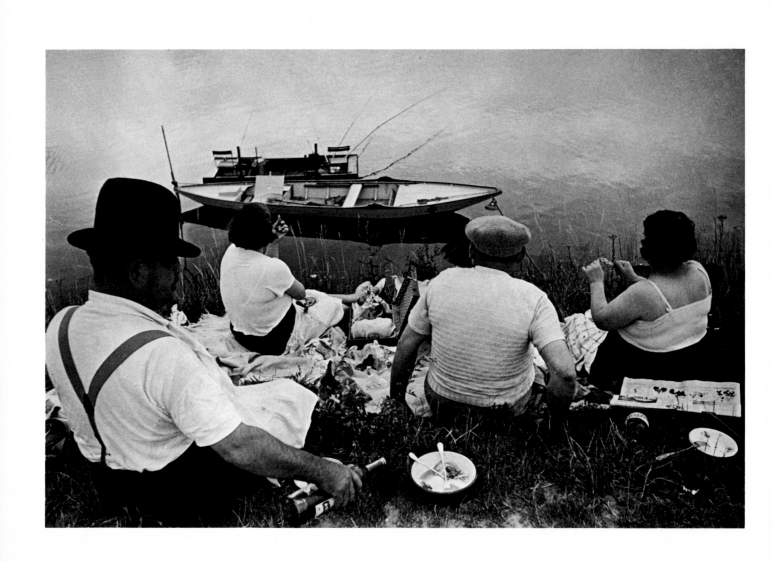

[PLATE 3]

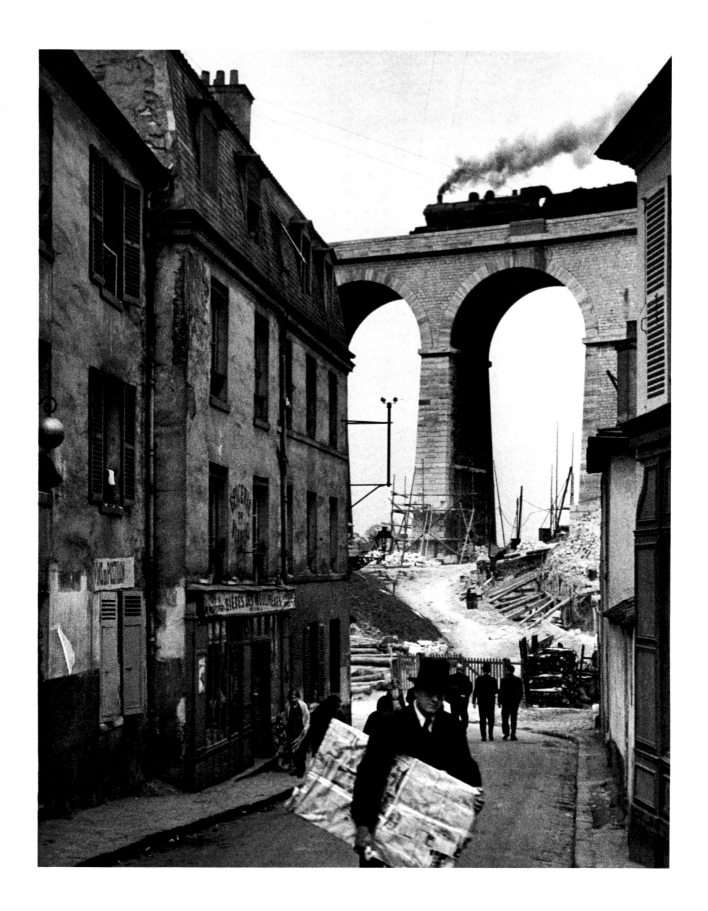

[PLATE 4]

Henri Cartier-Bresson
French, born 1908

Banks of the River Marne
Gelatin silver, before 1950 from negative of 1938

9¾ x 14⁹⁄₁₆ inches • 24.9 x 37 cm
1981.1152.1
Warner Communications Inc. Purchase Fund
and Gift of Mrs. Peter Pollack, in memory of her husband, 1981

[PLATE 3]

WHEN THE HISTORY of modern photography in Europe is finally written we shall find that André Kertész is a little like Christopher Columbus, who discovered a new world that, in the end, was named for someone else. Cartier-Bresson is a little like Amerigo Vespucci, for whom the New World was named, a man who, although revered as an innovator, was a half-step behind his predecessor. The name of Kertész, like that of Columbus, became briefly submerged as history cleared the record, while Cartier-Bresson became, through many publications, a touchstone. With the humility of greatness, Cartier-Bresson acknowledges the older man's influence, although there seems to have been less personal contact between Kertész and Cartier-Bresson than between Kertész and Brassaï.

A magnanimous rivalry exists between the two photographers, but it is a rivalry of forms, not personalities. Cartier-Bresson is characterized by outer seriousness and inner humor, Kertész by outer humor and inner seriousness. Both emerged from the Surrealist circle that formed around the Au Sacre du Printemps gallery in the early 1930s, with Kertész more obviously influenced by the experience. Both were attracted to studio art and fitfully practiced traditional art-making forms, Kertész as a sculptor and Cartier-Bresson as a painter. Kertész allowed his studio training to pass to the periphery of his consciousness; Cartier-Bresson still carries a notebook in which he inscribes nervous jottings that mirror his temperament. The two photographers share a concern for the commonplace, for the manifestly ordinary, to such an extreme degree that their collective bodies of work have contributed to a definition of the elusive in modern life. In pursuing elusiveness as a motif in and of itself, they treat highly personal perceptions by a means that could be confused with lack of style, particularly in their later work.

Kertész is mainly concerned with the interaction between life and the container that shapes it; Cartier-Bresson is often concerned more with the interaction between individuals and the frame he places around them rather than between people and their contexts. *Banks of the River Marne* is such a work. The river is a backdrop that supplies a clue to the means of transportation by which the party arrived at their destination; it is not otherwise made the focus of attention. We are more concerned with the taut arrangement of bas-relief figures on the flat surface formed by the paper than we are with deep plastic space.

The search for Cartier-Bresson's roots begins with his own one-sentence declaration: "*I consider myself a Surrealist.*"[3] This statement begs us to examine what relation-

Meudon (France)
Gelatin silver, 1977 from negative of 1928
19⅞ x 16 inches · 50.3 x 40.5 cm
1977.501.2
Warner Communications Inc. Purchase Fund, 1977

[P L A T E 4]

ship *Banks of the River Marne* bears to Kertész, Man Ray, and the writer André Breton —the fountainheads of Surrealism—and to reflect upon another clue dropped in a recent interview when Cartier-Bresson said that he was *"an observer of chance."*[4] Twenty-five years before, Cartier-Bresson had verbalized why he had set about pictorializing chance: *"In photography there is a new kind of plasticity, a product of the instantaneous lines made by the movements of the subject. We work in unison with movement as though it were a presentiment of the way life itself unfolds. But inside movement there is one moment at which the elements in motion are in balance. Photography must seize upon this moment and hold immobile the equilibrium of it."*[5] Photography appears to fit as a transitional element between Dada and Surrealism. Cartier-Bresson viewed his photograph as a kind of ready-made object not unlike Marcel Duchamp's *Bottle Rack* (1914), which was transformed into art by the very act of its coming into being through seizure from the real world. The photograph acted as a displacement of life from actuality to the surface of a sheet of paper just as a urinal or drainpipe assumed a new identity once it was removed from its expected locus. The machine was admired in and of itself by Duchamp and Francis Picabia; the Leica camera favored by Cartier-Bresson, Kertész, and others was a high-technology instrument, unlike the traditional wooden cameras in general use. The photograph itself resulted from a process of visual automatism—a kind of automatic writing favored by Surrealists. We must imagine that in its own time *Banks of the River Marne* was a revolutionary photograph. It is descended from work described by Julien Levy as amoral, equivocal, ambivalent, antiplastic, and accidental.[6]

Kertész's *Meudon* embodies, perhaps even more perfectly than *Banks of the River Marne*, an image in which, for a unique instant, elements in motion are in full intellectual balance. We recognize the source of Cartier-Bresson's admiration for Kertész in the masterful way content has been created where none had existed in the journalistic sense of the phrase. We also understand from this image why Kertész has characterized himself as a *"naturalist Surrealist."* The forces in motion are a steam engine and a man walking. The engine will continue on its way and the man will complete his errand without knowing that they have been part of a history-making event— the creation of a work of art that will outlive the actuality represented. Kertész and Cartier-Bresson adhered intuitively to the advice given by Goethe to visual artists that it is good to think, better to look and think, best to look without thinking.[7]

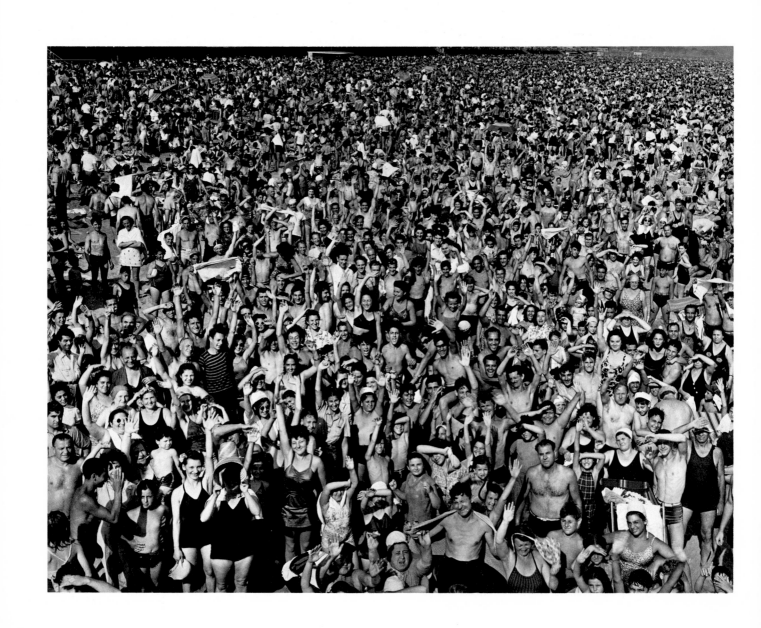

[PLATE 5]

Arthur Siegel
American, 1913–1978

Right of Assembly
Gelatin silver, 1941 (May 19)

16⅝ x 13⅝ inches · 42.2 x 34.5 cm

1981.1046

*Purchase, Warner Communications Inc. Gift
and matching funds from the National Endowment for the Arts, 1981*

[PLATE 6]

ing, and engaged in all manner of horseplay, so that together they form a topographical map of a certain pleasureful response. The photographer creates a collective portrait of hundreds of foreground figures whose individuality is discernible. The beautiful, the commonplace, and the homely are all represented, as are the seven ages of man. Few can resist feeling good when looking at this image, for the faces seem to be cheering on the observer in the present, as they did when the photographer stood before them.

Arthur Siegel, a friend and student of Moholy-Nagy's (*Pl. 24*) at Chicago's Illinois Institute of Technology, where German expatriates created the New Bauhaus, interpreted the crowd very differently in his *Right of Assembly*. The people in his crowd are wearing hats and are dressed in dark suits. The bird's-eye view causes the sense of spatial depth to be diminished. Also diminished are the individual identities of the people, who are pulled into a planar relationship as ornaments on the surface of the paper. There is no trace of emotion in the crowd except perhaps resigned expectancy that something is about to happen. But what? From the title it would seem to be a political event, from which Siegel has distanced himself so as not to become involved with its ebb and flow of emotion. Siegel deftly reconciles the opposites embodied in abstract

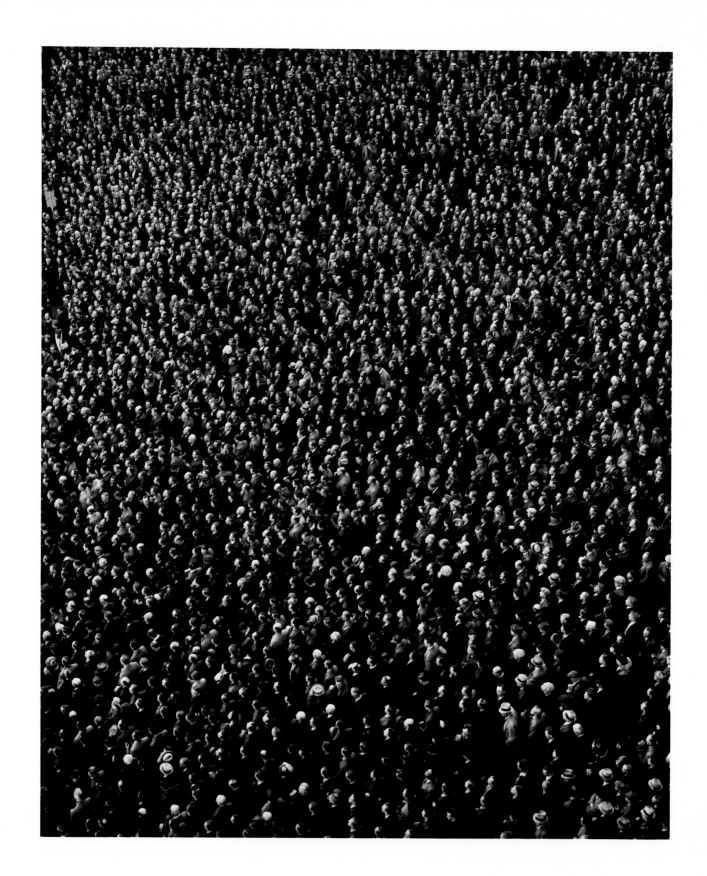

[PLATE 6]

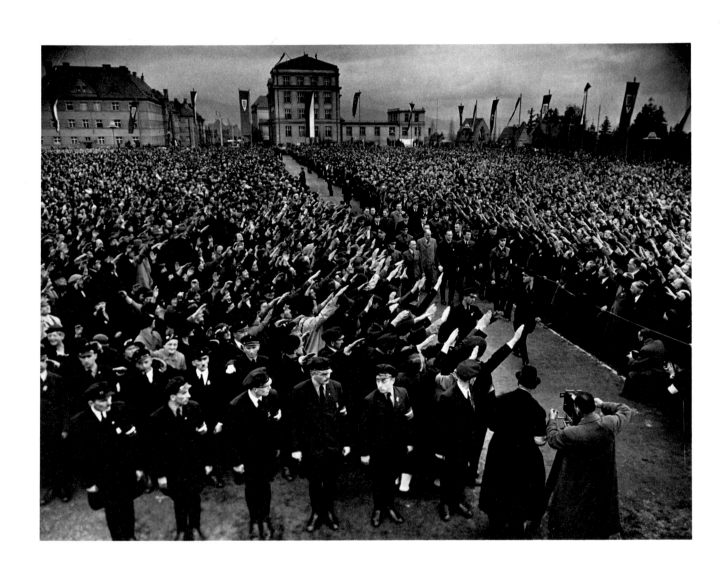

[PLATE 7]

Weegee (Arthur Fellig)
American, 1899–1968

Coney Island

Gelatin silver, 1945 (July)

10½ x 13⅝ inches · 26.7 x 34.6 cm

1977.538

Warner Communications Inc. Purchase Fund, 1977

[PLATE 5]

CERTAIN LANGUAGES are intrinsically fascinating to persons untutored in their grammar and syntax and for whom there is not a particle of cognitive meaning—tea leaves in the bottom of a cup, the squared-off characters of Chinese calligraphy, tracks left on the ice viewed by a nonskater.[8] Crowds may be studied as both a kind of language and an organism. It is said that every crowd is different and that every crowd has a collective message. Each crowd has a personality that can be recorded like the expression on the face of an individual, but a crowd can also be just a faceless mass. In different ways and with different results, each of these photographs represents a different position regarding the individual versus the mass. More important, each photograph challenges the photographer to maintain his own individuality, since crowds, under most circumstances, resist being manipulated by all but the most potent of forces.

Through a naive understanding that the most powerful crowd-forming influence is the orator, Weegee exerted his influence upon the multitude assembled at Coney Island in July 1945. The sun is bright, the costumes are peculiar to bathing, and the mood is relaxed. Through a feat of social finesse, Weegee's camera became the orator, and he managed to involve hundreds of foreground persons into a collaboration with his machine. They gaze at the camera, eyes into the sun, gesturing, clowning, shout-

Margaret Bourke-White
American, 1904–1971

Nazi Rally, Czechoslovakia
Gelatin silver, 1937

10½ x 13½ inches · 25.6 x 34.2 cm

1979.550

Warner Communications Inc. Purchase Fund, 1979

[PLATE 7]

and exact seeing as prescribed by Moholy-Nagy, who was not alone in his concern for retaining form and emotion. Paul Strand, who had experimented with abstraction between 1917 and 1920 only to drop it, expressed the perpetual dilemma between form and emotion in terms that are applicable to Siegel: *"It is in the organization of this objectivity that the photographer's point of view toward life enters in, and where a formal conception born of the emotions, the intellect, or of both, is an inevitable necessity for him before an exposure is made, as for the painter, before he puts brush to canvas."*[9] Siegel proved that just as painting survived the birth of photography, photographers could survive the insistence of ascendant painterly influences.

Bourke-White's *Nazi Rally, Czechoslovakia* sparks many questions: What was a young American woman doing in the enemy's camp in a time of war? How did she get such a privileged viewpoint? Whose side was she on? As to why she was there, Bourke-White answered this herself when, recollecting her reasons for going to the Soviet Union in 1930, she wrote, *"Nothing attracts me like a closed door. I cannot let my camera rest until I have pried it open."*[10]

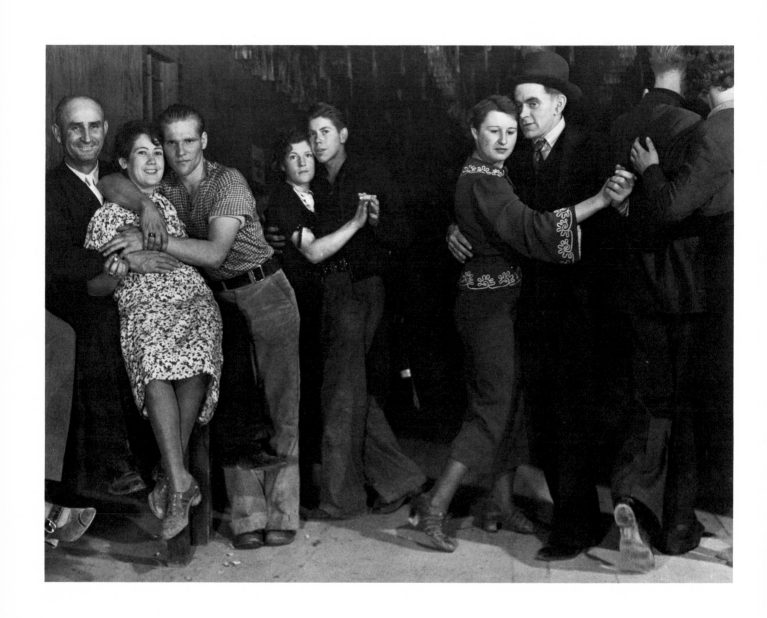

[PLATE 8]

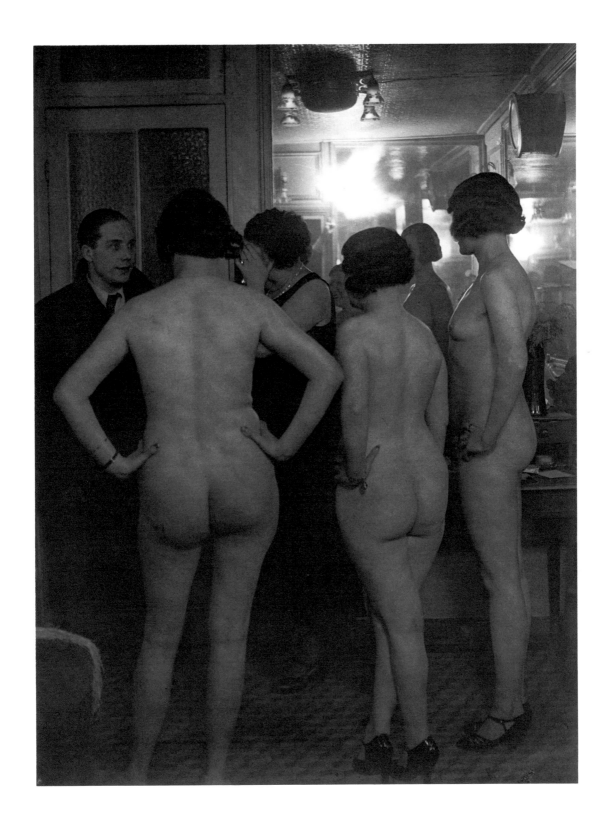

[PLATE 9]

Margaret Bourke-White
American, 1904–1971

Saturday Night, Fort Peck, Montana
Gelatin silver, 1936

14.7⁄16 x 19⅜ inches · 37.4 x 49.2 cm
1978.537
Warner Communications Inc. Purchase Fund, 1978

[PLATE 8]

PHOTOGRAPHY more than any other of the visual arts risks being vulgar, because it is dependent upon actuality. Since vulgarity is among the most powerful inspirations to the literary sensibility, this is an asset when the motivation of a photograph is as much literary as visual. The camera has practically no ability to distinguish between states of dreaming and states of fantasy or between discomfort and agony. Despite this handicap, photography is a medium that does invite the viewer to create his own fictions around a picture, and these fictions can be as convoluted as any novel. The fictions produced by photographs are of a different variety from those of words, and in the end, only some pictures are worth a thousand words. Conversely an equally small number of words are worth a thousand pictures.[11] Ever since the first easel paintings some pictures have required words to be understood properly, and ever since the dawn of writing, some words have inspired pictures. Since the beginning of the sixteenth century, poets and picture makers have debated whether words or pictures were more noble or effective as a means of expression.

Beginning in 1932, Brassaï began to haunt the hangouts of the Paris underworld while he was making night views of streets, parks, and monuments. The title of the series was *Paris de nuit* ("Paris at Night"), a small selection from which was published as a picture book in 1933; the photographs of underworld characters had enormous commercial potential, but Brassaï, surely recognizing their publishability, withheld this important work until 1979. His table of contents reads like a collection of sensational headlines: Cesspool Cleaners, Urinals of Paris, Underworld Criminals, Lovers, Bals-Musette, Bijou, Prostitutes, Houses of Illusion, Artists' Dances, Sodom and Gomorrah, Opium Den. Not since Edgar Degas's monotype illustrations for Maupassant's *La Maison Tellier* (created from studies made at 14, rue de Provence) had the bordello been treated by an artist with such powers of observation.

Brassaï's wryly clinical text that accompanied the first publication of his *Chez Suzy* series is a recollection made some thirty years after the event. Based upon notes made then, it is of necessity colored by the passage of time. For all we know, it could be complete fiction because no words can render the look of an eye, the twist of a smile, the roll of fat, or the line of a thigh as can the photograph. It makes no difference whether the photograph is posed in collaboration with the subjects or taken surreptitiously with a subminiature camera so long as the subjects are who and what they purport to be. No matter how it was made, we are in awe of the skillful human relations

Brassaï (Gyula Halász)
French, born Romania, 1899

La "Présentation" chez Suzy,
quartier Saint-Germain-des-Prés
Gelatin silver, about 1975 from negative of about 1932
11⅞ x 8⅞ inches · 29.9 x 22.5 cm
1980.1023.8
Warner Communications Inc. Purchase Fund, 1980

[PLATE 9]

required to produce even a staged event in a real bordello. The photograph does not require the text for the essence of its meaning to be transmitted, but the photograph and text together drive home the powerful narrative possibilities when the two are wed.

Eventual publication may have been deep in the recesses of Brassaï's mind when he photographed *Chez Suzy*, but when Margaret Bourke-White photographed a dance hall in *Saturday Night, Fort Peck, Montana* in 1936, she did so with the knowledge that the result would possibly be reproduced in the first issue of *Life*, where it actually did appear. The editor described Bourke-White's association with the magazine as follows: "*Margaret Bourke-White closed her highly successful commercial studio to join* Life's *staff and so doing returned one of the world's most effective cameras to the practice of journalism. Six years ago she started a new school of industrial photography in* Fortune. *Now her pictures of Fort Peck workers . . . make a notable contribution to candid photography, bring elements of design and composition without loss of spontaneity and naturalness.*" The text accompanying *Taxi Dancers* is flossy and unperceptive compared with the gravity and expressiveness of the photograph: "*These taxi dancers with the chuffed and dusty shoes lope around with their fares in something halfway between the old barroom stomp and the lackadaisical stroll of the college boys at Roseland. They will lope all night for a nickel a number. Pay is on the rebate system. The fare buys his lady a five cent beer for a dime. She drinks the beer and the management refunds the nickel. If she can hold sixty beers she makes three dollars—and frequently she does.*"[12] The text and photograph do not jibe. Is this really a Wild-West image with the barroom populated by amazons capable of sixty beers a night all for the fun of it? What we see are working-class couples in intimate, genuinely affectionate embraces under the editorial headline "The Frontier Has Returned to the Cow Country." The writer lopes lackadaisically through every pseudo-upbeat phrase in the copywriter's lexicon without hitting on an iota of truth regarding what we are seeing, except the where and when.

These photographs and their full texts tell us as much about the ways of getting at the truth as they do about the social customs of Paris versus Fort Peck. They tell us in particular that truth is the most elusive ingredient shared by art and literature. Both photographs approximate truth better than the texts accompanying them and together help define what is meant by the term *visual intelligence*.

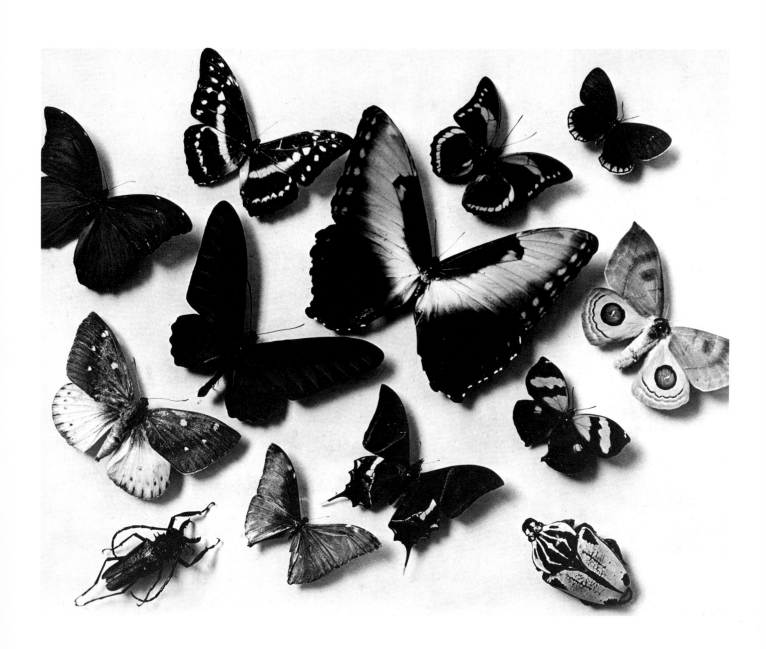

[PLATE 10]

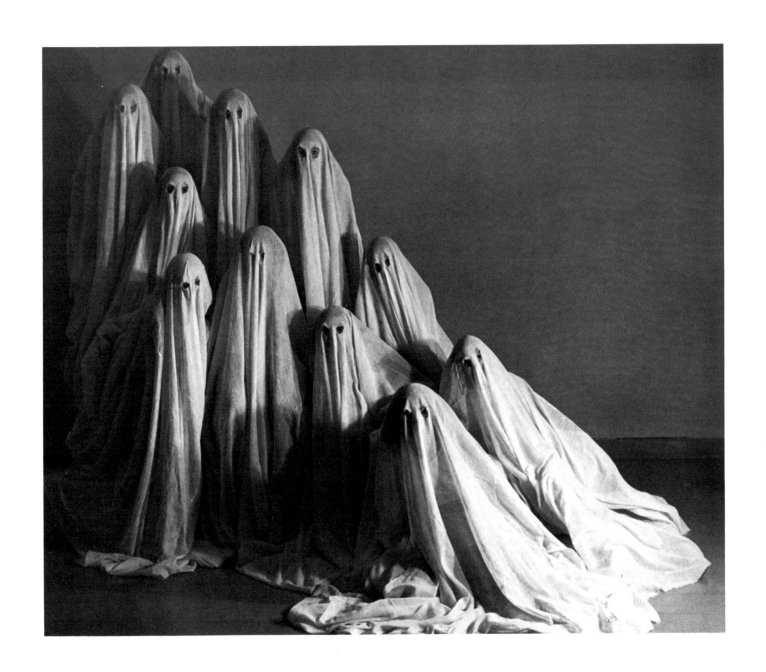

[PLATE 11]

Man Ray
American, 1890–1976

Untitled (Insects)
Gelatin silver, 1926–32

10½ x 13¾₆ inches · 26.7 x 33.5 cm

1977.539

Warner Communications Inc. Purchase Fund, 1977

[PLATE 10]

OF ALL TYPES of works of art, photographs most invite an interactive relationship between the photograph, an imprint of nature, and the observer of the photograph, who brings to it his own experience of the people, places, and objects represented. In part, at least, the ultimate meaning in the photograph depends on the viewer's consciousness, not his intelligence or education. Intelligent photographs have a certain significance established by their maker, but part of their meaning comes from outside the photographer's will. No group of artists recognizes this new element of meaning better than the Surrealists, whose movement rose contemporaneously with the popularization of Albert Einstein's theories and who were intrigued by the metaphysical implications of his relativity principle.

Surrealism evolved very indirectly through a complex process of social and artistic fission that resulted in stylistic incoherence for the movement as a whole as well as for its individual artists. This factor makes identifying and cataloguing the movement's work complicated tasks. Man Ray was no exception, and his art took several different directions at once; sometimes it was quite static, and at other times it was volatile and spontaneous, connected by his obsessive fear of being recognized by a fixed style.[13] Man Ray shared with Einstein the view of a universe in constant motion and in constant change.

Let us assume that all art is connected in some traceable way to the biography of its maker. In Man Ray's autobiography we find that in the 1930s, the date at which the printing paper places his untitled photograph of insects, he was propelled along several, sometimes divergent tracks: filmmaking, commercial photography, creative photography, and, in all of these, the umbrella activity of making Surrealist objects. Instinct tells us that this image of insects is more allied with art than commerce, but it is a work that relies heavily on the representational and aesthetic tools of commercial photography.

Man Ray's autobiography supplies a slender lead to where, in his mix of activity,

Untitled (Ghosts)
Gelatin silver, about 1935

6½ x 7½ inches · 16.6 x 19.1 cm
1980.1064.4
Warner Communications Inc. Purchase Fund, 1980

[PLATE 11]

he found inspiration. *"Among the photographs I brought back to Hollywood* [when the Germans occupied Paris] *was a batch of prints I had made in the thirties as a basis for a series of paintings. These were objects . . . which lay in dusty cases at the Poincaré Institute."*[14] Did Man Ray photograph insects on display at some public institution in Paris as an embodiment of his philosophy that each new subject demanded its particular technique? The image may be interpreted as a throwback to Man Ray's first days in Paris when found objects, such as a flatiron with metal tacks attached to its surface, were one of his primary interests. The new context created by insects having been surgically removed from their original setting becomes an object intended to trigger a different array of associations in every viewer. Man Ray's picture of insects is related to his first American works after World War II, which he entitled collectively *Objects of My Affection*. The photograph of insects is perhaps a prototype of those works that were *"made to amuse, bewilder or inspire reflection."*[15]

Renger-Patzsch was not a Surrealist, but occasionally he made Surreal photographs. We have neither an autobiography of him nor a year-by-year chronology that would permit us to devise a context for this untitled photograph of eleven figures draped in white cloth, which acts like insects' shells. Man Ray's insects are grouped in an unnatural orderly order, but each bears the camouflage of nature in its patterns, its spots, or its earth-colored shell; Renger-Patzsch's figures are grouped in the natural disorderly order that we would expect among a handful of people, but the people are draped with unnatural camouflage. One photograph deals with the costumes nature supplies, while the other deals with the human desire to be costumed on occasion.

What Man Ray and Renger-Patzsch have in common is an appeal to the observer's imagination as the ladder down which meaning must descend if it is to enter the realm of the conscious. If imagination may be defined as the ability to see one thing in the form of another, then Man Ray and Renger-Patzsch share the talent of orchestrating the context within which alteration and transformation can occur.

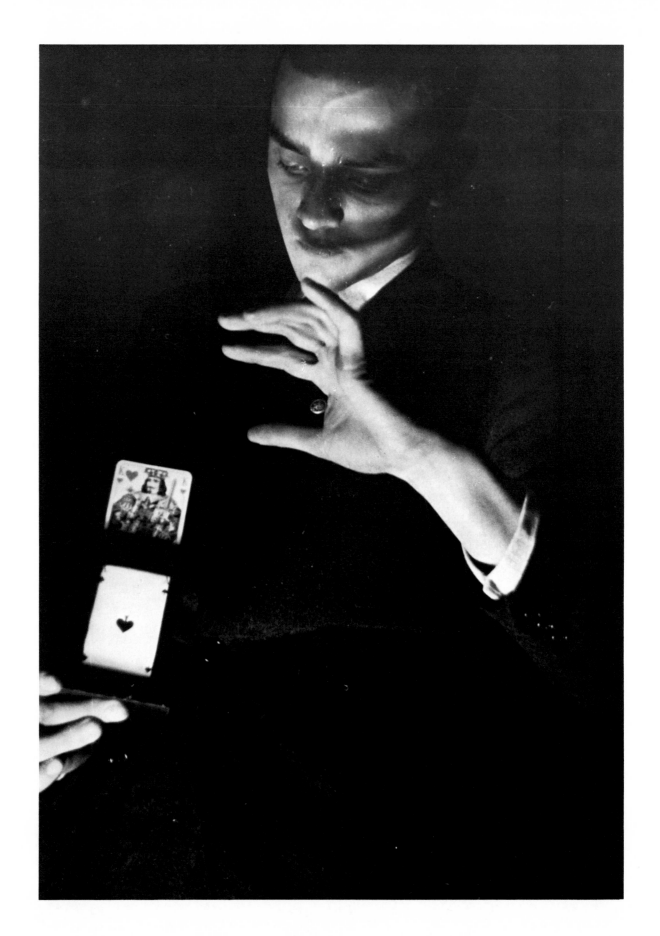

[PLATE 12]

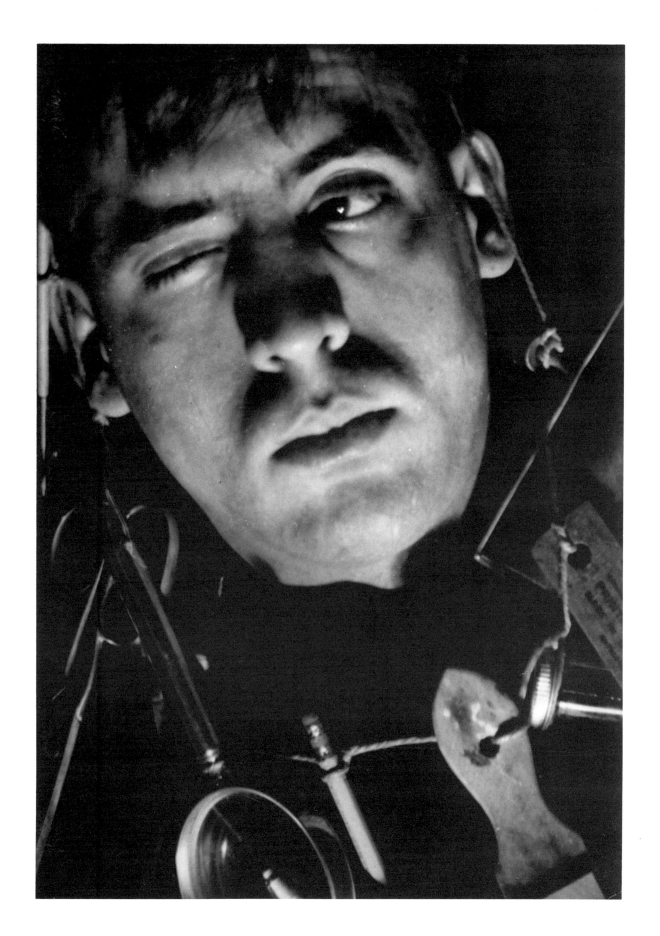

[PLATE 13]

Ludwig Schorer
German, active 1930s

Untitled (Magician)
Gelatin silver, 1920–30

6⅝ x 4¾ inches · 16.8 x 12 cm
1980.1089.4
Warner Communications Inc. Purchase Fund, 1980

[PLATE 12]

PHOTOGRAPHS SEEM to be of two kinds: those about which we know too much and those about which we know too little. No category of art is more baffling and frustrating to the collector than one that cannot be placed in a context, particularly when the object is so charming or so truculent that you want to know more about it. Such is the case with these photographs by Kate Steinitz and Ludwig Schorer.

Kate Steinitz, who was once a companion of Kurt Schwitters's, in Hanover, Germany, knew Man Ray in Paris in the 1930s. They were out of touch for many years, however, and did not renew their friendship until the 1940s when they found each other living in Los Angeles. One of the main questions asked about this photograph, then, is: Was it made during the flowering of German Dadaism in the 1920s, or is it an example of the stylistic contradictions inherent in Surrealism? If the latter is the case, is it possible that the photograph was made much later than the twenties in Los Angeles under the influence of Man Ray?

Man Ray's style at the time he relocated to Los Angeles from Paris, in the wake of the German invasion of France, is typified by his untitled study of insects (*Pl. 10*). Its Surrealism lies in removing subjects from their expected context and presenting them as components of a work of art. For example, although the insects resemble specimens used by naturalists, we know nothing at all about their original context. Moreover, Man Ray's tongue-in-cheek coolness in this period is quite removed from the theatricality of the Steinitz photograph.

The Designer has much more in common with the Dadaist art performances of Kurt Schwitters and Raoul Hausmann. One such performance staged in Hanover in December 1921 consisted of Schwitters and Hausmann standing on a darkened stage

Kate Steinitz
American, born Germany, 1889–1975

The Designer
Gelatin silver, 1920–30
9⅜ x 6¹¹⁄₁₆ inches · 23.9 x 17 cm
1977.536
Warner Communications Inc. Purchase Fund, 1977

[PLATE 13]

where Schwitters read one of his poems while Hausmann, holding the switch to an electric light, turned it on at the end of each line, revealing himself in a sequence of grotesque poses.[16] It is an amalgam of fantasy and realism of this kind that Steinitz seems to have used as the basis for her photograph. The work is every bit as experimental as Schwitters's *Merz* collages, which were intended to fuse art and life through the use of both biographical and autobiographical content. The pencil, the pair of scissors, and the magnifying glass among the props in Steinitz's photograph seem to relate to the life of a person, either the one represented or the photographer. This use of found objects as elements in a work of art is typical of Dada, and it is with the German phase of Dada that this photograph may be associated.

Ludwig Schorer lived in Germany and was apparently a near contemporary of Steinitz's. His name does not appear in the published lists of creative photographers of his epoch, however, and the question raised by his photograph is whether he was an artist creating in the medium of photography or a commercial illustrator whose imagination was fired by the desire to win attention for his client. Superficially, his photograph resembles Steinitz's in its theatricality, but there the similarity ends. Steinitz's photograph has to do with the metaphor of a shaman's fetishes, while Schorer's is about a magician doing a trick. It is a work of instant appeal to the layman, perhaps because of the innate human fascination with magic and sleight of hand.

The main differences between these two works is that Schorer deals with the known — an actor creating an illusion — while Steinitz deals with an imagined state of being, something mysterious and, in the end, deeply rooted in the psyches of both the photographer and the model.

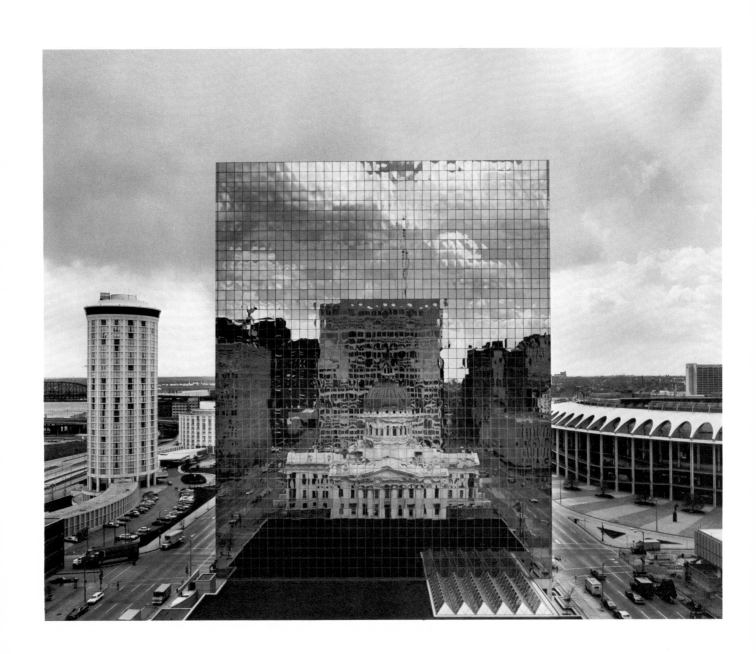

[PLATE 14]

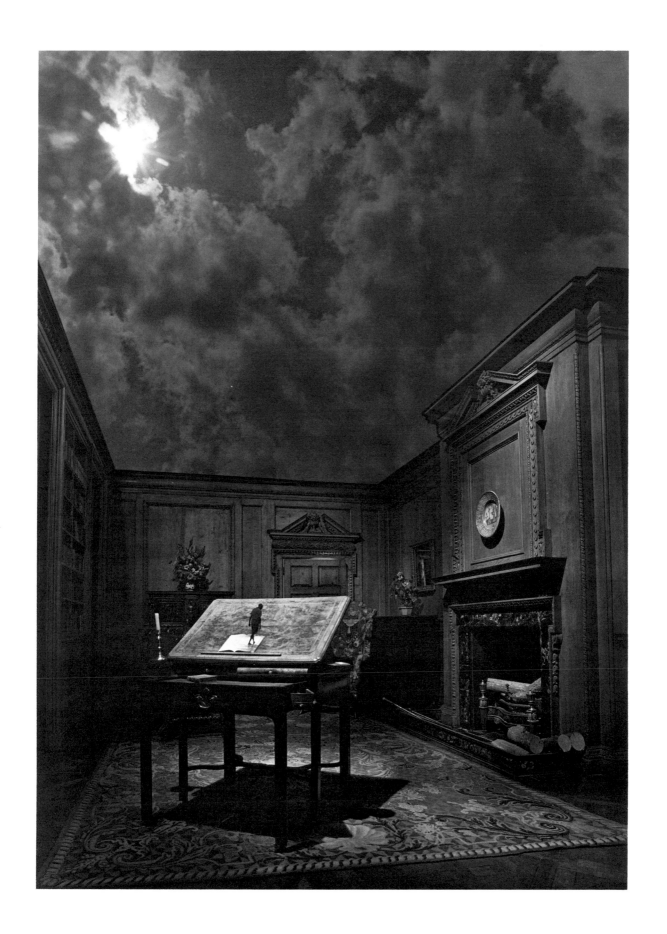

[PLATE 15]

ONE OF THE GENERAL assumptions underlying the growth of the photography collection at the Metropolitan Museum is that the photograph can be art if the camera is in the hands of an artist. One of the goals of these essays is not to debate whether or not photography is art but to provide some clues as to what kind of art it is. The photographs of Clift and Uelsmann direct our attention to a further question: Is the artfulness of the photograph in any way contingent upon whether it is "made" or "taken"?

The traditional vocabulary of art generally employs the phrase "to make" to refer to the process by which a painting, print, or decorative object is created, reserving "to take" for the process by which photographs are created. In traditional vocabulary, Uelsmann's photograph may seem more "made" than Clift's. Who would deny, however, that Clift's photograph represents a highly carpenter-like handling of the more abstract building blocks of the photograph—camera angle, point of view, foreground versus background, and quality of light? Is this not to an equal degree a photograph that has been made rather than taken?

Both Clift and Uelsmann were confronted with a mix of experiences involving historical time and contemporary time that challenged being pictorialized in a single image; both photographers were determined to reduce their vision of an experience to a single picture. In doing so, they created artistic problems for themselves. Uelsmann solved the problem by finding several negatives that, when combined, said what he imagined. Clift solved the problem by choosing with inordinate deliberation the perfect location to place his camera so that four buildings important to him would be recorded as he imagined them: the two modern structures with curved facades at left and right; the very contemporary glass-faced building at center; and his main subject, the domed

Jerry Uelsmann
American, born 1934

Untitled
Gelatin silver, 1976

19⅜ x 14¼ inches · 49.3 x 36 cm
1981.1073
*Purchase, Warner Communications Inc. Gift
and matching funds from the National Endowment for the Arts, 1981*

[PLATE 15]

courthouse actually behind the camera but reflected in the glass facade of the central structure. The photograph we see is the result of Clift's desire to subordinate the predictable classicism of the courthouse to the diversity of the modern and contemporary buildings around it. The solution required making a picture within a picture, actuality reflected in a fragmented mirror. Clift invokes a device often used in literature to flash back in time or to evoke a dream state.

Uelsmann apparently had an experience similar to Clift's involving a room designed in the eighteenth-century British Neoclassical style, presumably the library of a mansion that he saw as having relevance to modernism. In the center of the room is a print table with an atlas open upon its easel. Uelsmann accepted the fact that the way he visualized this room could not be accommodated in a single exposure and determined to create the final image by amalgamating parts of different negatives—one or more negatives representing the walls and floor of the interior of the room, one representing the sky to replace the actual ceiling, and another to represent a man walking barefoot. The room has been synthesized to create a context for the barefoot figure, just as Clift analytically created a context for the county courthouse. Each used different tools to heighten or diminish, and to distinguish between, present time and past time.

To an equal degree Clift and Uelsmann treat actuality as raw material rather than as a given. They both wish to interpret experience, not just revive memory of it, and in different ways they both deal with a universal confrontation between the static and the volatile. Stylistically the two photographers are distinguished by their attitudes toward the power of will. Clift believes that in the end nature will have its way, while Uelsmann is determined to make the flesh obey.[17]

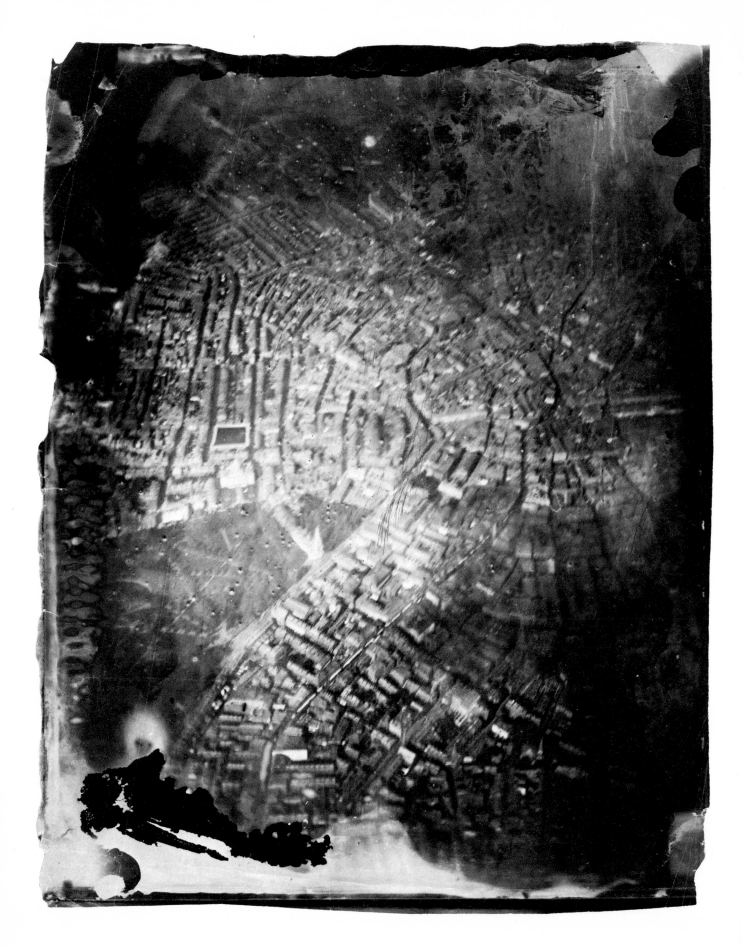

[PLATE 16]

James Wallace Black
American, 1825–1896

Untitled (Boston from hot-air balloon)
Albumen, 1860 (October 13)

10 x 7^{15}⁄$_{16}$ inches · 25.3 x 20.2 cm
1981.1229.4
Robert O. Dougan Collection, Gift of Warner Communications Inc., 1982

[PLATE 16]

CLASSICAL AESTHETICS identified two schools of thought from which works of art tend to be created, one grounded in the imitation of nature, usually identified with Aristotle, and the other grounded in the communication of thought and emotion, usually identified with Plato. In photography, imitation of nature is inevitable, since all photographs require the collaboration of actuality, yet photographs can embody, in differing degrees, not only actuality but idealism and particularism. Particularism is not difficult to understand in photography, because no other art form is so assuredly rooted in specifically identifiable particles of nature as are even abstract photographs. Photography is more than imitation and it is more than representation; it is the actual imprint of nature. For recognizable reality to be absent from a photograph an act of will is required. Conversely, to a greater extent than is popularly believed, actuality can be manipulated to serve nonobjective ends. Cameraless photographs and photographs made from the air bear a special relationship to actuality because they represent something elusive and invisible to the unaided eye while still remaining close imprints of nature itself. As a photographer moves farther away from his subject, the content of the photograph becomes more general (see *Pls. 62–64*).

During the first two decades after the invention of photography — between about 1840 and 1860 — the photograph was prized almost exclusively for its power to imitate nature. Because of the limited understanding of the ways in which the photograph could narrate ideas, the attempts to produce storytelling photographs generally failed. Those few who tried to produce such photographs presumed that the types of ideas the camera could articulate were those derived from Gothic novels, which were dependent upon complex layers of narrative. H. P. Robinson, Oscar Rejlander, and B. Braquehais all attempted in different ways to create visual narratives. Their work proved that in the expression of dramatic motifs the photograph was inferior to painting and writing. The degree to which photography was unsuited to narrative applications was apparently not well understood then. Still to be established were systematic principles for judging the success or failure of a photograph. Opinions in this regard were based almost entirely upon technical, rather than pictorial, considerations.

J. W. Black's series of aerial photographs of Boston and Providence from a balloon were celebrated as the first pictures of their type outside of Europe, but they were

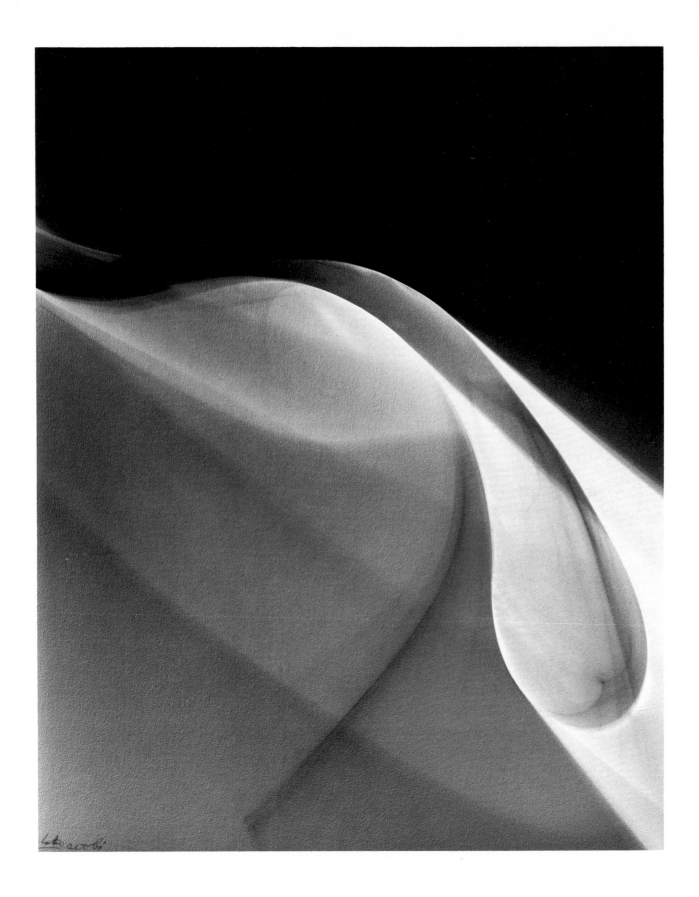

[PLATE 18]

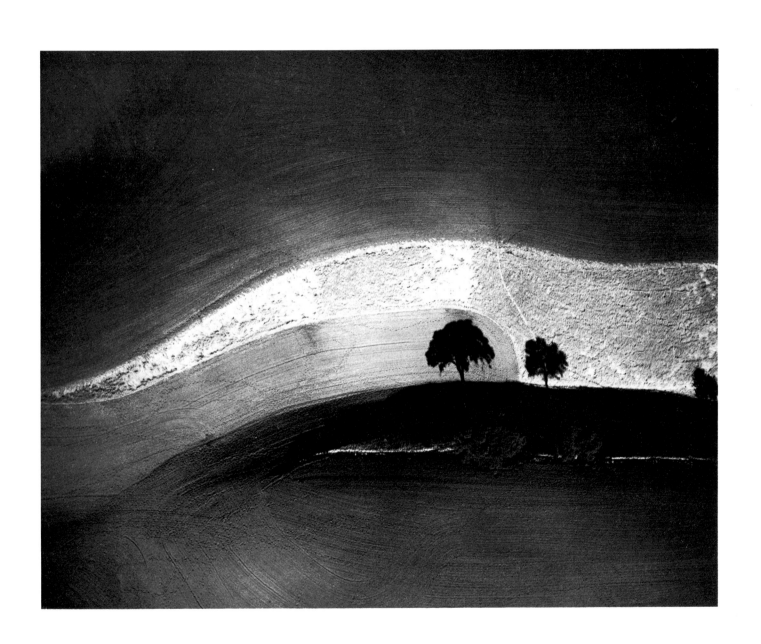

[PLATE 17]

William A. Garnett
American, born 1916

Near Paso Robles, California
Gelatin silver, 1974

15¾ x 19¾ inches · 40 x 50 cm

1981.1009.1

Purchase, Warner Communications Inc. Gift
and matching funds from the National Endowment for the Arts, 1981

[PLATE 17]

technical failures. For the first time the contours and relationships of complex urban terrain could be studied from a picture as well as from a map. The blotchy surface and primitive blurriness perhaps elicited laughs from Boston cartographers, whose product was defined by sharp lines and perfect proportions, the accuracy of which was determined by the limitations of their measuring devices and the inevitability of human error. "Boston as the Eagle and the Wild Goose See It" (so the picture was dubbed by contemporary journalists) is abstract in both spirit and fact. It is now seen as a work of great relevance, but in 1855 it had little application or philosophical importance beyond the fact that it had successfully attained the experimental goal of making an aerial photograph. The functional uselessness of Black's photograph establishes a closer relationship to the fine arts than to the applied arts that inspired its creation. Black's aerial photographs were ineffective as pictorial tools, and yet they hold an attraction to the unaided eye that defies rational explanation. Perhaps the beauty emerges from total nonfunctionalism and an application of Kubler's theorem that *"a work of art is as useless as a tool is useful."*[18] Perhaps uselessness is the ingredient that elevates this photograph to the realm of fine art.

Black could not have foreseen that the time would come when the airplane would make systematic aerial cartography possible; nor would he have thought that one day a photographer, William Garnett, would devote most of his creative life to photographing from the air and that the airplane would be as important in the creation of his work as the camera.

Garnett was motivated by the simple perception of how different and beautiful something that is familiar on the ground looks from the air. In *Near Paso Robles, California* we see a small hill with three trees surrounded by freshly plowed fields. None of the individual elements looks the way we expect it to look. Very little of the actual hill and trees is evident to the eye; we see broad shadows cast by a late-afternoon or early-morning sun. The resulting image resembles simultaneously a photographic negative superimposed upon a print from the same negative and a double exposure made of the same subject with the camera in two different positions. The earth itself resembles an artist's canvas primed with its base coat but with only portions of the design painted in. The subject of the photograph is less nature or landscape than it is a

Comet
Gelatin silver without negative (Photogenic), about 1950
9¹⁵/₁₆ x 8 inches • 25.1 x 20.2 cm
1976.632
Warner Communications Inc. Purchase Fund, 1976

[PLATE 18]

statement about the fundamental ambiguity of nature and the influence of painting on photography at the time.

Prior knowledge of Black and Garnett invites interpretation of Lotte Jacobi's photograph as a sand dune seen from the air. Her untitled photograph is not of a sand dune, nor is it likely that the photographer even had a sand dune in mind when the picture was made. Ironically, Jacobi did not even see the image she created at the time of exposure because her work was done without a camera by directing a small flashlight at the photographic paper through a flexible sheet of plastic. The result embodies accident and intention, an abstract design that resembles a form in nature articulated by the edges of shapes and the degrees of gray. The process resembles the photogram technique used by Man Ray and Moholy-Nagy in producing a one-of-a-kind picture. Jacobi called her process "photogenic," a word that harks back to the earliest days of photography, when photography was described as the pencil of nature. Jacobi's designation was apt, for we see light delineating itself beautifully. It is not light observed with the naked eye, but something closer to the soul of light or the inner spirit of a person in portraiture. If light had a subconscious level as revealable as the human mind is under psychotherapy, it might look like this.

Could, or would, Garnett and Jacobi have made their pictures without the prior existence of modern abstract painting and sculpture, which redefined the classic idea that art results from the imitation of nature? Perhaps, but it is not likely. Both required understanding that a recognizable subject in nature neither adds to nor subtracts from the merit of a picture or sculpture.[19] It was necessary to believe that art, including photography, was appreciated for reasons that Ezra Pound articulated many years before those particular photographs were made: "*The eye* likes *certain plainnesses, certain complexities, certain arrangements, certain varieties, certain incitements, certain reliefs and suspensions. It likes these things irrespective of whether or no they form a replica of known objects.*"[20] Painters arrived at these beliefs before photographers, and the prior existence of their work directly or indirectly inspired photographers, who contributed the photograph's unique capacity to specify and generalize simultaneously about its subjects.

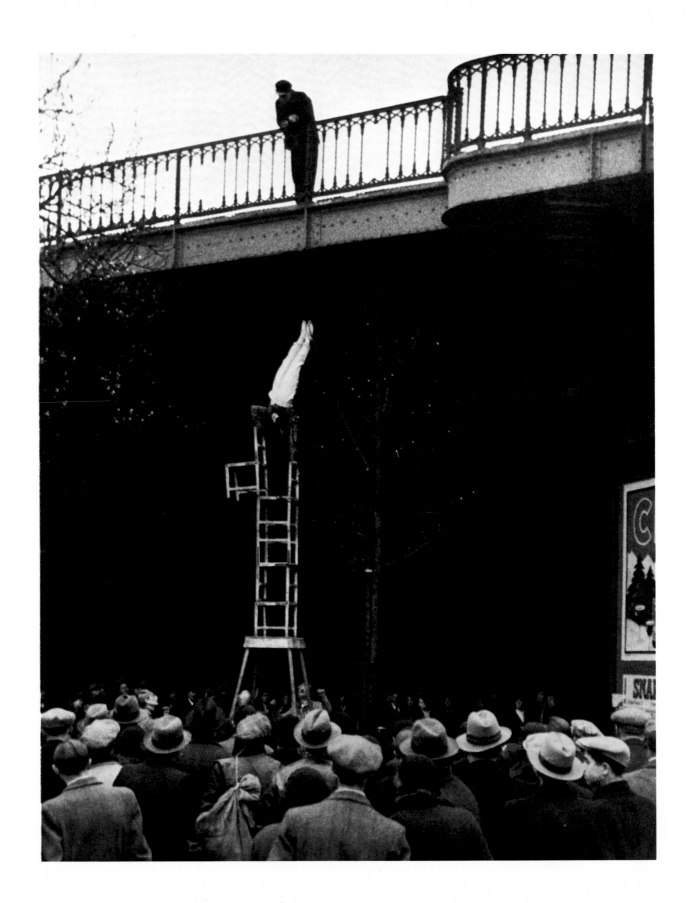

[PLATE 19]

[PLATE 20]

André Kertész
American, born Hungary, 1894

Fête foraine, Paris
Gelatin silver, 1977 from negative of 1931

14 x 11 inches · 35.7 x 28 cm

1977.501.3

Warner Communications Inc. Purchase Fund, 1977

[PLATE 19]

CAN PHOTOGRAPHY ultimately realize the tantalizing wish for a "*Raphael without hands*"? This is the phrase coined by the art historian Edgar Wind to express the frustration felt by painters and poets at not being able to achieve simultaneity between having a perception and recording it. It was translated into the dream that an image could be created in the eyes and mind without going through the hands.[21] In photography image making is connected to feeling by the time elapsed between the experiencing of emotion and the reflex of the shutter release; it is partly because of the close connection between feeling and recording that photography is such a valued medium of expression.

André Kertész and Robert Doisneau experienced two moments that may only be described as pregnant because what we see leads us to imagine with absolute certainty what soon will be: the glances will shift and the balancing man will end his performance. In both instances the photographer's perception was simultaneous with its recording; what we see was not locked into an airtight composition simply by feeling but rather through an act of imagination by which unrelated actualities are given material form through gifted perception. Purely optical elements are fused with something visceral. Both photographs are built around networks of unrecorded lines that we feel more clearly than we see. Doisneau's lines move from right to left, directed by the

Robert Doisneau
French, born 1912

Un Regard oblique
Gelatin silver, 1981 from negative of 1948

9½ x 11¹³⁄₁₆ inches · 24.1 x 30 cm

1981.1199

Warner Communications Inc. Purchase Fund, 1981

[PLATE 20]

man's glance; the woman's gaze creates a line of energy like a hole in space. Kertész establishes a vertical dotted line that extends from the lone figure observing the performance through the performer and his apparatus and on to the crowd. The creation of these relationships from life itself is imagination in photography.

Our eyes cannot relax from the inferred directions of force or from the curious relationship between form and content. The form of these photographs resides in something that exists in the mind, not something material. The miracle is that as distinct and independent as form and content are, here they are as inseparable as if they had been seamlessly woven into the fabric of the picture. Photographs have the curious potentiality of weaving feelings of interlocked actuality with emotions of gesture. The photograph can be about accident and about intellectual systems simultaneously.

Elsewhere we have observed that it is unlikely that Model (*Pl. 57*) and Frank (*Pl. 58*) recognized the particular meaningfulness, in picture language, of the moment they had realized latently at the time of exposure. Kertész and Doisneau depend entirely upon our recognition that they were present at the instant of the unique intersection of events. The difference between these sets of pictures may be described as that of experiment versus certain conquest. Model and Frank give us one fragment of a larger story; Kertész and Doisneau here tell an entire story with a single stroke.

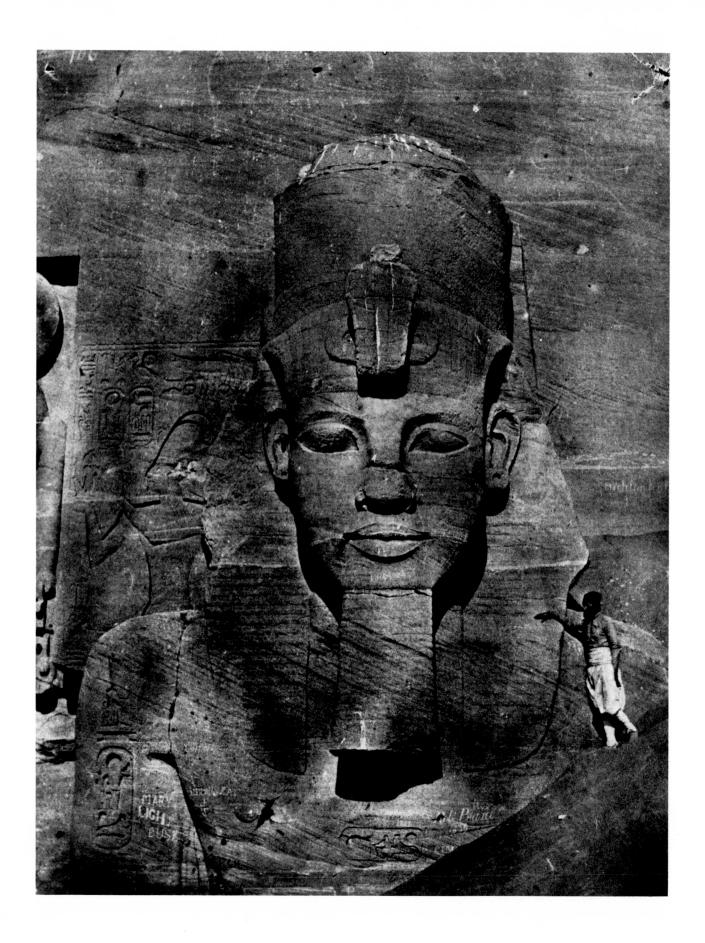

[PLATE 21]

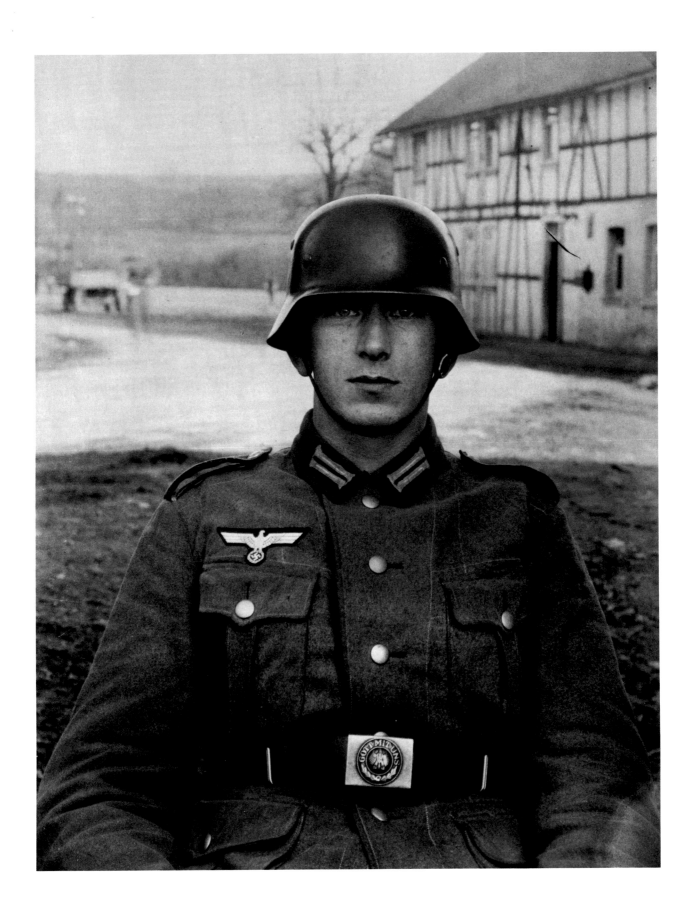

[PLATE 22]

Maxime Du Camp
French, 1822–1894

Colossus of Ramses II at Abu Simbel
Albumenized salt print, 1852

8¼ x 6⅜ inches · 21 x 16.3 cm

1981.1229.2

Robert O. Dougan Collection, Gift of Warner Communications Inc., 1981

[PLATE 21]

MOST WORKS OF ART are produced for reasons other than the sake of art alone. A little-acknowledged fact is that through art the political—an intangible force—is made observable in one time and place. To be effective, political art must be highly visible; and before ways of making exactly repeatable pictorial statements[22] were devised in the fifteenth century, size was the most effective way of ensuring visibility. The invention of woodcut, engraving, and finally photography made it possible to command the public's attention in more subtle ways. Today it is through photography that most people experience works of art. The political cannot be directly represented in a single picture and becomes a subject for the visual arts only by invoking the traditional narrative devices of metaphor, analogy, and symbol.

Maxime Du Camp and August Sander here deal indirectly with symbols of politics and power by using artifacts as their vehicles. Actual human beings are incidental; artifacts are, to different degrees, the main subjects.

The camera drastically alters the ways works of art are represented. Before Du Camp's sumptuous volume entitled *Egypte, Nubie, Palestine et Syrie* (Paris, 1852),[23] the monuments of the Nile Valley had been depicted in paintings, drawings, and prints that adequately pictured the outline and design of a subject but never recorded exactly what many different observers might wish to see about surface texture, ephemeral marks, or quality of light. A monument such as the Colossus at Abu Simbel, unless visited personally, could be experienced only insofar as it was observed and delineated by someone else.

The Colossus is first of all just that—a thing of gigantic size—and stands for the type of monument that was necessary to realize political ends before the age of mechanical reproduction came to be. The photograph as an object represents in ways that are purely photographic—through truthful rendering of the hill of sand, through the traces of time's pocks and scars, and through a convincing sense of scale—how mutable are the people and institutions that for a brief time control the destiny of a nation and its people. The monument as represented in the photograph tells us something slightly different from what the monument itself must have told those who beheld it in the time of Ramses II. We may imagine a political structure topped by a single leader whose power was so great that he could command an army of workers to create a monument in his memory. Implied but not stated is the concentration of great wealth in the hands of a few in a society based on slavery. The representation carries no message of malevolence; on the contrary, it suggests a benevolent dictator. The skill with which the

August Sander
German, 1876–1964

Young Soldier, Westerwald
Gelatin silver, 1978 (by Gunther Sander) from negative of 1945
11⅝ x 9 inches • 28.4 x 22.7 cm
1979.521.6
Warner Communications Inc. Purchase Fund, 1979

[PLATE 22]

work is executed indicates the existence of a body of sophisticated artists and of a political system that valued the work of art either for its intrinsic merits or for its propaganda value.

August Sander dealt with the political in a manner different from Du Camp's. First, it should be made clear that he was not a Nazi or even a sympathizer and had suffered the confiscation and destruction of his book *Antlitz der Zeit* ("Face of Our Time"). The course of Sander's career was significantly altered by not having free access to all the levels of society necessary to continue his lifelong project, *Menschen des 20. Jahrhunderts* ("Man of the Twentieth Century"). There are many reasons to believe that this image was not intended to honor the political powers that caused this young man to look the way he looks and to be dressed the way he is dressed; neither was it intended to satirize. The meaning is more universal. The camera has transformed the boy into a living sculpture; the photographer presents a person literally molded by the political forces of his time. The recognition that both Du Camp's and Sander's photographs are about sculpture is at the heart of the transformation of perception that occurs when they are juxtaposed. Can any observer resist transposing the German face onto the Egyptian monument and vice versa? Does anyone other than the author see the German face as having a dignity and nobility worthy of a pharaoh and the stone visage of the pharaoh as suggesting that he once must have been as sweet and idealistic as this boy?

These two works embody such a delicate form of the empirical, become so intimately identified with matter, that they become theory and not fact. Are we being told by the Colossus, through Du Camp, that its creator did not anticipate the decline of the civilization he helped create? Are we being told by the boy, through Sander, that at the end of the war he would be one of those able to cry with sincerity, "We didn't know, we didn't know"? The questions have no universally accepted answers, but they do bring us one step closer to understanding the ambiguous relationship between art as photography and photography as art. We may comprehend more amply how photographs are, like all other pictures, simply a translation of their subjects into light and dark, foreground and background, surface and texture, which when leavened with the imagination of both the maker and the observer may possess an emotional ingredient of great strength. Photography is not a replacement for actuality; photography *is* photography, a medium of expression with its own inner necessities and supple beauties unconnected by necessity to either stone, flesh, or the spoils of war.

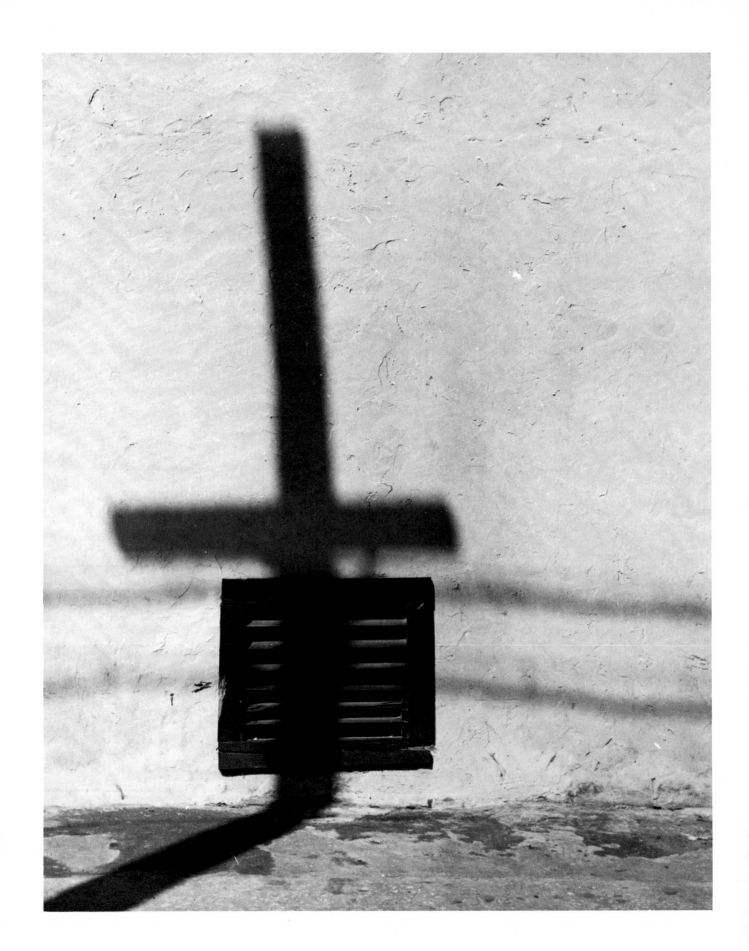

[Plate 23]

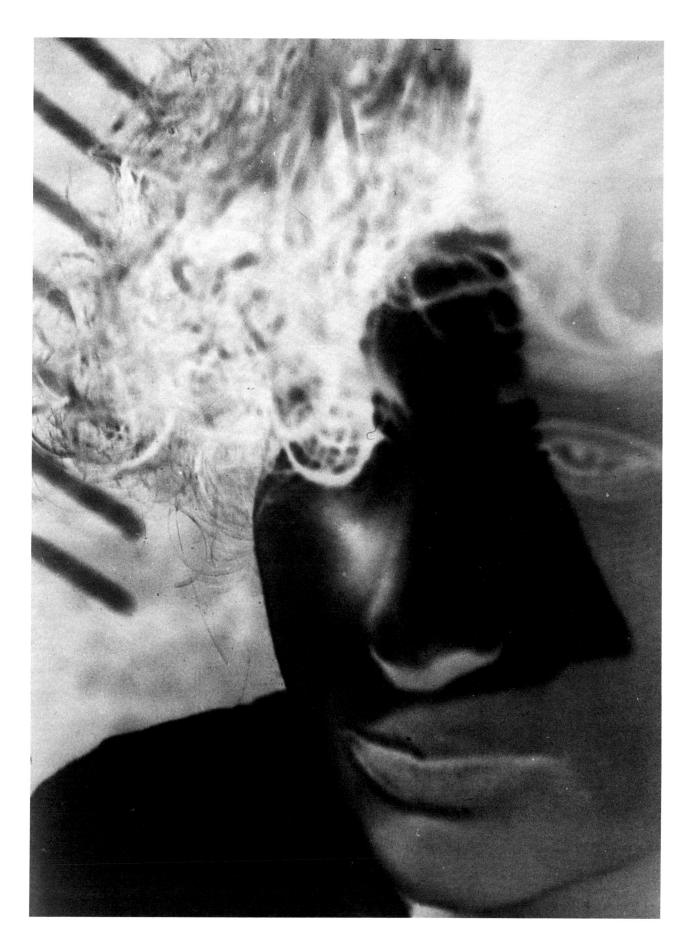

[PLATE 24]

Arnold Newman
American, born 1918

West Palm Beach
Gelatin silver, 1940

9¹⁵⁄₁₆ x 7¹⁵⁄₁₆ inches · 25.2 x 20.2 cm
1981.1179
Warner Communications Inc. Purchase Fund
and Gift of Augusta Newman, 1981

[PLATE 23]

SHADOWS ARE SO commonplace and ultimately familiar to everyone with sight that they would appear to be unpromising subjects for art. They have long been useful as literary metaphors, but for centuries nothing else visible to the unaided eye was thought to be as fleeting as a shadow. The limited availability of artificial light placed shadows beyond human control and made them more worthless than air except to the artist. Certain aspects of the shadow, especially the inevitability of its being the negative imprint of the object that produced it, were not really knowable until strong sources of artificial illumination and lenses for focusing light made it possible for man to subject shadows to experiment. The invention of photography paved the way for further experiment, but everyone thought he knew all there was to know about shadows, which therefore remained unstudied, except by a handful of painters, until after 1900. As far as is known, no nineteenth-century photographer studied shadows except those incidental to objects casting them, where more or less equal pictorial weight was given to the umbra and the opaque body.

László Moholy-Nagy was trained as a painter, but he also frequently photographed. He believed with religious zeal that the ability to grasp reality is the measure of human thinking.[24] Much of his creative life was spent energetically experimenting with different ways to plumb reality, which he believed to be the means by which artists and ordinary people orient themselves in the universe. Shadows were much more of a reality for him than for earlier generations of artists, in part because of his knowledge of the shadow-like image that appears on every black-and-white negative, where dark becomes light and light dark. In this untitled negative print of a woman's face, the appearance of the normal world is reversed to create a double play on the theme of light and dark. The shoulder and face were actually struck by a triangular patch of brightness covering the nose and right eye that in the negative print reads like a deep shadow; the balance of the woman's face was actually in shadow but reads here as though it were bathed in light, but light that is the inverse of actuality. Moholy-Nagy was creating here an embodiment of his belief that black-and-white photography revealed for the first time the interdependence of light and shadow. This photograph

László Moholy-Nagy
American, born Hungary, 1895–1946

Untitled (Face)
Gelatin silver (Negative print), about 1929

9¼ x 6⅞ inches · 23.4 x 17.5 cm

1981.1163

Warner Communications Inc. Purchase Fund, 1981

[PLATE 24]

and others in a series made just prior to their 1930 publication were the means by which Moholy-Nagy proved for himself what he had said privately to his many painter friends: Photography is a new medium of creative expression. He saw in the special character of the gray tones unique to the photograph the fundamental "materials" of photography. For Moholy-Nagy the archenemy of photography was convention, images produced by the rules in how-to books. *"The salvation of photography comes from the experiment,"* he wrote, because *"the experimenter has no preconceived idea about photography."*[25]

Moholy-Nagy was a gifted teacher, both in the classroom and through his writings. One of his most common themes was the process of learning and teaching. His message about the need to experiment continuously found a particularly receptive audience in aspiring photographers like Arnold Newman, who had just taken up photography in 1938 when he made his study of a shadow against the stucco wall of a Florida building. Newman began photographing as a way of depicting things he understood but for which he had not yet found words; photographs were his experience. His apprenticeship had been in a high-volume portrait emporium, which laid part of the groundwork for his future as a portraitist. This required being a photographer both of faces and of places. Just as a portrait should convey the essence of a person, so too should the character of place, not just its surface, be rendered. But what if the place is nowhere and what you are looking at is nothing? Some places have an abstract identity whose fleeting essence may still be pictured. The magic of art in any medium of representation—words, pigment, or light-sensitive silver—is the creation of something from nothing. Moholy-Nagy and Newman demonstrate that they are truly shadow-catchers whose meaning comes from depicting the soul of light, a delineator of both face and place. The fundamental motivation for the photographer to cast his eye upon patches of light exceeds the camera's facility to record it well and has been shared by poets and every other kind of artist. In "The Dry Salvages," T. S. Eliot wrote: *"For most of us, there is only the unattended | Moment, the moment in and out of time, | The distraction fit, lost in a shaft of sunlight."*[26]

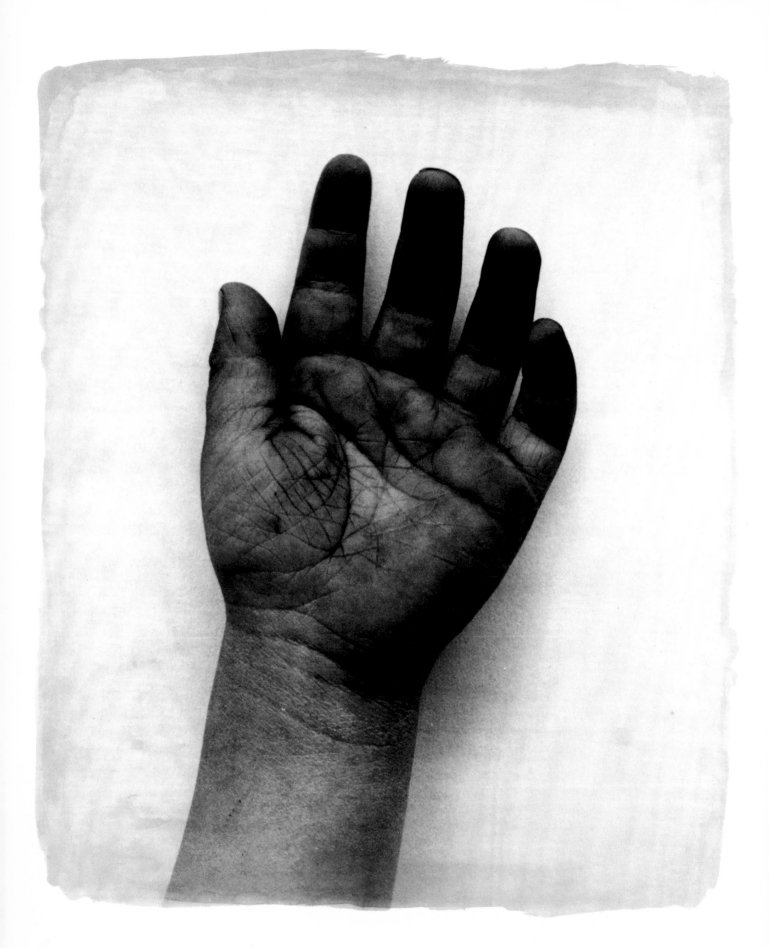

[PLATE 25]

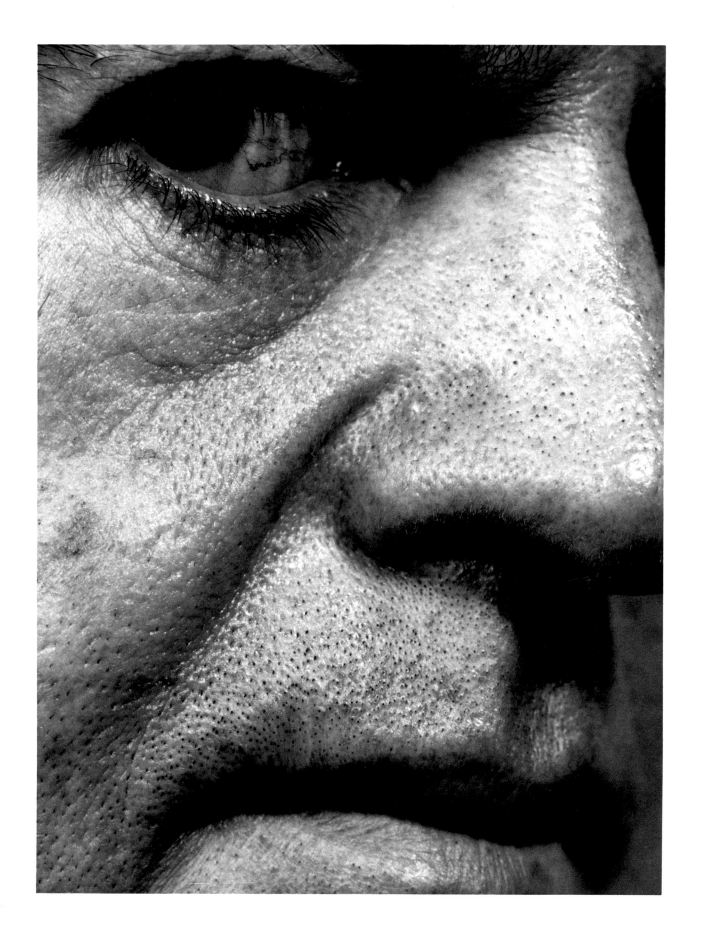

[PLATE 26]

Wendy Snyder MacNeil
American, born 1943

Adrian Sesto

Platinum and palladium on vellum, 1981

19⅛ x 16⅛ inches · 48.8 x 41.2 cm

1981.1164

Warner Communications Inc. Purchase Fund, 1981

[PLATE 25]

SINCE THE RENAISSANCE, portraits—whether painted, drawn, engraved, or photographed—have been directed chiefly toward a single end: the glory of the person represented. In the twentieth century, however, this is no longer always true. Photographic portraiture especially is often concerned with ignominy as well as glory, conflict as well as approbation. The goal of the highest portraiture is to reveal character, not just likeness, and to provide clues to the personality behind the mask, below the surface. In these photographs, John Coplans and Wendy Snyder MacNeil assert that even though surfaces are all the photographer has to work with, the deepest message comes through when the surface is the human epidermis.

John Coplans's portrait of Irving, one of the photographer's oldest friends, is iconoclastic not only in the portraitist's attitude toward vanity, to which traditional portraiture has always appealed, but in his approach to the methods and processes of photography. Coplans, who took up photography in his late fifties without formal instruction, was naturally less bound by convention than someone who had learned by the book. The print of this photograph has been greatly enlarged from one portion of the negative, a practice that is unacceptable to purists, who believe in such strict pre-visualization of the composition that the final image results from printing the full frame of the negative. Purism limits the photographer's imagination and fails to accommodate the natural ease with which photography adapts to unanticipated circumstances. In *Irving* a different treatment of the surface and of the eye would have been the result if Coplans had used a telephoto lens or a normal lens with the camera close to the face. Coplans brought to photography an intense desire to have it replace his former involvement with the process of creation and destruction as a painter and through his personality as a sometimes abrasive *provocateur*. The portrait of Irving assaults the sitter's vanity. The traces of whiskers and the lines of the eye suggest a sinister temperament that does not exist in actuality. All we can say with certainty is that these particular aspects were in the mind of the photographer at this particular moment. The creative act in this case involves an element of destruction and is admissible for the photographer only when working with a sitter from whom there is an

John Coplans
American, born England, 1920

Irving
Gelatin silver, 1980

17 x 13 inches · 43 x 33 cm
1981.1064
*Purchase, Warner Communications Inc. Gift
and matching funds from the National Endowment for the Arts, 1981*

[PLATE 26]

assurance that his remark upon first seeing the image would not be *"I never thought you understand me like that."* In this case, wrenching philosophical differences existed between the photographer and his subject before the portrait, a fact that cannot be ignored when considering the various forces that coincided to cause this powerful characterization to come into being. It may be hypothesized that such an uncompromising representation can only emerge from a deep friendship and from a photographer whose focus is as much the concept of friendship as it is the face before him. It projects the comprehension of one who is seasoned and who knows how to communicate in the language of symbols and emotions. It is a photograph that epitomizes the torment of seeking and the danger of finding.

Wendy Snyder MacNeil, more traditionally educated in photography than Coplans, shares his commitment to the portrait as a favored subject. She differs from him in her concern for portraiture that is biographical in a literary way. She wants the photograph to reveal where a person has come from and where he is going. To do this, she invokes the visual mechanism of inference and suggestion. Her very large photograph of Adrian Sesto's hand is ambiguous. Where Coplans leaves us in doubt as to whether or not he respects his sitter, MacNeil deals with ambiguity of a more general sort, forcing us to ask whether this is the hand of a male or a female, of youth or of old age. The lines of the hand are signs not unlike the lines of Irving's eyes; both are comparable to footprints on the beach, traces that are so undeniably natural that they have intrinsic meaning. The lines of Adrian Sesto's hand resemble the side effects of years of labor, but they also resemble what is left after a child has been playing in the dirt all day. For a child a day hard at play is not unlike an adult's day of hard work. In either event the owner of this hand, whether hard at work or hard at play, will surely be pleased that the traces of a fundamental but ephemeral activity have been arrested for future regard. Here is a photograph about the pleasure of seeking and the fortune of finding. Neither of these photographs represents glory, but neither could have been made without an element of glory deep in the background.

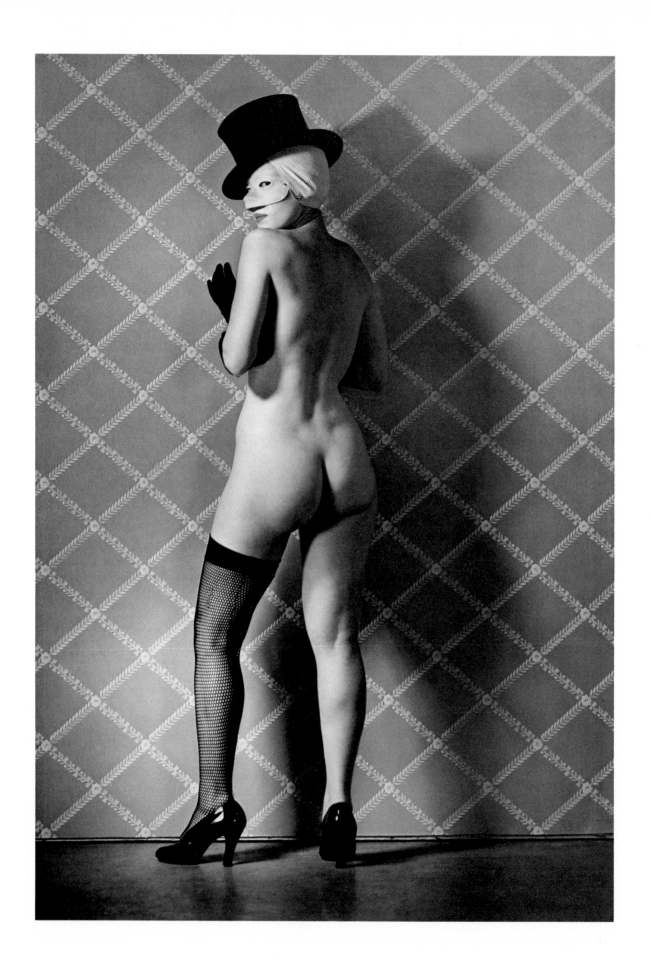

[PLATE 27]

[PLATE 30]

Irving Penn
American, born 1917

Untitled (Female torso)
Gelatin silver, bleached and redeveloped, 1949–50
15⅞ x 15¼ inches · 40.5 x 38.5 cm
1981.1068.1
Purchase, Warner Communications Inc. Gift
and matching funds from the National Endowment for the Arts, 1981

[PLATE 29]

figure as a dictionary of forms and shapes that epitomize perfection and imperfection. The torso is an armature for experiment not unlike the white cup and saucer photographed by Steichen a thousand times to learn the camera's response to every variable. Penn offers the supreme challenge to the observer by demanding that we look simultaneously at his rendering of shape and edge, mass and line, light and dark, while fighting the recognition that the anatomy represented is a catalogue of the erogenous zones. His technique is that of the taxonomist. In his attempt to elevate this work to the level of textbook universals, Penn is being asexual and amoral.

The three photographs express meaning like clocks showing several time zones. Their messages about manhood and womanhood are central to any consideration of shifts in cultural attitudes. Outerbridge reverses the role of man and woman and suggests female superiority; Mapplethorpe suggests that males can be as sensual, pliant, and yielding as the stereotyped female; Penn inspects womanhood as a vessel of pure form, a fertility goddess. Do these photographs tell us anything about the advance or decline of civilization? Hardly. In fact, they serve to debunk further the notion that developments in art are necessarily contemporaneous with its social or moral decline. Fertility rituals, the battle of the sexes, and homosexuality predate recorded history; these pictures merely represent the ways in which some photographers sincerely interpret themes that have attracted artists since the beginning of art.

Paul Outerbridge, Jr.
American, 1896–1958

Untitled (Masked woman)
Tricolor carbro, 1938

16⅞ x 11⅜ inches · 42.7 x 28.9 cm

1977.640

Warner Communications Inc. Purchase Fund, 1977

[PLATE 27]

PHOTOGRAPHS INEVITABLY EMBODY the personality behind the camera, but certain ubiquitous subjects to which many photographers direct their attention resist individualizing treatment. Irving Penn, Paul Outerbridge, and Robert Mapplethorpe have succeeded. Each of us sees the nude form as we dress and undress, and the nude is such a frequent subject of photographs that it tends to become commonplace. The challenge for the photographer is to realize the unexpected in his pictures. Desire, sexuality, morality, and objectivity are among the sensibilities that govern the photographer's response to the nude, but these complicate the photographer's task because our own attitudes tend to be confused.

Photographers become historians of desire, since the camera records only that to which their eyes are attracted. The subject of photographs may be likened to pollen, which does not always come from plants that are beautiful or possess pleasing fragrances. The photograph can be a creation of instinct or a creation of near-total rationality. In some cases it represents an object of personal desire or expresses a personal fantasy. At other times the model or subject is simply someone who happened to be available—a professional hired for the occasion—and with whom there is no specifically emotional relationship.

Just as a story can evolve from the innermost experience of the narrator, so too can the photograph. Outerbridge, for example, is confessing to his fantasy of being peri-

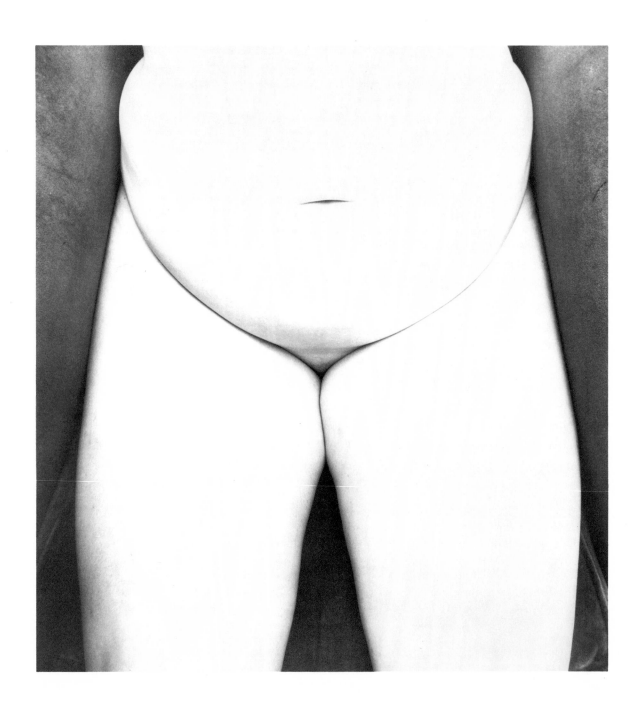

[PLATE 29]

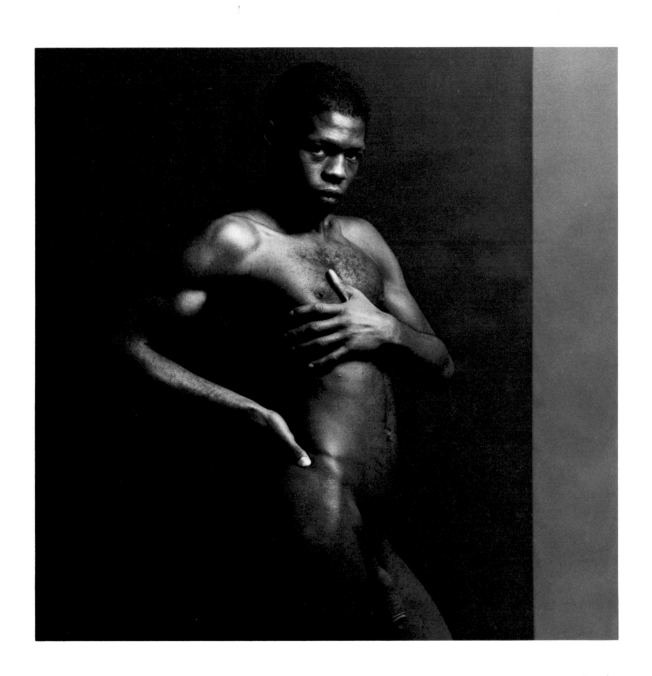

[·PLATE 28]

Gregg Cauley
Gelatin silver, 1980

13¾ x 14 inches · 35 x 35.5 cm
1981.1067
Purchase, Warner Communications Inc. Gift
and matching funds from the National Endowment for the Arts, 1981

[PLATE 28]

odically dominated by a lascivious female with himself behind the camera in the role of the pliant, victimized male. His photograph could serve as an illustration to *Venus in Furs*, by Leopold von Sacher-Masoch, who gave us the word *masochism*.[27] Outerbridge's photograph was never published in his lifetime, and therefore his confession remained in the realm of the diarist whose thoughts and example were influential long after they were composed. The photograph is more about sexual than moral issues. In its composition careful design accompanies unobscured meaning.

Mapplethorpe's photograph leaves undisguised his attraction to this young man, one of many photographed in the course of a series representing black males. We observe a well-formed individual, apparently of gentle spirit, who is momentarily elevated as an object of desire. The photograph documents the breakup of stereotyped attitudes to race and a certain dissolution of bigotry concerning sexual preferences. The photograph is about moral, rather than sexual, issues.[28]

Outerbridge and Mapplethorpe deal, respectively, with sexuality and morality throughout the bodies of work from which these individual photographs are drawn. Penn concerns himself with reason, not desire, with form, not philosophy; his quest is for the archetype of objectivity and his subject is womanhood. Penn turns his back on a premise of fashion and product photography, where the photographer's task is to create desire for what is represented, by proving in his nude that he can eliminate something thought to be inherent in the subject: sexuality. Penn uses the unclothed

66

[PLATE 31]

Stone Relic at Polonnaruwa, Ceylon
Albumen, about 1875

5⅞ x 7¹³⁄₁₆ inches · 15 x 19.8 cm
1977.673.5
Robert O. Dougan Collection, Gift of Warner Communications Inc., 1977

[PLATE 30]

IN EVERY FIELD of creative activity there are some whose ideas and works are in advance of their times, and because of the element of experiment involved, their artistic development is seldom along a straight line. Diversions in the course of experiment are inevitable. Such was the case with the still lifes of André Kertész; he briefly addressed them in the 1920s, but they did not become central to his art until much later.

Kertész began photographing in 1912, while a teenager. By 1928, he had progressed far beyond his amateur stage and produced a body of photographs that catapulted him into a position so influential that Cartier-Bresson has said, "*We owe it all to Kertész.*" His first highly visible public showings were in the famous Film-und-Foto exhibition at the Kunstgewerbe Museum in Stuttgart during the summer of 1929. It was there that the photographs of Charles Sheeler, Edward Weston, Ralph Steiner, Paul Outerbridge, and Edward Steichen (among the American contingent) were also shown and that the phrase *neue Sachlichkeit* ("new objectivity") was coined by critics to describe the precisionist, structured, antipictorialist sensibility, which was thought of simply as the "new" photography. No one had an exact definition of the new photography, but for Kertész it proved to be a fertile amalgam of realism and imagination that distinguished him from most of the Americans represented in Film-und-Foto. The still life in Mondrian's studio evidenced these concerns but did not indicate the major direction Kertész would take as an observer of everyday life later in his career.

Nature morte I, with Mondrian's pipe and glasses as its subject, is a visually puzzling work even in the context of the main body of Kertész's photographs of this period. Its concreteness and objectivity force the question: Is this new realism or something else? In Paris, to which he had moved from his native Hungary in 1925, Kertész was respected by avant-garde painters, poets, and filmmakers for his joyful and intimate studies of bistro life and Paris streets and for sensitive portraits of figures in the world of art. He frequented the Café du Dôme, a Surrealist haunt, and it was there that the gallery director Jan Slivinsky offered him his first public exhibition. *Nature morte I* was first displayed at this show, which opened in 1927 and was attended by various Surrealists, including the poet Paul Dermée, whose verse composed in honor of the

André Kertész
American, born Hungary, 1894

Nature morte I (Mondrian's pipe and glasses)
Gelatin silver, 1926

6³⁄₁₆ x 7³⁄₁₆ inches · 15.7 x 18.2 cm

1977.501.1

Warner Communications Inc. Purchase Fund, 1977

[PLATE 31]

occasion mentions the photograph. The final line reads, *"In this asylum for the blind, Kertész sees for us."*[29] The question is less whether this key work in Kertész's first solo exhibition was influenced by Surrealism than how it is manifested. The answer is to imagine not a Surrealism that necessarily represents a dream state but a more formalistic variety that feeds on unexpected juxtapositions and the love of found objects, which take on other meanings when placed in a new context. The key to understanding the Surrealist elements of Kertész's *Nature morte I* is to see how Kertész crafted the new context not by manually arranging the objects but rather by responding with a flash of the mind at the moment of exposure, when he composed his subject with the three critical triangular dark shapes at the top that represent the photographer's creation. When juxtaposed with the unmodulated white surface nearby, the black triangles transform the pipe and glasses into objects suspended before a flat surface. Kertész has mentally rearranged the objects, giving an illusionary new context that is distant from the time and place of Mondrian's studio.

The enormous degree to which objectivity was totally subordinate to Kertész's own sensibility without seriously compromising the truthfulness of his representation can be placed in perspective if we compare *Nature morte I* to a photograph made for archaeological purposes by Lawton, an Englishman active in the 1870s. Lawton lived in Ceylon, where a museum and archaeological office were established in 1872–73 under the auspices of the governor of Ceylon, Sir William Gregory. The set of 224 photographs, among which is this one of a stone at Polonnaruwa, was designed as a visual inventory of the sites. The stone was thought by its discoverers to date from about 500 B.C. and therefore to be contemporary with Periclean Athens. Astonishment greeted the finding, in a remote jungle, of an object that echoed Mediterranean designs which were contemporary or near contemporary with it and from which mid-Victorian English styles and ornament were derived. The object fascinates today for the same reasons but also for reasons that did not exist in the 1870s. Like Mondrian's pipe and glasses in Kertész's still life, the object becomes one of mystery because it is now being viewed outside its original context and speaks of associations not possible in its own time.

71

[PLATE 32]

[PLATE 33]

André Kertész
American, born Hungary, 1894

In the Cellar, Williamsburg
Gelatin silver, 1977 from negative of about 1948

9¹¹⁄₁₆ x 7¾ inches · 24.6 x 19.5 cm

1977.501.4

Warner Communications Inc. Purchase Fund, 1977

[PLATE 32]

THE PIONEER ART HISTORIAN and theorist Alois Riegel reduced the ebb and flow of styles in art to movement between two poles that he called the haptic and the optic.[30] According to Riegel's scheme, art moves from the haptic, where artists—including photographers—are motivated by a sense of touch (that is, of addressing physical actuality) and reaches the second pole, the optic, where artists focus on painterly and impressionistic perceptions that transform actuality into a pictorial illusion. One is tactile; the other is impressionistic. In haptic art the identity of the maker is subordinate to the subject represented, while in optic art the work of art is about the personality of the maker.

The setting and furnishings of Kertész's *In the Cellar, Williamsburg* typify Riegel's notion of the haptic. The tile floors, the stucco walls, and the stiffly curvaceous settee are objects that appeal to the sense of touch. However, Kertész renders the place in a style that is personal and impressionistic. Thus, his photograph is very close to what Riegel would call the optic. He tells us far less about Williamsburg or colonial American style than he does about his own eccentric view of what he has observed. Namuth's *Jackson Pollock* is an objective and documentary work. Pollock's paintings are, of course, at the extreme opposite of any definition of the haptic, but the scene rendered by Namuth's photograph records the touch, the texture, the very feel of the artist at work. In Riegel's scheme it is haptic. The photographer retired behind the camera and coolly orchestrated his subject so as to make it more comprehensible to his audience.

Both of these works are simultaneously document and interpretation, but what is even more important is the fact that under surfaces of somewhat fanciful peripheral elements, one finds metaphysical connotations. *"For whatever a man may do, he does it in order to annihilate Time, in order to revoke it, and that revocation is called Space,"* writes Hermann Broch in *The Sleepwalkers*.[31] Elsewhere in the same book, he says that every concept, every thing, every comprehensible unity in the world is the *"product of a product."*[32] In different ways, Kertész and Namuth, directly or indirectly, consciously or unconsciously, before or after the fact, deal with destiny, death, birth,

Hans Namuth
American, born Germany, 1915

Jackson Pollock (with painting No. 32)
Gelatin silver, 1950

19⅛ x 15¼ inches · 48.5 x 38.7 cm

1980.1063

Purchase, Warner Communications Inc. Gift
and matching funds from the National Endowment for the Arts, 1980

[PLATE 33]

resurrection, and products of products.

When, at the suggestion of Alexey Brodovitch, Namuth began photographing the promising young painter Jackson Pollock, he became enmeshed in human destiny. Six years after this session, Pollock met an accidental death, and through the photographs his name became forever linked with Namuth's. Since the artist is shown in the act of creation, the photograph is also about birth. However, our perception of it is irrevocably altered by the knowledge that the photograph was made a few years prior to Pollock's death and that it can be read as a sort of clock of destiny for clues as to whether or not the painter sensed what fate had in store for him. Finally, the photograph is an icon of resurrection because Namuth succeeds in conquering time by making Pollock seem an active presence.

Kertész was retained by an editor for *House and Garden* to visit colonial Williamsburg and make a series of photographs. The moment he accepted, he, like Namuth, became enmeshed with destiny, but of another type. Art may be understood as a continuous series of replications that spring from nature and pass through many combinations, permutations, and alterations until works of art themselves beget works that are occasionally more satisfying to a larger audience than the art that inspired them. With a single change in their arrangement, the room and furniture in *In the Cellar, Williamsburg* would cease existing in one context and would assume a new and different life in the photograph. It is a process of death and resurrection. Through a new creation, Kertész opens the way for a new destiny and forces us to ask how long this new work will last before it, too, is transformed by the machinery of time that brought it into being.

The haptic and the optic are modes of perception; birth, death, and resurrection are philosophical modes; and products of products are psychophysical modes. Each ingredient appears in these two photographs in its own way. Together they help us understand the uniqueness of the photograph as a picture formed by the eye, the hand, and the brain.

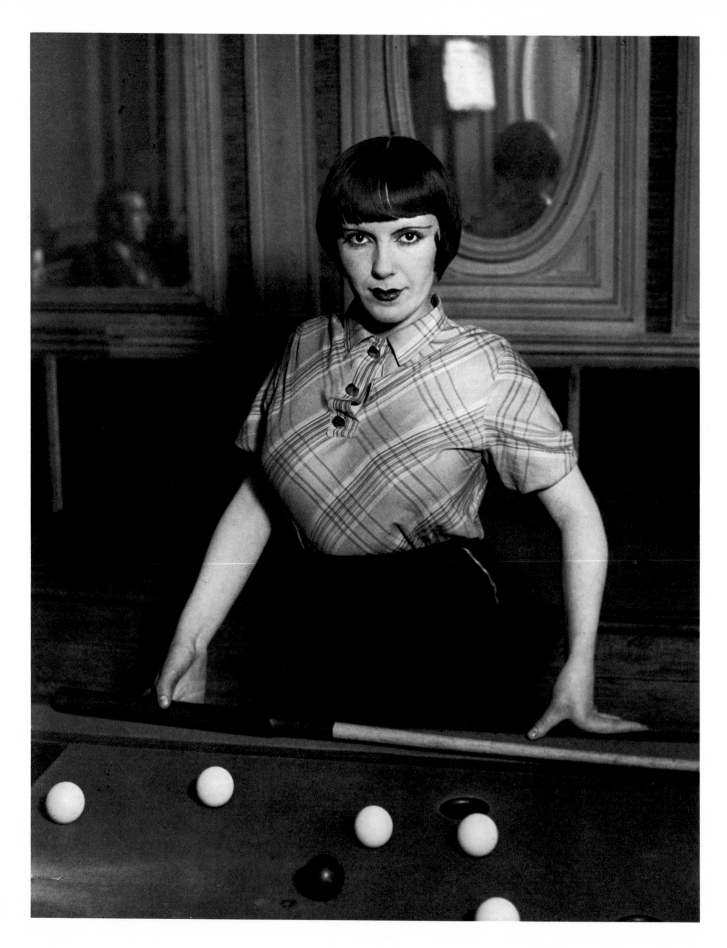

[PLATE 34]

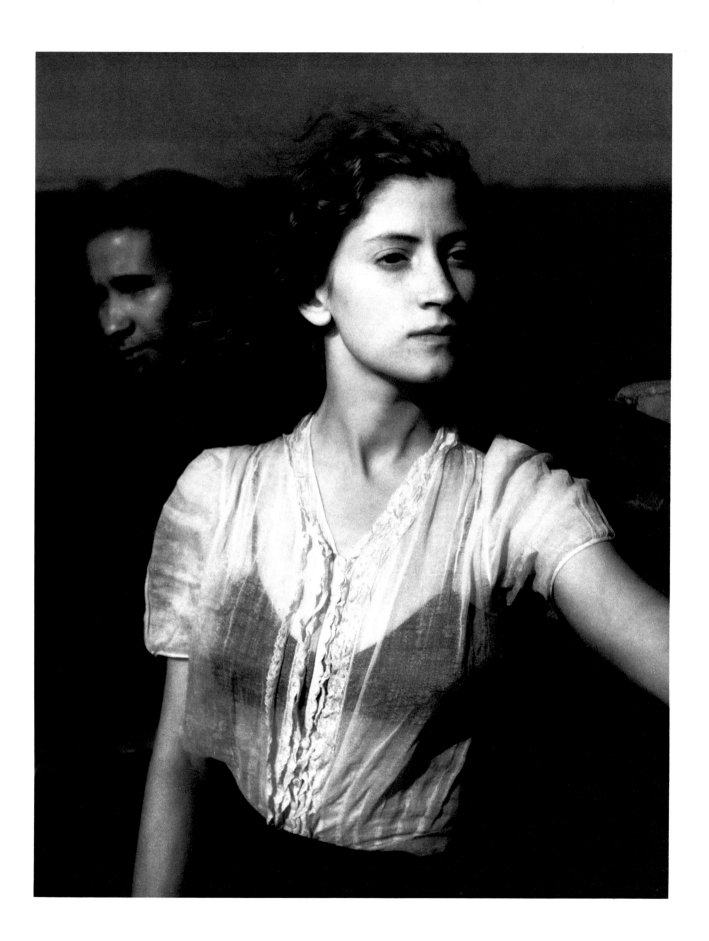

[PLATE 35]

Brassaï (Gyula Halász)
French, born Romania, 1899

Fille de joie au billard russe,
boulevard Roche-Chouart, Montmartre
Gelatin silver, about 1970 from negative of about 1932

11 ³⁄₁₆ x 8 ¹¹⁄₁₆ inches • 28.4 x 22 cm

1980.1023.9

Warner Communications Inc. Purchase Fund, 1980

[PLATE 34]

ROGER W. SPERRY, the scientist, has demonstrated that the two spheres of the brain have different and essentially independent functions: the left side is the seat of reason, while the right side is the seat of the unconscious. Brassaï's and Boubat's photographs are, for this observer at least, visual proof of this, for they appeal simultaneously to reason and intuition and embody an interdependence between the rational and the irrational, the conscious and the unconscious.

The eye cannot focus for long on a single element of either photograph. It is constantly torn between two centers of interest. Just when we respond to the rational and focus on the eyes of the subjects, their breasts command the irrational mode of our visual apparatus, and our attention unconsciously shifts from the eyes to the breasts and back again. In an instant the process is repeated, and our eyes shift back and forth just as the armature in an electric motor is destined to rotate forever between two poles so long as the current is on.

No matter how hard we try, we cannot observe the faces in these photographs simply as portraits. We are constantly torn between looking at what our eyes can see and searching for what they cannot see.

The secrets of the billiard player are not far below the surface and can be detected with gentle scrutiny. What we find elicits sympathy and some anxiety. The pool cue

Edouard Boubat

French, born 1923

Lella, Bretagne

Gelatin silver, 1959 from negative of 1948

12⅛ x 9⅜ inches • 30.6 x 23.9 cm

1976.609.1

Warner Communications Inc. Purchase Fund, 1976

[PLATE 35]

is like a weapon. We imagine her able to use it with equal sureness on a man or a billiard ball. Our eyes shift restlessly between the table, her eyes, and her torso. Just what Lella is concealing is more elusive. Her face and costume project the image of a woman with nothing to hide, but something does not jibe. A quick turn of the mind causes a reversal of perception, and we no longer see her as naive and inexperienced. She seems more like a Lolita exercising a powerful and unnatural influence over one, two, who knows how many persons. We can appreciate this photograph, in which tenderness for the subject is manifest from one edge of the image to the other, without reference to the fact that Lella was the photographer's wartime nurse, with whom he was deeply in love.[33] However, knowledge of this relationship permits us to observe that the photograph was apparently the product of the photographer's rational, as well as his irrational, attitudes toward this woman.

We recognize the presence of emotions such as sympathy and empathy in these photographs, but neither the camera nor our eyes tell us all we want to know. It is precisely because part of their meaning will always remain beyond rational knowledge that the photographs are successful. We are given clues to a mystery that will never be solved.

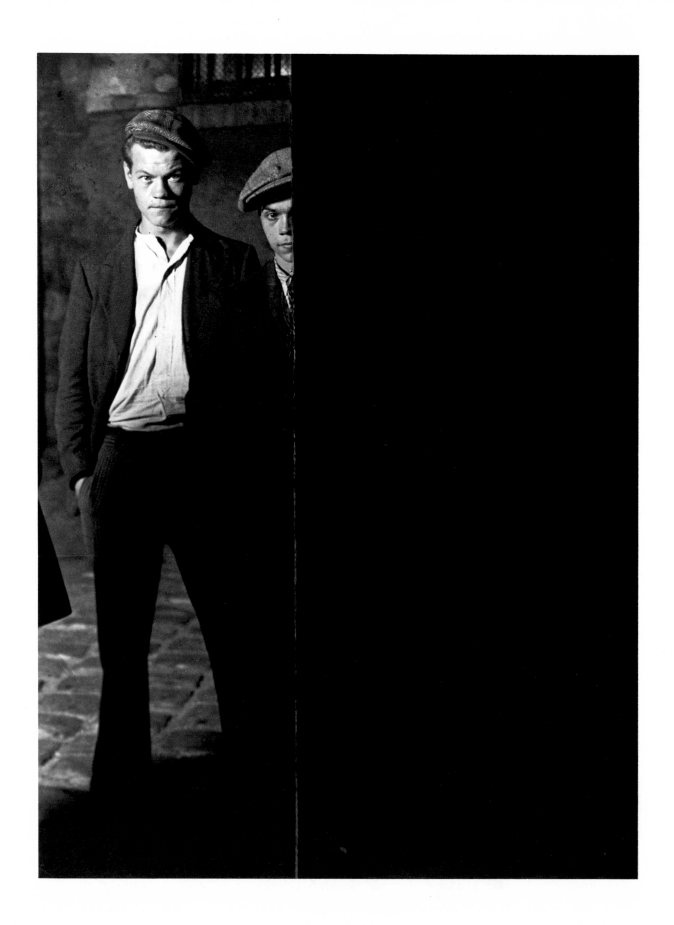

[PLATE 36]

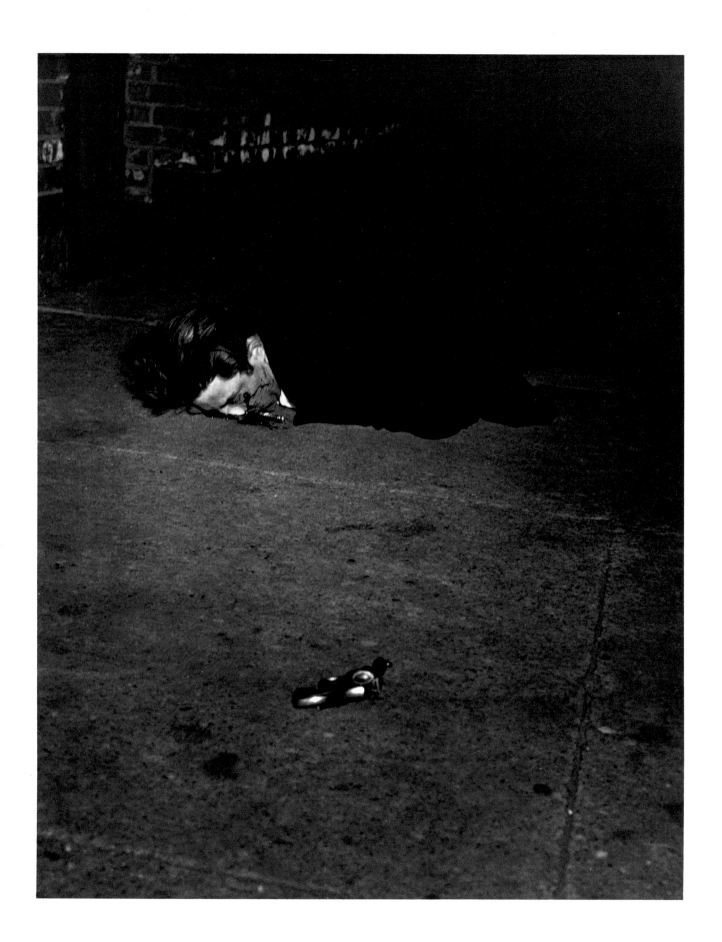

[PLATE 37]

Brassaï (Gyula Halász)
French, born Romania, 1899

Deux Voyous de la bande du Grand Albert,
quartier Italie
Gelatin silver, about 1975 from negative of 1932
11 1/16 x 8 3/4 inches · 29.5 x 22.5 cm
1980.1023.6
Warner Communications Inc. Purchase Fund, 1980

[PLATE 36]

FEW PHOTOGRAPHERS have written extensively or searchingly about their work. Two who have are Brassaï and Weegee. Among the other biographical coincidences they share is the adoption of pseudonyms and a fascination with the city at night, one in Paris and the other in New York. Excerpts from their recollections reveal something of their motivations and the circumstantial facts of what it is we see. Weegee wrote, *"Things went back to normal. The cops and reporters were happy, and I was happy. Gang wars, shootings, stick-ups, kidnapings . . . I was in the chips again. My pictures . . . with my by-line: 'Photo by Weegee' . . . were appearing in the papers every day. Life magazine took notice, and ran a two-and-a-half page spread in their 'Speaking of Pictures' section on how I worked at police headquarters. I made the 'Picture of the Week' several times.*

"Now all the papers and syndicates offered me jobs. I told them not to be insulting; I intended to remain a free soul.

"I bought myself a shiny, new 1938 maroon-colored Chevvy [sic] coupe. Then I got my press card and a special permit from the Big Brass to have a police radio in my car, the same as in police cars. I was the only press photographer who had one.

"My car became my home. It was a two-seater, with a special extra-large luggage compartment. I kept everything there, an extra camera, cases of flash bulbs, extra loaded [film] holders, a typewriter, fireman's boots, boxes of cigars, salami, infra-red film for shooting in the dark, uniforms, disguises, a change of underwear, and extra shoes and socks.

"I was no longer glued to the teletype machine at police headquarters. I had my wings. I no longer had to wait for crime to come to me; I could go after it. The police radio was my life line. My camera . . . my life and love . . . was my Aladdin's lamp." [34]

Weegee and Brassaï shared a fascination with the underworld. Their entrance to it and their reasons for being there were similar, but their interpretations of what they saw were quite different. Both were fascinated with the similarities between silk-stocking society and the society of outcasts, a relationship that Brassaï articulated in *The Secret Paris of the Thirties* — *"If entry into 'high society' requires family crests, titles, diplomas from the best schools, wealth and fame, entry into the underworld requires widespread criminal activity, a police record full of arrests, and, of course, an illegitimate background, suspicious forebears, [and] closely supervised training."* He went on to observe that both worlds are tainted with snobbery and both speak in a

82

Weegee (Arthur Fellig)
American, 1899–1968

Untitled (Slain gangster)
Gelatin silver, 1940–45

13⅜ x 10⅚ inches • 34 x 27 cm

1976.634.2

Warner Communications Inc. Purchase Fund, 1976

[PLATE 37]

language full of expressive catch phrases, an exclusive slang that only the initiated learn and fully understand. *"And yet, drawn by the beauty of evil, the magic of the lower depths, having taken pictures for my 'voyage to the end of night' from the outside, I wanted to know what went on inside, behind the walls, behind the façades, in the wings: bars, dives, nightclubs, one-night hotels, bordellos, opium dens. I was eager to penetrate this other world, this fringe world, the secret, sinister world of mobsters, outcasts, toughs, pimps, whores, addicts, inverts. Rightly or wrongly, I felt at the time that this underground world represented Paris at its least cosmopolitan, at its most alive, its most authentic, that in these colorful faces of its underworld there had been preserved, from age to age, almost without alteration, the folklore of its most remote past. . . . The infatuation with outcasts I had derived from some of my favorite writers: Stendhal, Merimée, and above all Dostoevsky, Nietzsche. Enthralled by outlaws living outside the conventions, the rules, they admired their pride, their strength, their courage, their disdain for death. 'Extraordinary men,' wrote Dostoevsky in* The House of the Dead, *'perhaps the most richly endowed, the strongest of all our people. . . .' And let there be no mistake. The admiration expressed by the author of* Crime and Punishment *was not for revolutionary intellectuals or for political prisoners, but for real criminals: thieves, murderers, convicts—his own prison companions. These criminals cast out by society became his mentors, their doctrine of life—never written but clear nonetheless—became his ideal."*[35]

These recollections and the photographs they illumine reveal two almost opposite types of human beings. Weegee expresses an overriding concern for personal survival in a threatening universe of his own making. He is motivated by the desire to see his name in the papers, and beneath a tough exterior, he nourishes doubts concerning his employers' reliability and honorability. The fears and ambitions that motivated him were those of the working man.

Brassaï could not be more different. He is and was an aristocrat. For him the underworld was a subject for observation for the sake of observation alone. Just as a botanist seeks out a rare orchid in order to study it at first hand, so Brassaï is a student of social types. He ventured out with the mental furniture of the intellectual and the fortitude of a sportsman; his guides were writers and poets. His photographs are verbal concepts as much as they are picture concepts. Where Weegee appeals to the emotion of surprise, Brassaï appeals to the emotion of recognition.

[PLATE 38]

Ralph Gibson
American, born 1939

Untitled
Gelatin silver, 1975

12⅜ x 8¼ inches · 31.5 x 21 cm
1978.542.3
Warner Communications Inc. Purchase Fund, 1978

[PLATE 38]

DURING THE 1970S it appears that more serious photographers in America were aware of each other than at any time since the turn of the century. One result of this heightened sensitivity to peers was the realization that photography could be both a collaboration with contemporary actuality and also the solution of a theorem about certain picture-making possibilities unique to photography that earlier photographers had expressed in either theory or pictures. Both Mark Cohen[36] and Ralph Gibson,[37] for example, acknowledge a large debt to Cartier-Bresson (*Pl. 3*), without whom their work would have assuredly taken a different form. There were other influences in their work (Robert Frank, *Pl. 58*, for example), but let us consider for the moment just Cartier-Bresson's legacy.

Cohen and Gibson were less influenced by Cartier-Bresson's subjects than by his process, his attitude, and especially his belief that the perfectly realized photograph embodies a network of interlocked relationships between the major parts of a subject, the energy and coherence of which are sustained by the photographer's grasp of how he and the event recorded relate to the actual time they share. Gibson draws from Cartier-Bresson the deep commitment to photographs that have an abstract sense of surface geometry; Cohen has absorbed a respect for the ineffable character of time and the special ways the camera arrests time. Both Gibson and Cohen strictly adhere to a brand of reductive composition that Cartier-Bresson summarized in his advice to cut and cut from the raw material, but cut with discrimination. Besides the desire to reduce the subject to its minimum, Gibson and Cohen take from Cartier-Bresson the style of composing at the moment the shutter is pressed, of hovering around a situation while

[PLATE 40]

[PLATE 39]

Mark Cohen
American, born 1943

Untitled (Hand)
Gelatin silver, 1975

11½ x 17⅝ inches · 30 x 44.7 cm
1981.1068.2
*Purchase, Warner Communications Inc. Gift
and matching funds from the National Endowment for the Arts, 1981*

[PLATE 39]

it develops, of orchestrating the brain, the eye, and the emotions in order to depict a mini-event while it is unfolding. From small events they produce photographs with a significant graphic impact, but with a kind of heroic nonmeaning and concrete non-communication that are the exact opposites of the qualities of Cartier-Bresson's work. The perplexing fact in all this is that these two photographers' avowed kinship with their illustrious precursor is scarcely evident on the surface of their photographs.

Cohen and Gibson advance their own aesthetic identities through hybrid Sur-realism, the stylistic thread that Cartier-Bresson articulates least clearly as a distinctive concept in *The Decisive Moment* but the one that the work's text and accompanying photographs attempt to define. The most successful of Cartier-Bresson's images in *The Decisive Moment* astonish and please us because of the sureness with which the sub-jects are removed from their actual context and given a new picture life. Decontextu-alization is the first working principle of Surrealism, and it is the effect that both Gibson and Cohen magnify in different ways. For Gibson the act of recognizing the right subject as he scans his surroundings is a decisive moment in which his motion, not the subject's, is arrested. The priest's collar is removed from the context of daily life and placed in the context of art, as a vessel of line and shape that surpasses any social, religious, or political message that lingers because of the subject.

Cohen uses the stroboscopic flash, a powerful tool abhorred by Cartier-Bresson, as an aid in Surrealist decontextualization. He uses flash to magnify the effect of automatic expression dear to Surrealists, because flash makes it possible to hold the camera at arm's length and expose without precise focus at a fixed shutter speed. The eye often

88

Untitled (Face and boxing glove)
Chromogenic (Ektacolor), 1981

12⅞ x 19⅛ inches · 32.6 x 48.3 cm
1981.1041
Purchase, Warner Communications Inc. Gift
and matching funds from the National Endowment for the Arts, 1981

[PLATE 40]

does not (and cannot) see the image as the film records it at the time of exposure. At bottom, is the question one of a credible genealogy? How (if at all) do we get stylistically from Gibson and Cohen, who both profess to have been strongly influenced by Cartier-Bresson, to Kenneth Pelka?

Pelka's is the crafted composition based on a highly charged subject—violence to the face—which, in its intrinsic strength, may be compared to the hand that Cohen slams at us and the polarizing symbolism of the priest's collar in Gibson's photograph. Pelka's composition is a tight intersecting of broad masses contained within an event that only appears transitory. Whereas Gibson and Cohen interact with an actuality beyond their absolute control, Pelka indulges in deception. We are invited to believe that this is a real punch and that the expression is real pain when in fact it is a model acting out a role under the controlled circumstances of the studio. If he is unsuccessful the first time, the photographer can restore the scene until he gets it right. Cartier-Bresson would never return to a subject once his chance had evaporated, but Pelka shares with his predecessors Cohen and Gibson a natural tendency to question sacred premises.

Time, chance, truth, and emotion are precepts dear to Cartier-Bresson. They are also dear to his successors, who do not accept them as holistic unities but rather as binary elements to be paired with an opposite. Cartier-Bresson's heirs make photographs about real time versus camera time, chance versus certainty, truth versus illusion, and emotionally charged subjects versus cool ones.

[PLATE 41]

[PLATE 42]

Albert Renger-Patzsch
German, 1897–1966

Zeche Katarina, Essen (Germany)
Gelatin silver, 1956
8⅞ x 6⁷⁄₁₆ inches · 22.5 x 16.4 cm
1978.602.1
Warner Communications Inc. Purchase Fund, 1978

[PLATE 41]

"IF THE NEW MOVEMENT *in the arts is going to produce a Utopia, that Utopia will be found in Germany. All the forward-looking ideas, ideals, enthusiasm of the century have found a home there. . . . Germany has suddenly become endowed with an intense modern consciousness and looks forward more easily than other nations because it does not look back.*"[38] These words written in 1929 by an English Germanophile testify to the fact that while some English-speaking intellectuals of the 1920s were enthusiasts of French art and culture, others felt as deeply about the strength and beauty of German art. In photography, one of the chief representatives of the forward-looking modern consciousness was Albert Renger-Patzsch.

Between 1925 and 1929—before Abbott, Adams, Strand, or Weston—Renger-Patzsch produced three influential books of photographs. It was *Die Welt ist schön* ("The World Is Beautiful"), published in 1928, that catalyzed Renger-Patzsch's leadership and became the visual chronicle of the new Utopia. He himself described the work as a model book of objects and things drawn from nature, architecture, and the products of modern industry. But scrutiny of the contents of the book suggests a rather offbeat notion of beauty. Moreover, in selecting objects such as factories, reptiles, baboons, poisonous plants, and sharp-beaked birds, Renger-Patzsch was suggesting, as Franz Roh has observed, that the world is not only beautiful but also *"exciting, cruel and weird."*[39] The average person in 1929 must surely have felt that the photographer had selected some very strange objects to define the beautiful. However, it is precisely because it questioned the definition of beauty and challenged conventional interpretations of it that the book became important.

Renger-Patzsch's reputation as the father of the new objectivity in Europe was based on photographs like that of the Essen minehouse, *Zeche Katarina*. We can appreciate the photograph if we imagine that we are Alfred H. Barr, Jr., apparently the first American to discover the fountainhead of Utopia in Germany, when he visited the celebrated Bauhaus in 1927. The meaning of *"form follows function,"* an aphorism adopted by Walter Gropius, and of *"less is more,"* a term coined by Mies van der Rohe, who together were the high priests of the new spirit in German architecture and industrial design, became clear to Barr once he was inside that steel and glass structure. The same principles that motivated the new architecture, called the International Style, in the late thirties—functionalism, structural clarity, avoidance of gratuitous forms, belief in the supremacy of content (volume), and a profound disdain for artifice (ornamentation)—governed the new photography. Renger-Patzsch said of himself in

92

Albert Renger-Patzsch
German, 1897–1966

Buchenwald im Herbst
Gelatin silver, 1936

9 x 6⅝ inches · 22.8 x 16.8 cm
1978.602.1
Warner Communications Inc. Purchase Fund, 1978

[PLATE 42]

1965, the year before his death, that his guiding principle was an *"unrelaxing aloofness to art for art's sake and rigid avoidance of spectacular effects."*[40] We do not have to dissect *Zeche Katarina* to understand the aesthetic values that Renger-Patzsch shared with the designer of the structure.

Renger-Patzsch's book *Der Baum* ("The Tree"), which was published in 1965, reveals a patience and gentleness that are masked by the toughness of his subjects in *Zeche Katarina*. His study of the tree is spare in its quest for the structural essence of the subject, and it is approached with an attitude that is less clinical than in the architectural and product photography he did in the 1930s but no less pure or committed to certain principles of composition. As different as *Buchenwald im Herbst* (1936) and *Zeche Katarina* (1956) are, the latter retains fundamental elements of Renger-Patzsch's style of twenty years earlier. Carl Heise's observation of 1929 is as applicable in 1981: *"Unsharpness merging into sharpness, each increasing the impact of the other. And the fact that it is not merely an exaggerated stylization by the artist but also a sharpness of photographic seeing which conjures up the fantastic in everyday nature, this is proved again and again by Renger-Patzsch's camera."*[41] Prolonged study of these two photographs by Renger-Patzsch gives rise to one question that crowds out all others: Do the manifest differences between the images indicate stylistic evolution, or does the profoundly different character of the two subjects obscure what is really stylistic coherence? An industrial structure and a tree are as complex in their effect upon the viewer as are a madonna and a Bacchus. A painter will render both in a way that makes his authorship recognizable, and a photographer may follow homogeneous principles of representation to delineate contrasting subjects. In these two photographs, Renger-Patzsch has fastidiously adhered to the notion that a photographer's subject is merely a package that defines a shape which will contain a supple wash of varying degrees of gray tone. What counts are the quality and position of light on his subject and the location of the camera, not the distinction between organic and geometrical shape. The ostensible subjects are important insofar as they trigger the first level of emotions in a viewer's response. The second level will inevitably be one of sensitivity to qualities of light and composition. Renger-Patzsch's photographs are persuasive evidence in support of Theodore Dreiser's belief that *"the camera is nothing, a mere implement like a painter's brush. It is the soul of the man who manipulates it that gives every picture its secured value."*[42] We would only add that it is the soul in conjunction with the eye and the heart that gives a photograph its secured value.

[PLATE 43]

[PLATE 44]

Rosamond Wolff Purcell
American, born 1942

Execution
Dye-diffusion transfer (Polaroid), 1979

9½ x 7½ inches · 24.1 x 19 cm
1981.1061
Purchase, Warner Communications Inc. Gift
and matching funds from the National Endowment for the Arts, 1981

[PLATE 43]

PHOTOGRAPHY HAS BEEN at war with itself since its invention. The battle has been waged over a general lack of agreement as to what is the most fitting and proper attitude by the photographer to the medium in which he works. The conflict is less over means than ends, less over methods or processes than principles. The issue at the core of this verbal warfare may be phrased as a question: Is the purest form of the photograph necessarily one in which the photographer collaborates with contemporary actuality, and if so, what constitutes "contemporary actuality"?

Edmund Teske and Rosamond Wolff Purcell, each in different ways, address the issue of how a photograph can be about something other than what is seen or experienced in one place at one time and how the idea of an experience rather than an experience itself may govern what is produced, a problem which at its core is not unlike that faced by Davis, Melamid, and Komar (*Pl. 56*) and Berghash (*Pl. 55*). In their life as objects to be observed and savored for the craft entailed in their production, these particular images may be regarded as the physical embodiment of an answer to the question: Why do people save photographs? Long before photographs had financial value, they were kept simply because they represented something or someone meaningful to the owner. The art of Purcell and Teske, as well as that of Uelsmann (*Pl. 15*), has evolved from this context. These photographers are less makers than collectors of images that have some significance to them. It is immaterial whether the image even issued from the photographer's own camera or whether it is necessarily a photograph, although the final reincarnation is a photograph. Their art is imagery that is the resurrection of prior images.

Purcell, for example, creates the final work by photographing and rephotographing Polaroid prints that may or may not have been altered by hand; this occasionally involves montage of several prints homogenized upon a single surface by rephotographing the original. For Purcell the photograph is a vicar of language, and her creative process is comparable to that of the writer who composes a text that is continuously edited and emended until it is published. The process through which her prints evolve is like the preparation of a manuscript in which each succeeding retyped draft incorporates into the fabric of the text alterations that may have been marginal or

Couple, Santa Monica

Duotone solarization, about 1965 from negative of 1944

13¾ x 11 inches · 35.3 x 27.7 cm

1981.1079.2

Purchase, Warner Communications Inc. Gift
and matching funds from the National Endowment for the Arts, 1981

[PLATE 44]

interlined on the preceding draft.

The print we observe becomes the actuality and must be distinguished from the actuality we come to expect to be embodied in photographs. Purcell is engaged in a collaboration with materials and processes that themselves become the thing itself; but it is a collaboration with its own boundaries and aesthetic imperatives and one requiring that an idea preexist the photographer's experience. The "idea" here is represented less by its title, *Execution*, than it is by the formalist concern with negative versus positive forms, mass versus line, or a sound and its echo, the elements that constitute pictorial actuality in this photograph. Finally we know very little about how these means relate to the title, which represents the end toward which the means are directed.

For Teske the photograph is a vicar of memory. Many of his images come from his own camera, while, like Purcell's, others are taken from prints that he found or inherited. He uses the images either singly (as is the case here) or combined. The character of what we see is governed as much by his choice of subject as it is by the application of the technique of solarization, which yields one-of-a-kind prints consisting almost entirely of middle tones, dense black or translucent highlights being absent. In this printing method a great deal is dependent on chance and accident, and the element of chance jibes with Teske's world view, which rejects Christian absolutism and espouses Vedantic Hinduism.[43]

Teske's *Couple, Santa Monica* may be viewed as constituting an autobiographical representation of the experiences that lead to redemption under the Vedantic system of beliefs, one that places high value upon the mysteries of time and space; the photographic negative becomes a cipher for memory. It is not appropriate for memories of this type to become mechanical; therefore, Teske devised a variable printing system that gives each printing of the negative a look slightly different from all others before it. Prints that differ one from the other more accurately resemble the process of memory, wherein each succeeding recollection of an instant is slightly different from all that preceded it. Teske has devised a system of representation that satisfies the philosophical need for predictably inexact repeatability.

[PLATE 45]

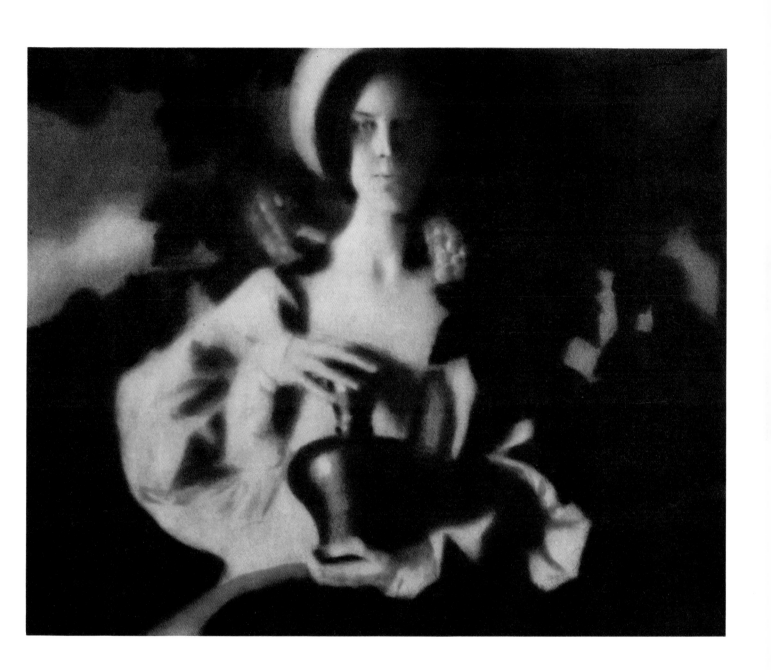

[PLATE 46]

Sheila Metzner
American, born 1939

Audrey—Vase and Fireplace
Four-color wash-off pigment (Fresson), 1980

24.¾ x 16⁹⁄₁₆ inches · 62.8 x 42 cm

1981.1009.3

Purchase, Warner Communications Inc. Gift
and matching funds from the National Endowment for the Arts, 1981

[PLATE 45]

IS THE MOST ENDURING work of even the most original photographer that in which the styles and methods of one's predecessors are overturned? Is photography descended from a single main trunk, from an underlying current that goes back to Talbot, Hill, and Adamson, Cameron and Watkins? Is progress the most natural or inevitable course of art? Must contemporary art, including photography, be avant-garde to be taken seriously? There are no universal answers to these questions, but any theory of art or photography must be framed so as to take into consideration both avant-garde and conservative tendencies, which will inevitably exist simultaneously and in succession. By way of defining more understandably *avant-garde* and *conservative* let us propose some hypotheses.

Avant-garde art, including photography, involves experiment and the taking of risks; conservative art seeks safety in the past and avoids risks. Avant-garde art may be described as a visual dialogue in which the maker and the observer comprehend, but cannot verbalize, the meaning of the work before them. Avant-garde art simply is, before it is anything else. The maker must be an artist who understands and accepts that he is being avant-garde; if the maker does not admit to being an artist, then the word *avant-garde* does not apply. In avant-garde art, subject and meaning do not have to be ambiguous, although they sometimes are. Traditional art tends to begin with unambiguous form and subject, which invite verbalizing because, consciously or not, traditional art begins with verbalized concepts that are pictorialized. The first response to traditional art is never "What is this?" or "What does this mean?" because what is represented grows from something accepted and familiar to its contemporary audience.

George Seeley was one of the most admired figures in Alfred Stieglitz's circle, which can be identified as the birthplace of the American avant-garde. Clarence White and Edward Steichen, among others, traveled out of their way to Seeley's studio in the Massachusetts Berkshire Mountains and involved him, at least peripherally, in the creation of what the participants thought to be the most advanced photographs being made. With his sister as his model, in costumes sewn by his mother, and using props assembled from around the house, Seeley created a make-believe world of fatal women and expectant situations, a legacy he bequeathed to Metzner. Seeley flirted with abstraction in some large winter landscapes but never pushed it as far as Paul Strand and Charles Sheeler, who were his younger contemporaries. Had he done so, his work would have been more far-reaching than it was. Instead, he remained an independent, idiosyncratic loner in the international society of art photographers.

Golden October
Gum bichromate over gelatin silver or coated platinum, 1909
17⅜ x 21³⁄₁₆ inches • 44 x 53.8 cm
1981.1160
Warner Communications Inc. Purchase Fund
and Gift of Marion D. Byron, 1981

[PLATE 46]

Aside from the gravures in *Camera Work*, his photographs were rarely reproduced; he traveled little and, as far as can be determined, did nothing to deflect the course of photography, as did Stieglitz, Steichen, White, and others through the example of their widely seen work and through their own personal sense of mission to improve photography.

Sheila Metzner is a conservative, since in the context of this pairing it is evident that her style emerges from the past. However, her style is also inextricably bound to the present because of the camera's inevitable collaboration with contemporary actuality. The model's costume and coiffure, the decorative objects and the architecture, and the methods used to make the print date from the 1950s and before. However, the model, who was one of Metzner's neighbors, is a woman of the 1980s surrounded by antiquarian possessions and dressed in her everyday clothes. Yet the image and its concept are so self-evidently neopictorialist that Metzner could be producing a homage to her illustrious predecessors that was intended actually to account for what progress there has been in photography in the seven decades since pictorialism lost most of its steam about 1910.

Has Metzner succeeded in exorcising the modernist and avant-garde that were part of her consciousness since school days? In a way this picture is radically reactionary, and to the degree that it is radical, it touches on the avant-garde. Reactionary ideas and methods are backward simply in that they involve no experiment. Metzner's mix of ideas and materials treads close to commercial illustration and could have failed. Courting failure involves risk-taking, and risk-taking is fundamental to the avant-garde. It may be possible for a photograph or other work of art to be both conservative and avant-garde. The belief in avant-garde art as a form of progress is possibly too confining, since it tends to deny the possibility that conservative artists have ideas and techniques to pass on and precludes the thought that Metzner grasped the baton from precursors like those represented in the collection of Alfred Stieglitz.

Serious photographers have sometimes found their subjects among family, friends, and neighbors; they have sometimes sought to endow actuality with an element of fantasy; and they have sometimes been troubled by the public distribution of works that emerge from private realities they share with others. These are ingredients used in both avant-garde and conservative art and, because of their authenticity, cannot be kitsch.

[PLATE 47]

[PLATE 48]

Eve Sonneman

American, born 1946

Sight/Sound: for Mike Goldberg, Samos, Greece

Cibachrome, 1977

Overall: 7¹⁵⁄₁₆ x 20 inches · 20.2 x 50.8 cm

1980.1073.2(1–2)

Purchase, Warner Communications Inc. Gift
and matching funds from the National Endowment for the Arts, 1980

[PLATE 47]

"TIME PRESENT *and time past | Are both perhaps present in time future, | And time future contained in time past.*"⁴⁴ The opening lines of T. S. Eliot's "Burnt Norton" are relevant to the photographs by Jan Groover and Eve Sonneman because they are concerned with our perception of the flow of time and because Eliot incorporated "Burnt Norton" into a larger work entitled *Four Quartets*, thereby creating one independent work from four separate poems joined together. By a comparable procedure of placing photographs end to end or side by side, Groover and Sonneman have created works that deal with time and place in a manner distinct from that found in their single photographs of the same subjects. Every photograph embodies time to one degree or another; time is one element pictorialized in photographs that is not also embodied naturally in painting, as it is in literature or the performing arts, neither of which exists for an audience except during the time that elapses as a work is read or performed.

Common sense tells us that no two photographs of different subjects taken by the same photographer can belong to the same instant, and yet Groover here asks us to imagine the photographer as a many-armed creature capable of making three simultaneous exposures of three places, all guided by the same intelligence. The photographs do not suggest the passage of time but rather the present stopped in three places. The choice of inanimate architecture as her subject ensures that what is represented will remain exactly as we see it for the time being. Groover has inscribed a circle around a particular nonelusive subject as if to challenge anyone else to find it and photograph it more revealingly. She does not address what might have been, nor does she encourage speculation about what came before or what may come after the instant of this image. The three photographs together lock in the present.

Sonneman denies the eternally present by choosing a subject that naturally has a

Brass Door
Chromogenic (Ektacolor), 1977
Overall: 15 x 45⅜ inches • 38.1 x 115.2 cm
1981.1140
Warner Communications Inc. Purchase Fund
and Gift of John Coplans, 1981

[PLATE 48]

very limited lifetime. Relaxation on the beach will soon end. The hat, the books, the tape machine, and the blanket will be packed up, and only rocks and the sea will be left. The piece declares two separate moments in time between which one stone was moved from the blanket to the hat. We are left to deduce that time does not stop and is redeemable only through its visual record. Unlike Groover's, this work is almost entirely about speculation as to what might have been and what will be in the near future. Most significantly, it asks what might have been the point of view if yet a third photograph had been made of the same subject; what might have been had the owner of these things been included in the picture; what might have been had the person not been reading and listening to tape recordings; what might have been if the event had taken place on another shore; and so on. Sonneman has observed a universe of speculation.

Past, present, and future are the fundamental ingredients of all narrative. Words can deal with all three elements almost simultaneously, as Eliot has done, while photographs can at best deal with one or two of these elements in a highly concrete but very limited form as visual analogues of the words. The photograph cannot represent the future except insofar as imagination moves the observer to invent a scenario inspired by the photograph. This may sound like a limitation, but consider how many words it would take to produce a better aid to the comprehension of the cited passage by Eliot. Words are not intrinsically superior to pictures, for each mode of expression at certain times and for certain reasons does certain things very powerfully. The photograph can be a pictured poem, and the poem can be a verbalized image. Sometimes poets seem to demand that their poems be set side by side for the meanings to be clear; the same is also true of photographers.

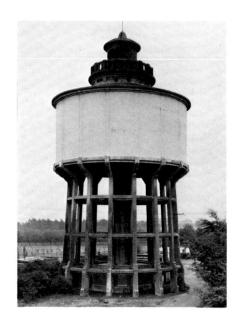
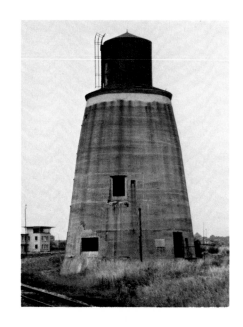
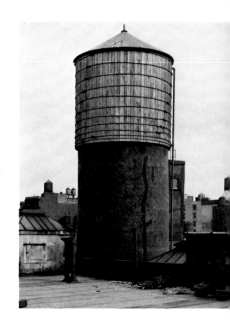
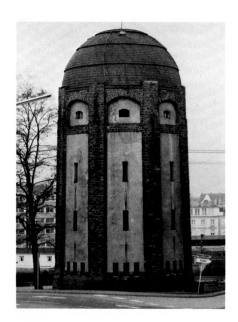
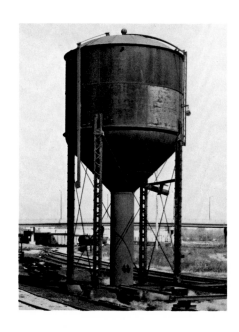
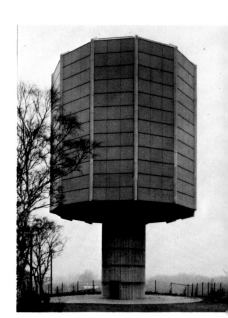

[PLATE 50]

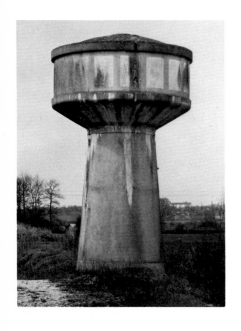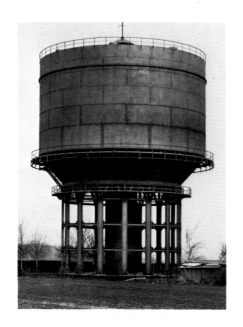
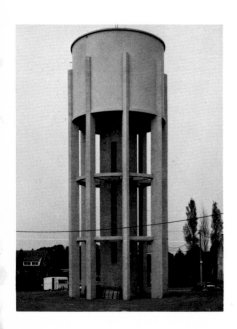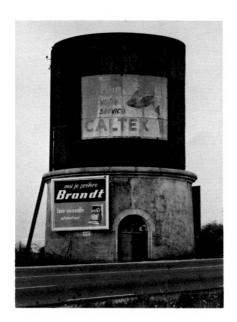

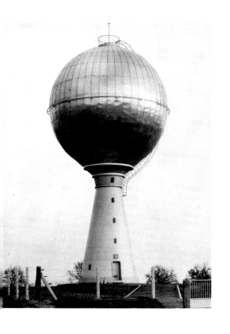

[PLATE 49]

Bernd and Hilla Becher
German, born 1931; 1934

Comparison of Different Types of Water Towers—
Germany, France, England, and America
One work in sixteen photographs, gelatin silver, 1980 from
negatives of 1967–80

Overall: 102⅛ x 32¼ inches · 257.5 x 82 cm
1980.107.1–16
Warner Communications Inc. Purchase Fund, 1980

[PLATE 49]

PRODUCTS SUCH AS August Sander's *Menschen des 20. Jahrhunderts* ("Man of the Twentieth Century") and Bernd and Hilla Becher's typologies of industrial structures have something in common with the Gaudí cathedral in Milan, Watts Towers, and Mount Rushmore in that their eccentricity, their scale, and their ambition elude the normal yardsticks for measuring works of art that are observable in one place at one time. Sander and the Bechers, who are a generation apart, came from the same general region of the Rhineland. Each of the three begins with a simple photographic idea that, motivated by a quest for comprehensiveness, grows to a complexity that becomes life-consuming. The two bodies of work are linked by comparability—the presentation of photographs in series that must be observed one against the other for the maker's intent to be realized. Concentration, observation, and selection are the mental processes that govern success or failure of work in this style.

In the years just before and during World War I, August Sander found that his portrait business in Cologne was rather slow. He decided that instead of waiting for clients he would pack up his gear and seek them out. He went to the countryside and photographed peasants and landowners in their Sunday best, speculating that they would buy prints when he returned with the finished work. After the war, Sander was able to reopen a studio in Cologne, but he continued to photograph in the countryside to satisfy his own personal artistic urges. During the 1920s, he began to think of himself not just as a commercial portraitist but as a chronicler of a certain cultural reality. He expanded his roster of subjects to include an encyclopedic cross section of trades, occupations, and social classes. The photographs in the atlas-sized portfolios that he produced were organized into forty-five specific categories within several general classes.[45] Each photograph was selected as an archetype of a given category. As might be expected, the undertaking was a commercial failure.

Heinz Heese, Cologne is a variant of the more often reproduced photograph of Heese wearing athletic clothes and standing beside his sparring partner, Paul Roderstein, in a gymnasium. Athletes constitute the seventh and last category in Sander's first class of country types (*Bauern*). Sander does not explain why athletes of all social classes, including aristocratic equestrians and amateur fliers, are placed in the same

August Sander
German, 1876–1964

Heinz Heese, Cologne
Gelatin silver, 1928
10³⁄₁₆ x 7⅞ inches · 25.8 x 20 cm
1978.603
Warner Communications Inc. Purchase Fund, 1978

[PLATE 50]

class as farmers, but it is possible that he saw the connection in lives based on physical exertion. Unity is achieved by never holding the camera in his hand but placing it on a tripod at eye level, by never employing strange perspectives, and by using a light that was as soft and even as possible. Sander sought to reduce the variable elements within each study to the minimum in order to permit the maximum degree of comparability, a principle that was also basic to the work of Bernd and Hilla Becher.

Bernd Becher first focused on the industrial landscape as a painter, in 1957. He saw photography as a tool that he could use in making paintings; finally, he realized that the photograph is an independent object. Hilla, a photographer of long experience with whom Bernd formed an artistic relationship before they were married, shared his respect for industrial landscape. When it became clear to them that the camera does not automatically produce truthful images and must be harnessed by the hand and the eye if it is not to produce the same sort of unresolved mush that brushes and pigment do in clumsy fingers, they developed a new aesthetic that suppressed the painterly, expressive urges that often exist below the surface of a photograph. At first they did not realize how close their concept was to that of August Sander. However, when they learned of his work, around the time of his death in 1964, they admitted that they were unknowingly following a parallel path. They had hoped that their photographs would appeal to the owners of the installations that they had photographed, but they soon learned that their product was useless. Their work stood between commercial photography and art photography, and it was scorned by both camps.

Perhaps the most fundamental trait shared by Sander and the Bechers is the passion of the collector. In forming a collection, the artist or photographer shares the pleasure of discovery. Sander discovers that an athlete is not unique but that his type exists in a variety of examples from region to region and from village to village; the boxer Heinz Heese is but one in his collection of types. The Bechers discover that water towers exist on a scale of quality from high to low and in versions that are antetypes and variants.[46] The photographers' pleasure, and much of ours, derives from recognizing patterns or organization, formal sequences, and the internal Utopia created by satisfying the instinctive human belief that order exists.

[PLATE 51]

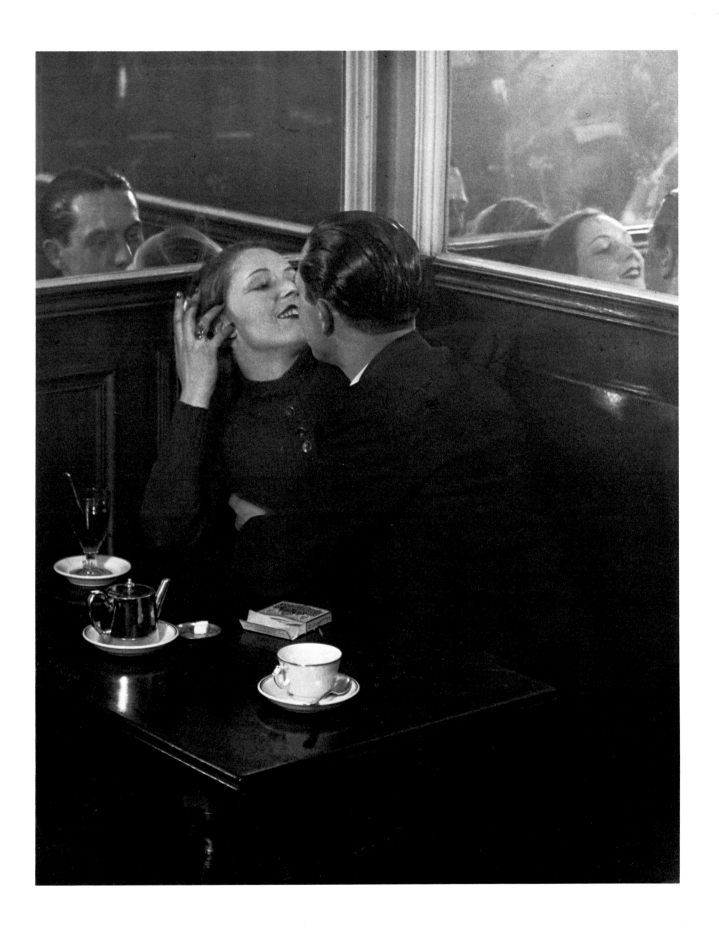

[PLATE 52]

Doris Ulmann
American, 1884–1934

South Carolina
Platinum, 1928–31
7⅞ x 6 inches · 20 x 15.3 cm
1978.506
Warner Communications Inc. Purchase Fund, 1978

[PLATE 51]

"ART IS FULL OF THINGS *that everyone knows about, of generally acknowledged truths,*" wrote Boris Pasternak, accepting how difficult it is for the most obvious substance of experience to be treated with dignity and sentiment but without sentimentality.[47] This raises two issues: How is the ineffable recognized, and how does a photographer learn the craft of chronicling it?

The study of photographers' biographies provides a few clues about the genesis of their talents. The trait shared by Ulmann and Brassaï is an instinct for humanity. Ulmann was born and educated in the city of New York, where she studied to be a teacher specializing in psychology. She briefly attended law school but abandoned it, according to an early biographer, "*because she felt that the human element was obscured.*"[48] Ulmann soon devoted her life to photography, first studying with Clarence White, whose influence she generously credited. As a portraitist, Ulmann specialized in literary personalities for book publishers, a profession that supplemented her already ample financial means. *South Carolina* (photographed after a Baptist revival meeting) was made during the course of a project undertaken for her own personal satisfaction in the rural South, where she traveled by chauffeured limousine. About this period in her life Ulmann observed, "*I am not interested exclusively in literary faces, because I have been more deeply moved by some of my mountaineers than by any literary person.*"[49] The clues Ulmann supplies are the need to be "deeply moved" by her subject, as if the process of making a great photograph proceeded as much through the body as through the eyes, and the need for a concrete physical experience to make her art materialize. Albert Einstein phrased this idea another way when he said in a lecture, "*Pure logical thinking cannot yield us any knowledge of the empirical world; all knowledge of reality starts from experience and ends in it. Propositions arrived at by purely logical means are completely empty as regards reality.*"[50]

Photographs that strive to realize deep emotions must start from real experience. *South Carolina* is an amalgam of opposites that defies logic. Bright sun on light garments is placed against shades of black that range from skin to deep shadow; unpainted boards are placed against finished textiles; the idea of the poverty into which rural blacks fall is placed against a middle-class gentility projected by costume and expression. We assume that this is a married couple but do not know for sure, and we sense that the contentment and relative material prosperity are at least in part the result of a life lived by the Golden Rule. Their faces are emotionless, perhaps out of fear of signifying feelings badly; miraculous emotion comes from the composition as a whole,

**Couple d'amoureux dans un petit café,
quartier Italie**

Gelatin silver, about 1970 from negative of 1932

11 3/16 x 8 5/8 inches • 28.3 x 22.7 cm

1980.1023.5

Warner Communications Inc. Purchase Fund, 1980

[PLATE 52]

not from gesture or expression alone.

Brassaï also learned photography from an eminent mentor: André Kertész (*Pl. 31*), in Paris in 1926. "*I was not a photographer then and had no intention of becoming one. . . . When I met André Kertész, I looked down upon photography and almost despised it. It was a lucky meeting because . . . I discovered how greatly* [*photography*] *had enriched man's means of expression. This eliminated my prejudices,*" recollected Brassaï of his early years.[51] Brassaï was friendly with writers and was very much interested in poetry and fiction. It is unclear how his understanding of literature influenced his point of view as a photographer. Unlike Kertész, Brassaï has never professed an abiding commitment to unadulterated realism in his photographs, and one mystery of this work is the degree to which *Couple d'amoureux* involved a collaboration between the photographer and his subjects.

How do we know when love is being recorded and not just affection, tenderness, or sympathy? How do we know when we are in the presence of genuine emotion and not artifice? There are no clear answers; impressions are highly subjective and are formulated independently by each observer. Brassaï records lovers, but not love, it would seem. He has rendered neither tenderness nor affection, possibly infatuation, and most certainly vanity. The scenario being enacted is so full of emotion for the observer that it is taken for granted that the parties represented are experiencing genuine feelings of romance. Then, in a flash, we ask, Where have we seen this man before? Are these not the same bulging ears, pudgy neck, slicked-down hair trimmed straight across just above the collar as those of the man choosing his date in *Chez Suzy* (*Pl. 9*)?

If the emotions represented here are suspect, the form is not, nor is the emotional involvement of the photographer in composing his subjects. It is the skill of the photographer in bringing the pieces together that makes the emotions of the subjects appear as genuine as they do. In one mirror she gazes at him; in the other mirror he gazes at her—two pairs of fictions in fictive compartments of space. Two minuses equal a plus, and two fictions equal an actuality; but they do not necessarily equal a truth.

If Ulmann's photograph encourages us to ponder the distinction between emotion and sentimentality, Brassaï's causes us to reflect upon the difference between form and emotion. "*I don't like snapshots. I like to seize hold of things, and the form is very important for this. Of course, all photography presents chances to relate things of interest, but it lacks often a sense of form. Form is very important . . . to create art,*"[52] said Brassaï to Colin Westerbeck, as if to justify his art.

[PLATE 53]

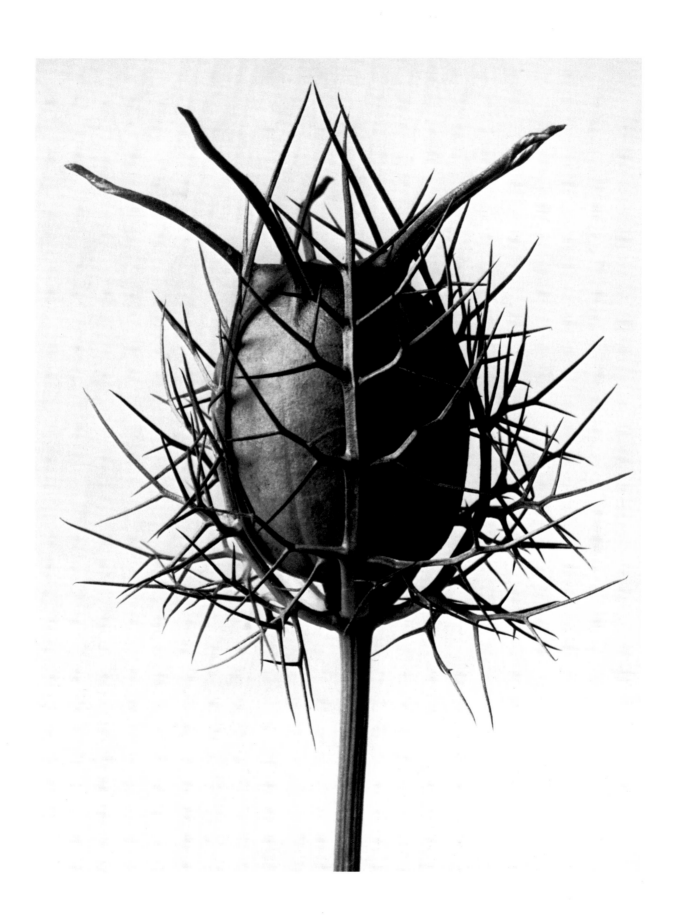

[PLATE 54]

John A. Whipple
American, 1822–1891

The Moon
Salt print (Crystallotype, copied from a daguerreotype), 1851
8⁵⁄₁₆ x 6⅜ inches · 21.2 x 16.2 cm
1981.1229.1
Robert O. Dougan Collection, Gift of Warner Communications Inc., 1981

[PLATE 53]

FOR GENERATIONS photographers and their audiences worked under the mistaken belief that the photograph was inherently more truthful than other forms of picture making and that the photograph was principally a form of document. It took a long time to discover that only some photographs are reliable documents and that, in the end, what is a document to one generation may be art to another.

Whipple and Blossfeldt, who worked fifty years apart, shared a fervent desire to produce visual documents. Whipple is the earliest American photographer represented in the collection of the Metropolitan Museum to whom the label "documentary" can be applied without qualification. Working in Boston at the moment when the daguerreotype was being replaced by prints from paper and glass negatives, he was among the few to grasp the importance of the photograph as a medium of real communicative power because it is, in the words of William M. Ivins, Jr., an *"exactly repeatable pictorial statement."*[53] He gave expression to this with the publication in 1852 of *Homes of American Statesmen*, one of the first American books illustrated with photographs. The frontispiece contains a photograph of Hancock House in Boston that was pasted by hand into each copy of the book.[54]

Whipple's moon was made two or three years later, and it is a classic example of the truly documentary image. Whipple did not look at the moon through a telescope and then photograph what he saw. He copied the first American lunar photograph, a daguerreotype made by John Draper. Since his negative, although less resolved in its details than the original, could be reprinted, multiple copies of the one-of-a-kind daguerreotype were made, thus permitting the image to be shared with scientists and friends. Whipple's copy was also used by engravers as the model for cuts printed in books and magazines, which were still dependent on traditional methods of illustration because ways of reliably reproducing photographs directly on the printing press had yet to be devised.

The usefulness of Whipple's photograph as a document ended a few years after it was made, when technological advances made it possible to photograph the moon directly on a negative. Today his lunar photograph is valued more for the traces it reveals of the photographer's hand than for the detachment and objectivity presumed to be inherent in documentation. It is seen as a work of art. We are charmed by the residual brush strokes left after the light-sensitive salts were manually coated on the paper;

Nigella damascena

Gelatin silver, 1976 (by Juergen Wilde)

from negative of 1915–25

9⅞ x 7⅝ inches · 25.2 x 19.3 cm

1978.602.2

Warner Communications Inc. Purchase Fund, 1978

[PLATE 54]

we are amused by the fortuitous deception that causes the black background upon which the daguerreotype was placed for copying to resemble a fragment of the galaxy. It is unusual to find a photograph in which the mark of the hand is as meaningful as that of the eye.

"*When man uses the camera without any preconceived idea of final results, when he uses the camera as a means to penetrate the objective reality of facts, to acquire truth, when he tries to represent by itself and not by adapting it to any system of emotional representation, then, man is doing photography*,"[55] wrote Stieglitz's friend Marius de Zayas, who was undoubtedly ignorant of the work of his German contemporary Karl Blossfeldt. As well as any other photographer, Blossfeldt embodies this prescription. He saw his photographs not as documents for botany students but as tools for artists and art lovers. He wanted to give substance to the then popular notion that nature is the ultimate creative genius behind all artists and all styles of art — that, in the words of an early critic of his photographs, "*the delicacy of a Rococo ornament, the severity of a Renaissance chandelier, the mystically tangled scroll work of flamboyant Gothic, domes, towers, and the noble shafts of columns — a whole exotic language of architecture. Crosiers embossed in gold, wrought with trellises, rich sceptres: all these man-made forms find their original form in the world of plants.*"[56]

Blossfeldt wished to show how logic and suitability could lead to the highest degrees of visual form. To do so, he editorialized at every juncture by carefully choosing plants with a character that suited his ends. In the selectively cast lighting, the close-up point of view, and the neutral background, he directed our attention to the particular details that he wished us to see first. The menacing thorns are half in shadow and half in light in order to exaggerate their mordant character and possibly to suggest something from the arsenal of a satanic warrior.

Whipple's and Blossfeldt's photographs do say something about the universe. They tell us that it is not the mechanistic system of Newton, because there is too much mystery in its elements, and that it is not a universe of light as described by Einstein, because its bodies are not independent entities occupying a space devoid of other matter and energy. We see, according to Whipple and Blossfeldt, a universe of communication that literally demands the grasp of visual analogy and of an active collaboration between the signified and the signifier.

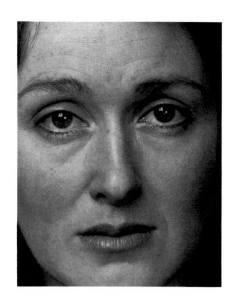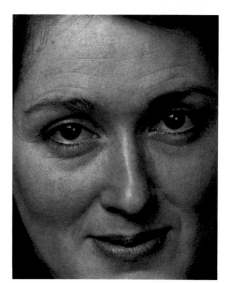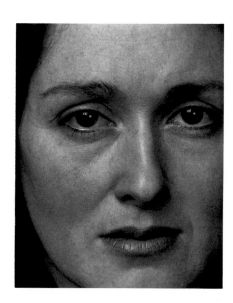

[PLATE 55 · *detail*]

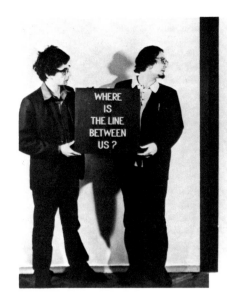
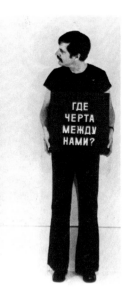
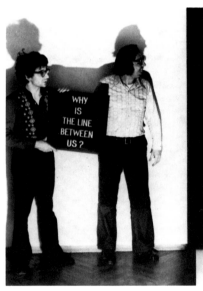
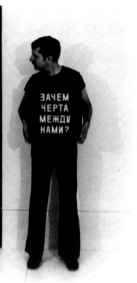

[PLATE 56 · *detail*]

Mark W. Berghash
American, born 1935

Serial Portrait of Thomasina Webb, Artist,
from the series Aspects of the True Self
One work in six parts, gelatin silver, 1980

18 x 72 inches · 45.8 x 180.28 cm

1981.1173.1–6

Warner Communications Inc. Purchase Fund, 1981

[PLATE 55]

"THE ONLY THING *valid in art is the one thing that cannot be explained*," Georges Braque is reported to have said. Braque's observation leads us to reflect upon how he would have responded to art that was created with the absolute necessity of an explanation, without which our experience of it would be significantly diminished.

Questions: New York Moscow, Moscow New York, by Douglas Davis, Aleksandr Melamid, and Vitaly Komar, came into being out of friendship and frustration over systemic impediments to lines of communication between them. Their work consists of twelve photographs documenting six different events seen from two points of view. Five of the prints represent two events that took place simultaneously in New York and Moscow (Nos. 1–4) and in New York and Tel Aviv (No. 5). The sixth print represents a single event in New York after the two Russians were unexpectedly given permission to emigrate. On four of the six occasions, at a prearranged time, Davis met in his New York studio with a photographer, while Komar and Melamid did the same in Moscow. The photographers' task was to record a single scene and a single gesture that were enacted to advance an interchange of stylized communication. To underscore the political motif of the collaboration, the performances were enacted on four consecutive national holidays: January 1, 1976; May 1, 1976; July 4, 1976; and November 7, 1976. Each event consisted of the performers holding a square black canvas on which had been painted a previously agreed-upon question. The performers stood near a black line painted on the wall behind them; the Russians had the black line to their left (overt symbolism), and the American had the line to his right; on the Russian side the question was phrased in English, while the same question was phrased in Russian on the American side. Following each event, the Russians sent their developed negative to New York, where Davis arranged for it to be printed, montaged, and rephotographed by technicians (Quesada, Burke and Burke) so that it would result in one image representing what took place in two locations simultaneously, as though the three performers were standing in the same room with a single black line between them.

Photomontage is an inherently powerful tool for dissolving time-space relationships and, thus, has been most effectively used by commercial photographers to sell products and by politicians for propagandistic ends. Here it is turned to the purposes of art. Montage is united with the series photograph. Taken together, these two devices were considered by Moholy-Nagy to be the foundation of a new visual language *"just as important as that of the alphabet"* and fundamental to the artists' vocabulary in

122

Douglas Davis, Aleksandr Melamid, and Vitaly Komar
American, born 1933; Russian, born 1945, lives New York;
Russian, born 1943, lives New York

Questions: New York Moscow, Moscow New York
Gelatin silver (realized by Quesada, Burke and Burke), 1980
from negatives made 1976 (Nos. 1–4, New York and Moscow), 1978
(No. 5, New York and Tel Aviv), 1978 (No. 6, New York)

119¾ x 23¾ inches · 303.5 x 65 cm
1981.1027.1–6
*Purchase, Warner Communications Inc. Purchase Fund
and Eugene M. Schwartz Gift, 1981*

[PLATE 56]

their *"perpetual plot against pettiness and inadequacy."*[57]

Questions: New York Moscow, Moscow New York is at core political. It is more an
act of will than the representation of a single perception. It is not, however, soulless,
for involved in the story of the work is the courage of the two Russians criticizing their
homeland and risking official censorship. The work is also about an American artist
paying respect to the political system in which he lives and to the often unacknowl-
edged role personal liberty plays in the creation of art.

Mark Berghash's *Thomasina Webb* shares with Davis, Melamid, and Komar's work
the concern with an overriding idea that is itself not representable: the inner spirit of a
person. The workings of the mind are, like the political, traditionally the province of
words rather than of pictures, but the desire to pictorialize inner states has been a con-
tinual quest of portraitists in all visual mediums. Berghash's work is part of a series of
portraits entitled *Aspects of the True Self*, which are graphic equivalents of the thought
of Berghash's mentor, Dr. Preston McLean, a psychiatrist and psychoanalyst who
believes that a person's character and destiny are established by one's parents and sib-
lings. Berghash attempts to represent the past on the face of his subject by seating his
subject in a private place where he has previously arranged a plate camera and books
or pictures to aid the person in reaching a self-reflective state of mind. Berghash fo-
cuses the camera, sets the proper exposure, and asks the subject to reflect upon the
first in a prearranged list of persons. The subject is given a remote-shutter release to
enable a self-portrait at the moment when the person being reflected upon—a parent,
a sibling, or the self—is clearest in the mind's eye. After each exposure, Berghash sup-
plies a fresh sheet of film and assigns the next subject to be reflected upon. The re-
sulting photographs are mounted in sequence and titled; they are meant to be viewed
in a way that permits the observer to glance from one picture to another as a means of
personally verifying the degree to which expression may be correlated to perceivable
emotional responses. Whether Berghash succeeds in truthfully plumbing his subjects'
minds is known for certain only by them; but there is no doubt that he strikes to the
core of the precept that photography is significantly related to memory. Photographs
are often saved simply because they revive the past. Berghash has pushed the process of
reviving the past to its most extreme and nearly unphotographable point by producing
work that is the manifestation of memory, not just an instrument of recollection.

[PLATE 57]

[PLATE 58]

Lisette Model
American, born Austria, 1906

Reflection, New York (Delancey Street)
Gelatin silver, 1940–50

12¾ x 10⅜ inches · 32.5 x 26.3 cm
1981.1040
*Purchase, Warner Communications Inc. Gift
and matching funds from the National Endowment for the Arts, 1981*

[PLATE 57]

THESE PHOTOGRAPHS by Lisette Model and Robert Frank embody a contradiction: they are about noise and they are about silence.[58] Despair, for example, is a very loud noise in visual language, but the expression of despair on the face of the gentleman in Model's photograph is a minute fragment of a picture that otherwise consists of largely out-of-focus reflections, which are like silence. Frank almost conceals the tenderness, a quiet noise, between the woman and child seated in the automobile; the most prominent features in the photograph are the glaring, out-of-focus headlight and the opaque, off-center density of the automobile body, which are like silence.

To understand the work of Model and Frank, one must be able to appreciate the desire to record the sound of a crowd, the din of a midtown traffic jam, or the hum of motion perceived as one dozes in transit. Both of these photographers are fascinated with ephemeral experiences and somehow obsessed with the archetype of banality. Frank's photograph suggests that the exposures just before and just after it chronologically are equal moments in a cinematic stream of consciousness. The blurriness and ambiguity of Model's standing man suggest that this face was not unlike the faces of many other people she saw but did not photograph. One question persists,

Robert Frank
American, born Switzerland, 1924, lives Canada

U.S. 90, en route to Del Rio, Texas
Gelatin silver, 1977 from negative of 1950
13⅛ x 8½ inches · 33.2 x 21.5 cm
1979.634.2
Purchase, Warner Communications Inc. Gift
and matching funds from the National Endowment for the Arts, 1979

[PLATE 58]

however: Could the makers have known at the moment of exposure that this was the special face that would work as art — that when the shutter was released, this particular moment in time would assume iconic identity when enlarged or reproduced in a book? It is unlikely.

Model and Frank have produced existential photographs that allude to the fluidity of life and to the process of its unfolding, during which many opportunities to photograph pass unobserved because the photographer is absent or simply because they elude the camera's arresting power. Their photographs are literally about being and nothingness, about the enormousness of the interdependence between something and nothing, and about how certain photographs eliminate the distinction between the focus of our attention and the context in which our attention resides. The pleasure that these pieces provide is in finding something unanticipated, in observing something that could be discovered only through the sensibilities of these photographers, who react to stimuli that others ignore. Model and Frank persuade us that we are in direct contact with their hearts, not just their minds.

[PLATE 59]

[PLATE 61]

William Clift
American, born 1944

La Mesita from Cerro Seguro
Gelatin silver, 1978

13½ x 19¼ inches · 34.3 x 48.4 cm
1981.1044.2
*Purchase, Warner Communications Inc. Gift
and matching funds from the National Endowment for the Arts, 1981*

[PLATE 59]

ONE OFTEN REPEATED theorem of photography holds that it is a medium incapable of generalization. All theorems can be proved to be true in some, but not necessarily all cases. Before accepting the assertion as an axiom, consider the following description of three images. Represented here in photographs are three places separated by thousands of miles. Each place has certain topographical and botanical features. Each of these features has an independent character, but no single one is represented in sufficient detail for the observer to know a great deal more than the outline. The places we see took centuries to evolve from something simple to something large and complex. We are invited to trace to a single source the causal processes by which they came into being; once we have identified the single source on our own, we are challenged to comprehend it as a universal truth. The identity of the single source and the character of the universal truth it represents may be different for each observer. For some observers of the photographs the universal truth can be nothing more than beauty. If so, we will have been brought full circle to equate truth and beauty, a primary goal of picture making since the time of Jan van Eyck.

The preceding exercise in applied aesthetics was meant to provide a possible counterproof of the original axiom that photography is a medium of representation lacking in the power to generalize. It may be concluded that the camera in the hands of a generalist may generalize as well as any other picture-making instrument, as the work of Clift, Shore, and Incandela (and that of Black, Garnett, and Jacobi [*Pls. 16–18*]) proves. The process of generalization takes place by the same pictorial methods of blocking out broad shapes, establishing compartments of space, and invoking edge and outline — the primary methods of traditional draftsmanship. Using these tools, the photographer

[PLATE 60]

Yosemite National Park, California
Chromogenic (Ektacolor), 1979
12 x 15⅛ inches • 30.7 x 38.5 cm
1981.1065.2
*Purchase, Warner Communications Inc. Gift
and matching funds from the National Endowment for the Arts, 1981*

[PLATE 60]

makes one place stand for many, makes a simple pictorial statement stand for something large and complex, and directly or indirectly confronts issues of truth and beauty. If this is not the power to generalize, what is? A photograph's power to generalize may be considered the visual equivalent of the dark between flashes of a beacon, the sound between strokes of a metronome, or the period of time between the past and the future.[59]

In different ways Clift, Shore, and Incandela observe the visual corollaries to the void elements in time. Stephen Shore's photograph is not about wilderness in the same way as J. W. Black's (*Pl. 62*) and Carleton Watkins's (*Pl. 63*) photographs are. Shore avoids depicting the grandeur of the place. His photograph is not about individual people and is only a little about a specific place; but it is very much about the space between people and the quality of light and line (the undulation of the river bank) that may be extracted from a site that others have particularized. It is about how to look freshly at a place that—like the pyramids of Egypt—has been photographed ad absurdum.

Gerald Incandela deals with the indeterminate terrain between earth and air and with the void between the purely natural and the purely man-made. We recognize the presence of soil but do not know where it begins or where it ends. Instead, there is a uniform but ambiguous white that extends from where the horizon should be to where the flora should be. We see traces of geometry that can only be man-made, but we recognize that this is no man-made structure of a familiar type or use. The photographer supplies no clues as to the utility of this image, which resembles a NASA composite, and recognition of potential utility outside art must come from each spectator's imagination

Untitled (Cypress and wall)
Gelatin silver, brush-developed from two negatives, 1981

40¾ x 40 inches · 103.3 x 101.7 cm
1982.1000
Purchase, Charles Cowles Gift
and Warner Communications Inc. Purchase Fund, 1982

[PLATE 61]

or prior experience. The photograph deals with the space between several actualities and raises more questions than it answers. Unanswered questions are the province of generalists; particularists supply the answers.

William Clift's photograph is about light, about winds that blow across desert plateaus and into valleys, and about a numbness that results from being totally alone. It conveys the essence of a light vapor that passes around the body only on certain days and in certain places. It represents a place that can be seen with the eyes from a particular viewpoint, but at a time when nature draws its own image on the film at the moment of exposure and when the sunlight acts as the pencil of nature. Like every great draftsman, the sun has a broad range of marks, some totally unexpected. Long, thin lines emanate from squat, round bushes, and jagged shapes articulate the shadow of a deeply eroded gulley that follows the gently meandering shape of a river. Like Shore, Clift has stopped a moment when fleeting forces of the most general sort intersected in a way such as they may never again. Even though the moment may prove to be unique, Clift persuades us that every day there is like this and that one view over a desert plateau may stand for every other such view over other, similar terrains. Neither he nor anyone else needs to return to this place.

In his own way each of these three photographers has photographed aura. "*What is Aura?*" asked Walter Benjamin. "*A particular web of space and time; the unique manifestation of a distance, however near it may be,*"[60] he answered. Is it possible that a photograph of aura can be anything but a generalization?

[PLATE 62]

James Wallace Black
American, 1825–1896

Artist Falls, North Conway (New Hampshire)
Albumen, 1854
12 ⁷⁄₁₆ x 9 ⁷⁄₁₆ inches · 30.5 x 24 cm
1981.1229.3
Robert O. Dougan Collection, Gift of Warner Communications Inc., 1981

[PLATE 62]

IN THE MID-1850s nature worship was nearly a religion in Boston, and ministers such
as Thomas Starr King, who had absorbed the writings of Emerson and Thoreau, made
transcendentalism part of their preachings. Wild nature became the American cathe-
dral, and since the White Mountains of New Hampshire were the closest preserve to
Boston, those mountains became a mecca for Bostonians who wished to meditate on
the orderliness that can be recognized in wildness. Faith in a divine ordainer was the
basis of religion, and faith in order was the basis of science, which gave birth to photog-
raphy. Photography was beginning to be valued as the medium that could unite
science and faith in picture form; and the course of landscape photography in America
can be viewed in terms of the rise and decline of nature worship or, alternatively, in the
traditional language of art history by citing examples of the preclassic, classic, and post-
classic styles grafted from Greek and Roman art on the history of photography.

J. W. Black traveled to the White Mountains in the footsteps of a generation of
painters whose work often seemed inspired by a desire to partake of nature's sacrament
but was actually a product of an aesthetic experience undertaken for its own sake. By
taking the camera to places hitherto the preserve of painters, Black made what may be
the first systematic series of landscape photographs by an American, a distinction
thought to be held by Carleton Watkins before the discovery of Black's White Moun-
tain photographs. Black composed his landscapes to reflect the nature symbolism of the
first generation of American landscape painters, especially Thomas Cole. Watkins,
on the other hand, advanced to a sharp understanding of how the photograph could
be a cipher of the perceptual process and a record of nature's seamless unity rather than
its contradictions. Black's composition places the massive forms of lichen-covered rocks
(symbolizing eternity) against the random shapes of fallen saplings (representing
mutability), punctuated by the delicate waterfall (signifying the Source). He used
little imagination in photographing Artist Falls, so named because it was the inspira-
tion for many paintings that had been made from its point of view.

Black worked in the mid-1850s, when photography was synonymous with the
portrait. There was no way that a livelihood could be earned by photographing land-
scape, since the art was too new for it to have a place on the walls of domestic interiors as
decoration or in schoolrooms as an instructional aid. Watkins was among those who
helped make this hope a reality.

Watkins's career as a photographer began on the Pacific coast not long after Black's

137

[PLATE 64]

[PLATE 63]

Carleton E. Watkins
American, 1829–1916

View on the Columbia River, Cascades
Albumen, 1868

15¾ x 20⅝ inches • 40 x 52 cm
1979.622
*Warner Communications Inc. Purchase Fund
and Elisha Whittelsey Collection, Elisha Whittelsey Fund, 1979*

[PLATE 63]

in the East. In 1859 Thomas Starr King, the dean of Boston's transcendentalist ministers, accepted a post in San Francisco, where his impassioned sermons and sensitive writings would kindle a fervent nature worship.[61] King's arrival coincided with Watkins's desire to photograph Yosemite with a mammoth-plate camera and established a link between the two coasts. Watkins avoided overdramatization and based his style on a representation of the flow of nature in increments, from foreground plants and gravel to distant peaks. The parts were unified by his remarkable power to weld the rhythm and flow of natural forms into a composition in which, in an interlocking network of thousands of forms, not a single element is out of place. The concentrated power of the web of relevancies calls to mind the writings of Emerson and Thoreau. Although there is no direct evidence that Watkins had read this literature, he probably knew of it through someone like Thomas Starr King.

Watkins's *Columbia River* series, from which this is one example, was made after the bulk of his Yosemite photographs and is an instance of a more diagrammatic type of composition that invites analysis. An understanding of the network of pictorial relationships in the Yosemite work comes only after prolonged observation. Here we see what amounts to a visual manifesto declaring that composition in the photograph is not just a matter of recognizing relationships in nature (typified by Black) but rather of creating relationships. The relationship between the three foreground trees and between those trees and the background space did not exist in a knowable way before the making of this photograph. The camera was deliberately placed so that the left edge of the composition creates a line that bisects the trunk along its vertical axis. This trunk consists half of textured bark in bright sunlight and half of shadow forming an impenetrable edge into the sky. The treatment of this tree is like an admonition from Watkins, a finger pointed at the observer, advising him to pay close attention to the pictorial carpentry of the picture, where nothing is left to accident. The straight tree is played against the gently curving one; the oddly shaped patch of sky between them is played against the landmass below; the fallen tree stretching visually nearly across the river blocks out a tenderly sinuous line that leads us to the background mountains. The rhythmic flow from edge to edge is matched by an equally brilliant orchestration of space from the foot of the middle tree, up the center of the river channel, to the distant mountains, which are rendered in a subtle, atmospheric haze. Breaking away from earlier influences, Watkins is asserting here that the hand of the photographer is

Karl Struss
American, 1886–1981

Cologne, Germany
Platinum, 1909

9¼ x 7 inches · 23.5 x 17.7 cm

1980.1012

*Purchase, Warner Communications Inc. Gift
and matching funds from the National Endowment for the Arts, 1980*

[PLATE 64]

as important as the hand of the divine ordainer in creating a photograph. The pre-Edenic paradise of Yosemite of 1860 had given way, by 1868, to Paradise after the Fall. Chopped tree stumps, certainly created by the photographer in quest of his compositions, signify the first stage of nature's corruption.

Karl Struss, who was active a generation and a half after Watkins, survived longer than any other photographer represented in Alfred Stieglitz's publication *Camera Work*. Black and Watkins were his silent, ruminative precursors. They were silent because Stieglitz and Struss were ignorant of forerunners who had fallen deep into oblivion.

Some of the enormous stylistic differences between Watkins and Struss were the result of differences in their audiences. Watkins addressed observers who were primarily interested in topography, some of whom may also have had experience looking at paintings; his compositional subtleties were a manifesto in picture language that the maker was an artist who left nothing to chance. Watkins forged a highly personal style from the conviction that topographical detail could be combined undiminished with art-for-art's sake interpretation, and he hoped this would help sell more photographs. For Struss and the rest of the pictorialists before 1910 — both those within the Stieglitz circle and those outside — to admit of documentary or commercial intent was to court being expelled from society. Their audience appreciated photographs for the sake of art, and the photographer seeking recognition was obligated to load his work with signs that it was absolutely devoid of commercial intent. The pictorialists felt that only art that was free of all outside influences could be pure. Struss instinctively adhered to these requirements by softening his focus to the point where his picture could be of no conceivable utility to the botanist or the geologist. Water becomes an indeterminate gray tone fused with the tree. Mood and tonality are the subjects of this photograph, not time or place. Watkins and Struss would perhaps have agreed that there is not a particle of art in the most beautiful scene of nature except as it is given shape by the photographer. Watkins may be regarded as a protopictorialist, but his genealogy could not have existed without the artists who succeeded him and who defined the later style. The process through which this is understood is like the philosophical notion of entelechy, which we may reinterpret as the means by which the soul of a picture is fathomed.

Notes

1. I am beholden to George Heard Hamilton for the Thompson anecdote.
2. Douglas R. Hofstadter, *Gödel, Escher, Bach: An Eternal Golden Braid*, New York, 1979, pp. 275–79.
3. Lee Kravitz, Tom Griswold, and Lee Phillips, "Henri Cartier-Bresson: An Interview," *Dialogue, The Ohio Arts Journal*, March 1980, p. 34.
4. Quoted in Cecil Beaton and Gail Buckland, *The Magic Image: The Genius of Photography from 1839 to the Present Day*, Boston and Toronto, 1975, p. 186.
5. Henri Cartier-Bresson, *The Decisive Moment*, New York, 1952, p. [8].
6. Julien Levy, *Memoir of an Art Gallery*, New York, 1977, p. 49.
7. Paraphrased by James Agee in Preface to Helen Levitt, *A Way of Seeing*, New York, 1965.
8. Howard Nemerov, "Writing," in *The New Yorker Book of Poems*, New York, 1969, pp. 816–17.
9. Quoted in Beaumont Newhall, *Photography: Essays and Images*, Boston and New York, 1980, p. 219.
10. Margaret Bourke-White, *Portrait of Myself*, New York, 1963, p. 90.
11. Man Ray, *Self Portrait*, Boston, 1964, p. 361.
12. *Life*, November 23, 1936, p. 9.
13. Man Ray, p. 340.
14. Ibid., p. 357.
15. Ibid.
16. William S. Rubin, *Dada, Surrealism, and Their Heritage*, Greenwich, Conn., 1968, pp. 204–05.
17. Edgar Wind, *Art and Anarchy*, London, 1963, p. 88.
18. George Kubler, *The Shape of Time: Remarks on the History of Things*, New Haven, 1962, p. 16. I am indebted to Peter C. Bunnell for impressing upon me the value of this book to the meaning of photographs.
19. Clement Greenberg, *Art and Culture: Critical Essays*, Boston, 1961, p. 125.
20. Quoted in Peter C. Bunnell, ed., *A Photographic Vision: Pictorial Photography, 1889–1923*, Salt Lake City, 1980, p. 197.
21. Wind, p. 83.

22. William M. Ivins, Jr., *Prints and Visual Communication*, Cambridge, Mass., 1953, p. 180.

23. Lucien Goldschmidt and Weston J. Naef, *The Truthful Lens: A Survey of the Photographically Illustrated Book, 1844–1914*, New York, 1980, pp. 119–20, no. 47.

24. Sybil Moholy-Nagy, *Moholy-Nagy: Experiment in Totality*, Cambridge, Mass., 1969, p. 19.

25. László Moholy-Nagy, *Vision in Motion*, Chicago, 1956, p. 197.

26. T. S. Eliot, *The Complete Poems and Plays, 1909–1950*, New York, 1971, p. 136.

27. David Wallechinsky and Irving Wallace, *The People's Almanac*, Garden City, N.Y., 1975, p. 991.

28. Edmund White, Preface to Robert Mapplethorpe exhibition catalogue, Galerie Jurka, *Black Males*, Amsterdam, 1980, p. vi.

29. Quoted in full in Nicolas Ducrot, ed., *André Kertész: Sixty Years of Photography, 1912–1972*, New York, 1972, p. 5.

30. Meyer Schapiro, "Style," in A. L. Krober, ed., *Anthropology Today: An Encyclopedic Inventory*, Chicago, 1953, pp. 301–02.

31. Hermann Broch, *The Sleepwalkers: A Trilogy*, Boston, 1932, p. 398.

32. Ibid., p. 563.

33. Edouard Boubat to the author, October 1981.

34. [Arthur H. Fellig], *Weegee by Weegee: An Autobiography*, New York, 1961, as reprinted in Vicki Goldberg, ed., *Photography in Print: Writings from 1816 to the Present*, New York, 1981, pp. 402–03.

35. Brassaï, *The Secret Paris of the Thirties*, New York, 1976, n.p.

36. Allan Porter, "Mark Cohen, Photographer: A Monograph," *Camera*, March 1980, p. 23.

37. Ralph Gibson to the author, September 1981.

38. Brian Stokoe, "Renger-Patzsch: New Realist Photographer," in David Mellor, ed., *Germany: The New Photography, 1927–1933*, London, 1978, p. 97.

39. Franz Roh, "Mechanism and Expression: The Essence and Value of Photography," in Mellor, ed., p. 31.

40. Fritz Kempe, "Albert Renger-Patzsch, 1897–1966: His Life and Personality," in Galerie Schürmann und Kicken, *Albert Renger-Patzsch* (exhibition catalogue), Cologne and Boston, 1979, p. 17.

41. Carl Georg Heise, Preface to Albert Renger-Patzsch, *Die Welt ist schön*, trans. and reprinted in Mellor, ed., p. 10.

42. Quoted in Bunnell, ed., p. 149.

43. Aron Goldberg, Introduction to Friends of Photography, *Images from Within: The Photographs of Edmund Teske*, issue number 22 of *Untitled*, Carmel, 1980.

44. Eliot, p. 117.

45. Ulrich Keller, *August Sander, Menschen des 20. Jahrhunderts: Porträtphotographien, 1892–1952*, Munich, 1980, pp. 47–48.

46. Kubler, p. 45.

47. Quoted in Frank O'Hara, *Jackson Pollock*, New York, 1959, p. 11.

48. Dale Warren, "Doris Ulmann: Photographer in Waiting," *The Bookman*, October 1930, p. 142.

49. Ibid.

50. Albert Einstein, *Essays in Science*, New York, 1934, p. 14.

51. Brassaï, "My Friend André Kertész," *Camera*, April 1963.

52. Colin L. Westerbeck, Jr., "Night Light: Brassaï and Weegee," *Artforum*, December 1976, p. 39; reprinted in Goldberg, ed., p. 410.

53. Ivins, p. 18.

54. Goldschmidt and Naef, p. 27, no. 87.

55. Quoted in Bunnell, ed., p. 190.

56. Karl Nierendorf, Preface to Karl Blossfeldt, *Urformen der Kunst*, trans. and reprinted in Mellor, ed., p. 19.

57. László Moholy-Nagy, pp. 208, 212.

58. John Cage, *Silence: Lectures and Writings*, Cambridge, Mass., 1966, p. 3.

59. Kubler, p. 16.

60. Walter Benjamin, "A Short History of Photography," trans. by Stanley Mitchell, *Screen*, Spring 1972, p. 20.

61. Thomas Starr King, *The White Hills: Their Legends, Landscapes, and Poetry*, Boston, 1859.

Bibliography

BARTHES, ROLAND. "The Photographic Message." In *Image-Music-Text*. New York, 1977, pp. 15–31.

———. *Roland Barthes by Roland Barthes*. New York, 1977.

BEATON, CECIL, and BUCKLAND, GAIL. *The Magic Image: The Genius of Photography from 1839 to the Present Day*. Boston and Toronto, 1975.

BENJAMIN, WALTER. "A Short History of Photography," *Screen*, Spring 1972, pp. 5–26. Trans. by Stanley Mitchell.

BERGER, JOHN. *About Looking*. New York, 1980.

———. "Understanding a Photograph." In *The Look of Things: Essays*. New York, 1974. Reprinted in Trachtenberg, pp. 291–94 (see below).

BOCHNER, MEL. *Misunderstandings: A Theory of Photography*. New York, 1970.

BOURKE-WHITE, MARGARET. *Portrait of Myself*. New York, 1963.

BRASSAÏ. "My Friend André Kertész," *Camera*, April 1963, pp. 7–8, 32.

———. *The Secret Paris of the Thirties*. New York, 1976.

BROCH, HERMANN. "Notes on the Problem of Kitsch" (1933). In Gillo Dorfles, *Kitsch: An Anthology of Bad Taste*. London, 1969, pp. 49–76.

———. *The Sleepwalkers: A Trilogy*. Boston, 1932.

BUNNELL, PETER C., ed. *A Photographic Vision: Pictorial Photography, 1889–1923*. Salt Lake City, 1980.

CAGE, JOHN. *Silence: Lectures and Writings*. Cambridge, Mass., 1966.

CALLAHAN, HARRY. *Harry Callahan*. Introduction by Paul Sherman. New York, 1967.

CALLAHAN, SEAN, ed. *The Photographs of Margaret Bourke-White*. New York, 1972.

CARTIER-BRESSON, HENRI. *The Decisive Moment*. New York, 1952.

———. *Henri Cartier-Bresson*. Millerton, N.Y., 1976.

CENTER FOR CREATIVE PHOTOGRAPHY. "Lisette Model," *Center for Creative Photography*, No. 4, May 1977, entire issue.

COKE, VAN DEREN. *Nineteenth-Century Photographs from the Collection: Art Museum, University of New Mexico*. Albuquerque, 1976.

COLEMAN, A. D. "The Directorial Mode: Notes Towards a Definition," *Artforum*, September 1976, pp. 55–61. Reprinted in Coleman, *Light Readings: A Photography Critic's Writings*, 1968–1979. New York, 1979; and in Goldberg, pp. 480–91 (see below).

COLES, ROBERT, and CLIFT, WILLIAM. *The Darkness and the Light: The Photographs of Doris Ulmann*. Millerton, N.Y., 1974.

DANESE, RENATO, ed. *American Images: New Work by Twenty Contemporary Photographers*. New York, 1979.

DESMERAIS, CHARLES. *The Portrait Extended*. Museum of Contemporary Art exhibition catalogue. Chicago, 1980.

DOISNEAU, ROBERT. *Three Seconds from Eternity*. New York, 1980.

DUCROT, NICOLAS, ed. *André Kertész: Sixty Years of Photography, 1912–1972*. New York, 1972.

EAUCLAIRE, SALLY. *The New Color Photography*. New York, 1981.

EDELSTEIN, J. M. "Kate's [Steinitz] Writings: A Selected Bibliography," *Wilson Library Bulletin*, January 1970, pp. 529–34.

EINSTEIN, ALBERT. *Essays in Science*. New York, 1934.

ELIOT, T. S. *The Complete Poems and Plays, 1909–1950*. New York, 1971.

ELLIOTT, DAVID. *Karl Blossfeldt: Photographs*. Museum of Modern Art, Oxford, exhibition catalogue. Oxford, 1978.

[FELLIG, ARTHUR H.]. *Weegee by Weegee: An Autobiography*. New York, 1961.

FIRSOFF, V. A. *Life, Mind, and Galaxies*. Edinburgh and London, 1967.

FLAUBERT, GUSTAVE. *Flaubert in Egypt: A Sensibility on Tour—A Narrative Drawn from Gustave Flaubert's Travel Notes and Letters*. Trans. and edited by Francis Steegmuller. Boston, 1972 (referring to Du Camp).

FRAMPTON, HOLLIS. "Digressions on the Photographic Agony," *Artforum*, November 1972, pp. 43–50.

FRIENDS OF PHOTOGRAPHY. *Images from Within: The Photographs of Edmund Teske*. Introduction by Aron Goldberg. Issue number 22 of *Untitled*, Carmel, 1980.

FUCHS, R. H. *Bernd und Hilla Becher*. Stedelijk van Abbemuseum exhibition catalogue. Eindhoven, 1981.

GOLDBERG, VICKI, ed. *Photography in Print: Writings from 1816 to the Present*. New York, 1981.

GOLDSCHMIDT, LUCIEN, and NAEF, WESTON J. *The Truthful Lens: A Survey of the Photographically Illustrated Book, 1844–1914*. New York, 1980.

GREENBERG, CLEMENT. *Art and Culture: Critical Essays*. Boston, 1961. Reprint, 1967.

GREENE, GRAHAM. *Collected Essays*. New York, 1969.

HARVITH, JOHN and SUSAN. *Karl Struss: Man with a Camera*. Ann Arbor, Mich., 1978.

HASKELL, FRANCIS. *Rediscoveries in Art: Some Aspects of Taste, Fashion, and Collecting in England and France*. Ithaca, N.Y., 1976.

HOFSTADTER, DOUGLAS R. *Gödel, Escher, Bach: An Eternal Golden Braid*. New York, 1979.

HOWE, GRAHAM, and MARKHAM, JACQUELINE. *Paul Outerbridge, Jr.: Photographs*. New York, 1980.

HOYLE, PAMELA. *The Development of Photography in Boston, 1840–1875*. Boston Athenaeum exhibition catalogue. Boston, 1979.

HUTTON, ERNEST H. *The Ideas of Physics*. Edinburgh and London, 1967.

IVINS, WILLIAM M., JR. *Prints and Visual Communication*. Cambridge, Mass., 1953. Reprint, 1969.

JAY, BILL, ed. "Facts and Fallacies from Photography's History," *Northlight*, No. 6, 1981, entire issue.

KAHMEN, VOLKER. *Art History of Photography*. Trans. by Brian Tubb. New York, 1974.

KATZ, LESLIE. "Interview with Walker Evans" (1971). In Petruck, vol. 2, pp. 120–23 (see below).

KELLER, ULRICH. *August Sander, Menschen des 20. Jahrhunderts: Porträtphotographien, 1892–1952*. Munich, 1980.

KEMPE, FRITZ. *Albert Renger-Patzsch*. Galerie Schürmann und Kicken exhibition catalogue. Cologne and Boston, 1979.

KING, THOMAS STARR. *The White Hills: Their Legends, Landscape, and Poetry*. Boston, 1859.

KOSTELANETZ, RICHARD, ed. *Moholy-Nagy*. New York, 1970.

KOZLOFF, MAX. *Photography and Fascination: Essays*. Danbury, N.H., 1979.

————. "Photography: The Coming of Age of Color," *Artforum*, January 1975, pp. 30–35. Reprinted in Kozloff, *Photography and Fascination*, pp. 186–99 (see above), and in Petruck, vol. 1, pp. 103–17 (see below).

KRAMER, HILTON. Clipping File, Thomas J. Watson Library, The Metropolitan Museum of Art, New York.

KRAUSS, ROSALIND. *Irving Penn: Earthly Bodies*. Marlborough Gallery exhibition catalogue. New York, 1980.

KRAVITZ, LEE; GRISWOLD, TOM; and PHILLIPS, LEE. "Henri Cartier-Bresson: An Interview," *Dialogue, The Ohio Arts Journal*, March 1980, p. 34.

KUBLER, GEORGE. *The Shape of Time: Remarks on the History of Things*. New Haven, 1962. Reprint, 1973.

LEVITT, HELEN. *A Way of Seeing*. Preface by James Agee. New York, 1965. Reprint, 1981.

LEVY, JULIEN. *Memoir of an Art Gallery*. New York, 1977.

LIFSON, BEN. Clipping File, Department of Prints and Photographs, The Metropolitan Museum of Art, New York.

LIVINGSTON, JANE, and KRAUSS, ROSALIND. "Surrealist Photography." Unpublished paper, 1981.

LYONS, NATHAN, ed. *Photographers on Photography*. Englewood Cliffs, N.J., 1966.

MALCOLM, JANET. *Diana and Nikon: Essays on the Aesthetic of Photography*. Boston, 1980.

MAN RAY. *Self Portrait*. Boston, 1964.

MAPPLETHORPE, ROBERT. *Black Males*. Preface by Edmund White. Galerie Jurka exhibition catalogue. Amsterdam, 1980.

MARLBOROUGH GALLERY. *Brassaï: Artists and Studios*. Exhibition catalogue. New York, 1979.

———. *Mark Cohen*. Exhibition catalogue. New York, 1981.

MELLOR, DAVID, ed. *Germany: The New Photography, 1927–1933*. London, 1978.

MOHOLY, LUCIA. *Marginalien zu Moholy-Nagy. Moholy-Nagy | Marginal Notes*. Krefeld, 1972.

MOHOLY-NAGY, LÁSZLÓ. *Vision in Motion*. Chicago, 1956.

MOHOLY-NAGY, SYBIL. *Moholy-Nagy: Experiment in Totality*. Cambridge, Mass., 1969.

NAEF, WESTON J. *The Collection of Alfred Stieglitz: Fifty Pioneers of Modern Photography*. New York, 1978.

NEMEROV, HOWARD. "Writing." In *The New Yorker Book of Poems*. New York, 1969, pp. 816–17.

NEWHALL, BEAUMONT. "Photo Eye of the 1920s: The Deutsche Werkbund Exhibition of 1929," *New Mexico Studies in the Fine Arts*, Vol. 2, 1977, pp. 5–12.

———. *Photography: Essays and Images*. Boston and New York, 1980.

NEWMAN, ARNOLD. *One Mind's Eye: The Portraits and Other Photographs of Arnold Newman*. Introduction by Robert Sobieszek. Boston, 1974.

NORI, CLAUDE. *Préférées*. Paris, 1980.

NORMAN, DOROTHY. *Alfred Stieglitz: An American Seer*. Millerton, N.Y., 1973.

NOVAK, BARBARA, ed. "On Diverse Themes from Nature: A Selection of Texts." In Kynaston McShine, ed., *The Natural Paradise: Painting in America, 1800–1950*. New York, 1976.

O'HARA, FRANK. *Jackson Pollock*. New York, 1959.

PENNELL, JOSEPH. "Is Photography Among the Fine Arts?," *The Contemporary Review*, December 1897, pp. 824–36. Reprinted in Bunnell, pp. 47–53 (see above).

PETRUCK, PENINAH R., ed. *The Camera Viewed: Writings on Twentieth-Century Photography*. 2 vols. New York, 1979.

PORTER, ALLAN. "Mark Cohen, Photographer: A Monograph," *Camera*, March 1980, entire issue.

PORTER, ALLAN, ed. "Albert Renger-Patzsch," essays by Fritz Kempe and Carl Georg Heise, *Camera*, August 1978, pp. 3–38.

———. "Ralph Gibson," *Camera*, April 1977, pp. 4–13.

READ, HERBERT. *The Meaning of Art*. London, 1931. Reprint, 1968.

RICHTER, IRMA. *Selections from the Notebooks of Leonardo da Vinci*. New York, 1977.

RUBIN, WILLIAM S. *Dada, Surrealism, and Their Heritage*. Greenwich, Conn., 1968.

RUDISILL, RICHARD, et al. "Carleton E. Watkins," *California History*, Fall 1978, entire issue.

SANDER, AUGUST. *August Sander: Photographs of an Epoch, 1904–1959*. Preface by Beaumont Newhall. Historical commentary by Robert Kramer. Philadelphia Museum of Art exhibition catalogue. Millerton, N.Y., 1980.

SANTAYANA, GEORGE. "The Photograph and the Mental Image." N.d. Reprinted in Goldberg, pp. 259–66 (see above).

SCHAPIRO, MEYER. *Modern Art: Nineteenth and Twentieth Centuries*. New York, 1978.

———. "Style." In A. L. Krober, ed., *Anthropology Today: An Encyclopedic Inventory*. Chicago, 1953. Reprint, 1957.

SONTAG, SUSAN. *On Photography*. New York, 1977.

STARKIE, ENID. *Flaubert: The Making of the Master*. Vol. 1. New York, 1967, pp. 167–82 (referring to Du Camp).

STETTNER, LOUIS. *Weegee*. New York, 1977.

STRAND, PAUL. "Photography and the New God," *Broom*, No. 3, 1922, pp. 252–58. Reprinted in Bunnell, pp. 202–06 (see above).

SZARKOWSKI, JOHN. *Looking at Photographs*. New York, 1973.

———. *Mirrors and Windows: American Photography Since 1960*. New York, 1978.

TRACHTENBERG, ALAN. *Classic Essays on Photography*. New Haven, 1980.

VARNEDOE, KIRK. "The Artifice of Candor: Impressionism and Photography Reconsidered," *Art in America*, January 1980, pp. 66–78.

———. "The Ideology of Time: Degas and Photography," *Art in America*, Summer 1980, pp. 96–110.

WAGSTAFF, SAMUEL. *A Book of Photographs*. New York, 1978.

WALLECHINSKY, DAVID, and WALLACE, IRVING. *The People's Almanac*. Garden City, N.Y., 1975.

WARREN, DALE. "Doris Ulmann: Photographer in Waiting," *The Bookman*, October 1930, pp. 129–44.

WELLING, WILLIAM. *Photography in America: The Formative Years, 1839–1900*. New York, 1978.

WESTERBECK, COLIN L., JR. "Night Light: Brassaï and Weegee," *Artforum*, December 1976, pp. 34–45. Reprinted in Goldberg, pp. 404–19 (see above).

WIND, EDGAR. *Art and Anarchy*. London, 1963.

WITKIN, LEE, and LONDON, BARBARA. *The Photograph Collector's Guide*. Boston, 1979.

Chronologies

Many of the books, monographs, exhibition catalogues, and articles listed in the Bibliography were valuable sources for the chronologies. Of the works cited, Lee Witkin and Barbara London's *The Photograph Collector's Guide*, Cecil Beaton and Gail Buckland's *The Magic Image*, and Sally Eauclaire's *The New Color Photography* in particular served as starting points for these chronologies. Additional information was obtained from unpublished documents, other ephemeral sources, and even directly from many of the photographers themselves. Julia Siegel supplied facts about her father, Arthur Siegel, and Professor Julius Kaplan of California State College, San Bernardino, and Victoria Steele of the Elmer Belt Library of Vinciana (University of California, Los Angeles) provided information on Kate Steinitz. The British Library in London supplied data on J. Lawton.

Bernd Becher

1931 Born August 20 in Siegen, Germany. **1947–50** Attends training program for stage design in Siegen. **1951** Travels in Italy. **1953–66** Studies at Staatliche Kunstakademie, Stuttgart, under Karl Rössing. **1957** Moves to Düsseldorf. First pictures of ironworks, Eisenhardter Tiefbau. **1957–61** Studies typography at Staatliche Kunstakademie, Düsseldorf. Also works at advertising agency. **1959** Collaborates with Hilla Wobeser, whom he marries in 1961. **1976–present** On faculty of Staatliche Kunstakademie, Düsseldorf.

Hilla Becher

1934 Born September 2 in Potsdam, Germany. **1951–54** Studies and trains as photographer in Potsdam. **1954–56** Aerial photographer in Hamburg. Works in commercial photography studio. **1957** Moves to Düsseldorf. **1958–61** Attends Staatliche Kunstakademie, Düsseldorf.

Bernd and Hilla Becher

1959 Begin to plan and build photo archives of nineteenth- and twentieth-century industrial buildings. **1961–65** Photography project in industrial sections of Ruhr district and Netherlands. **1966** Arts Council of Great Britain Scholarship for travel in British industrial regions. **1966–present** Continue to photograph industrial structures in France, Luxembourg, Belgium, and United States.

Mark W. Berghash

1935 Born March 8 in Buffalo, N.Y. **1952–55** Attends Buffalo University. **1955–56** Attends Vienna University. **1957–60** Attends Art Students League, New York. **1976–**

78 Studies in Department of Photography, New School for Social Research/Parsons School of Design. **Presently** Lives and works in New York.

James Wallace Black

1825 Born in Francistown, N.H. **1840s** Studies daguerreotyping with John (Jacob) Lerow of Boston. **1845** Employed in gallery of L. H. Hale & Co., Boston. **Late 1840s** Becomes partner in Ives and Black. **1852–56** Joins with John A. Whipple to manufacture photographic chemicals; also assists him in experiments with photography on paper. **1854** Takes photographs in White Mountains of New Hampshire. **1856–59** In partnership with Whipple operating a photography gallery. Black is art director and Whipple technician. **1859–65** Establishes studio with Perez M. Batchelder. **1860** On October 13 collaborates with Samuel A. King, balloon navigator, to make first successful aerial photographs in United States. **Early 1860s** Trains Oliver Wendell Holmes in photography. **1865** Forms partnership with John Case. **1866** They win gold and silver medals for "porcelain and best photographs" at Mechanics Exhibition, Boston. **1867–79** Works as independent photographer. **1870s** Authority on use of magic lantern. **1872** Photographs aftermath of Great Boston Fire. **1896** Dies January 14.

Karl Blossfeldt

1865 Born June 13 in Schielo, Germany. **1871–81** Attends school in Harzgerode. **1881–83** Apprenticeship as sculptor and modeler at ironworks and steel foundry in Mägdesprung. **1884** Studies at Royal Museum of Arts and Crafts, Berlin. **1891–96** Scholarship to study in Rome with Professor Meurer. Travels with him in Italy, Greece, Egypt, and North Africa. Collects plant specimens and takes first photographs. **1898** Returns to Berlin and becomes assistant to Professor E. Ewald, Royal Museum of Arts and Crafts; teaches modeling. Marries Maria Plank. **1899** Appointed assistant professor under Professor Bruno Paul, Royal Museum of Arts and Crafts, Berlin; specializes in sculpture based on plants. Makes first photographs of plants. **1900** Builds a 13 x 18 cm camera and systematically begins photographing plants; from these makes transparencies to illustrate his lectures. No prints contemporary with these transparencies survive. **1910** Divorced. **1911** Marries opera singer Helene Wegener; travels widely with her and collects plant specimens. **1911–31** Tenured at Royal Museum of Arts and Crafts, Berlin. **1928** Publication of *Urformen der Kunst.* **1932** Publication of *Wundergarten der Natur.* Dies December 9 in Berlin. **1976** First posthumous museum exhibition.

Edouard Boubat

1923 Born September 13 in Paris. **1938–42** Studies book design and typography at Ecole Estienne; becomes interested in photography. **1942–45** Works as phototechnician for company that prints art reproductions. Encouraged by Picasso, leaves work to concentrate on his own photography. **1946–50** Photographs *Petite Fille aux feuilles mortes*, published in 1950. **1947** Kodak Prize. **1951** Meets Albert Gilou, artistic director, *Réalités* magazine. **1951–65** Staff photographer, *Réalités*, with assignments in Europe, Africa, Middle East, Far East, India, and North and South America. **1973** David Octavius Hill Prize, Gesellschaft Deutsche Lichtbildner, Essen. **1977** Grand Prix du Livre d'Arles for *La Survivance*. **Presently** Lives and works in France.

Margaret Bourke-White

1904 Born June 14 in New York. **1921–27** Attends Rutgers University summer school; Clarence H. White School of Photography, New York; University of Michigan; Purdue University; and Western Reserve University. **1924** Marries Everett Chapman, engineer. **1926** Divorced. **1926–27** Attends Cornell University; becomes campus photographer. Graduates. **1927–30** Establishes studio in Cleveland, concentrating on industry and architecture. **1929** Becomes an associate editor, *Fortune* magazine. **1930** Photographs in Russia and Germany. **1931** Establishes New York studio. **1934** Photographs Dust Bowl. **1936** Tours United States with Erskine Caldwell. Employed by *Life* magazine; produces cover of first issue. **1938** Assigned by *Life* to cover Eastern Europe. **1939–42** Marries Erskine Caldwell. **1942–45** Accredited an official Air Corps photographer. Work used jointly by Air Corps and *Life*. Photographs in Germany during surrender. **1946–48** Photographs in India. **1949–50** Photographs in South Africa. **1950–52** Intermittently photographs Korean War. **1950s** First symptoms of Parkinson's disease. **1969** Resigns from *Life*. **1971** Dies August 29 in Darien, Conn.

Brassaï (Gyula Halász)

1899 Born September 9 in Brassó, Hungary (now Brașov, Romania). **1903–1904** In Paris with father, professor of French literature at Sorbonne and Collège de France. **1919–20** Attends School of Fine Arts, Budapest. **1921–22** Attends art school in Berlin. **1923** Moves to Paris; lives in Montparnasse. **1924–32** Works as journalist. **1929** Learns photography, inspired by André Kertész. Photographs Paris by night. First signs his work "Brassaï." **1930** Meets Henry Miller and other writers. **1932–33** Meets Picasso. Associates with Surrealist group. Work published in *Minotaure*, *Verve*, and *Labyrinthe*. **1933** Medal of Commendation from Peter Henry Emerson. **1940** Leaves Paris for Cannes; returns to rescue his negatives. Takes up drawing and sculpture again during war. **1943–45** Habitué of Picasso's studio; photographs his sculpture. **1945–50** Designs photographic backgrounds for ballet *Les Rendezvous* and play *En Passant*; designs set for Cocteau's *Phèdre*. **1945–60** Work published by *Harper's Bazaar*, including portraits of Braque, Matisse, Bonnard, Giacometti, and Miró. **1950–present**

Devotes his time to photography, movies, and books. **1955** First prize at Cannes for film *Tant qu'il y aura des bêtes* ("As Long as There Are Animals"). **1974** Made Chevalier des Arts et des Lettres. **1976** Made Chevalier de l'Ordre de la Légion d'Honneur. **1979** French National Grand Prize for Photography. **Presently** Lives in Paris.

Harry Callahan

1912 Born October 22 in Detroit. **1930s** Briefly studies engineering at Michigan State College. Begins work at Chrysler Motor Parts. **1936** Marries Eleanor Knapp. **1938** Becomes interested in photography as hobby; takes first pictures with Rolleicord camera. Meets photographer Todd Webb. **1940** Joins Detroit Photo Guild. **1941** Meets and is impressed by Ansel Adams at Detroit Photo Guild lecture. Begins to work with plate cameras; continues until 1965. **1942** In New York meets Alfred Stieglitz. **1944** Technician, General Motors photography laboratories. **1945** Lives in New York for six months; meets prominent photographers. First work in color; continues intermittently until 1964; takes up color again in 1977. **1946** Invited by Arthur Siegel to become instructor in photography, Institute of Design, Chicago. Meets artists László Moholy-Nagy and Hugo Weber. **1948** Meets Edward Steichen and Aaron Siskind, with whom a deep friendship is formed. **1949** Becomes head of Department of Photography, Illinois Institute of Technology (which has absorbed Institute of Design). **1950** Makes two films, *Motions* and *People Walking on State Street*. **1951** In summer teaches photography with Aaron Siskind at Black Mountain College, North Carolina. Receives award at Photokina: International Photo-und-kino Ausstellung, Cologne. **1956** Graham Foundation Award for Advanced Studies in the Fine Arts. Spends sabbatical in Europe, principally Aix-en-Provence. **1961** Resigns from Illinois Institute of Technology; becomes associate professor of photography, Rhode Island School of Design (R.I.S.D.), Providence. **1963** Photographs in Mexico. **1964** Appointed professor at R.I.S.D.; initiates a major and a master's program in photography. Sabbatical in Europe. **1969** Again photographs in Mexico. **1970** Travels in Scandinavia and Ireland. **1972** Guggenheim Fellowship. Spends three months in Mexico; travels in Peru and Bolivia. **1976** Leave of absence from R.I.S.D. to travel in Romania. **1977** Retires from faculty of R.I.S.D. Travels in Europe. **1979** Honorary Doctor of Fine Arts, R.I.S.D. **Presently** Lives and works in Providence.

Henri Cartier-Bresson

1908 Born August 22 in Chanteloup, France. **1922–23** Attends Ecole Fénelon and Lycée Condorcet. Develops great interest in painting and studies once a week with André Lhote. **1927–28** Decides against entering family business; again studies painting with Lhote. **1929** Begins eighteen-month stay in Cambridge, England; paints and attends lectures on literature. **1930** Military service at Le Bourget. Continues painting part-time. Becomes interested in photography through Gretchen and Peter Powell. **1931** Travels in Africa; lives in village on French Ivory Coast; contracts blackwater fever.

1932 Travels in Europe. Begins first serious photography with Leica camera. **1933** Travels in Italy and Spain. **1934** Joins anthropological expedition to Mexico as a photographer. **1935** Lives in United States. Studies motion pictures with Paul Strand. **1936** With Jacques Becker and André Zvoboda assists director Jean Renoir on film *Partie de campagne* ("A Day in the Country"). **1937** Films documentary *Victoire de la vie* ("Return to Life") about medical aid to hospitals in Spain during civil war. Photographs with Robert Capa and Chim (David Seymour) in France. Marries Ratna Mohini. **1938** Photographs in London during coronation. **1939** Assists Jean Renoir on film *La Règle du jeu* ("The Rules of the Game"). Photographs Hyde Park series in London. Drafted into French army at outbreak of war. **1940** Corporal in Film and Photo Unit, French army. **1940–43** Captured, spends three years as prisoner of war in Germany; escapes back to France. **1943** Works on a farm in Touraine. Moves to Paris with false papers; works for underground organization for ex-prisoners of war. Makes portraits of writers and painters, including Claudel, Bonnard, Braque, and Matisse, for publisher Pierre Braun. **1944–45** Organizes group of professionals to photograph occupation of France and liberation of Paris. **1945** Films *Le Retour* ("The Return"), documentary for United States Office of War Information on return to France of prisoners of war and deportees. Works on series in England for *Harper's Bazaar*. **1946** Visits New York to prepare exhibition of his work at Museum of Modern Art. Goes to New Orleans for *Harper's Bazaar*. **1947** Founds cooperative agency Magnum with Robert Capa, Chim, and George Rodger. **1948** Overseas Press Club Award for reportage on death of Gandhi; also wins awards in 1954, 1960, and 1964 for best reportage of year. **1948–50** Travels in Pakistan, India, Burma, China, and Indonesia. **1952–53** Works in Europe. **1954** Photographs in Soviet Union. **1958–59** Returns to China for three months. **1960** Photographs in Canada, Cuba, and Mexico. **1965** Spends six months in India and three in Japan. **1966** Retires from active membership in Magnum. **1969** Prepares 1970 Paris exhibition *En France*. Makes two documentary films for CBS television network. **1975** Honorary Doctor of Letters, Oxford University. **Presently** Lives in Paris. Concentrates on painting and drawing.

William Clift

1944 Born in Boston. **1954** Becomes interested in photography; sets up first darkroom. **1959** Attends workshop given by Paul Caponigro. **1962** Becomes charter member of Association of Heliographers, New York, with Walter Chappell, Marie Consindas, and Paul Caponigro. **1963–71** Business partnership with Steve Gersh under name Helios; Clift's specialty is architectural photography. **1970** Commissioned by Massachusetts Council on the Arts to make extensive photographic documentation of abandoned Boston City Hall. **1971** Moves to New Mexico. **1972 and 1979** National Endowment for the Arts Fellowship. **1974 and 1980** Guggenheim Fellowship. **1975–76** Photographs county courthouses for Joseph E. Seagram & Sons, Inc. Bicentennial project.

1977 Photographs in France. 1978 Teaches fine photographic printing workshop in Australia. Contributor to American Telephone and Telegraph Co. project *American Images: New Work by Twenty Contemporary Photographers*. **Presently** Lives and works in Santa Fe, N. Mex.

Mark Cohen

1943 Born August 24 in Wilkes-Barre, Pa. 1961–63 Attends Pennsylvania State University. 1963–65 Attends Wilkes College; receives B.A. 1965 Marries Lillian Martha Russin. 1967 Opens commercial studio in Wilkes-Barre. 1968–72 Teaches at Kings College, Wilkes-Barre. 1971 and 1976 Guggenheim Fellowship. 1973–77 Teaches at Wilkes College. 1975 National Endowment for the Arts Fellowship. Teaches at Princeton University. 1979 Teaches at Rhode Island School of Design, Providence. 1980 Teaches at Cooper Union for the Advancement of Science and Art, New York. **Presently** Lives and works in Wilkes-Barre.

John Coplans

1920 Born in London (raised in South Africa). 1937 Goes to sea as assistant baker. 1938 Enlists in Royal Air Force but is released for physical reasons. 1940–46 Recommissioned in army; serves as captain, Kings African Rifles, in Ethiopia and Burma. 1947–50 Studies art in London and Paris. 1960 Emigrates to United States. 1961 Visiting professor of art, University of California, Berkeley. 1962 First editor, *Artforum* magazine. 1964–66 Contributing editor, *Art News*. 1965–67 Director, Art Gallery, University of California, Irvine. 1967–70 Senior curator, Pasadena Art Museum. 1969 Guggenheim Fellowship. 1971–77 Editor at large and editor in chief, *Artforum*; contributing editor, *Art News*. 1973–74 Frank Jewett Mather Award, College Art Association of America. 1975 and 1978 National Endowment for the Arts Fellowship. 1978–80 Director, Akron Art Institute. **Presently** Lives and works in New York.

Douglas Davis

1933 Born in Washington, D.C. 1956 B.A. in art history and literature, American University, Washington, D.C. 1958 M.A. in literature, Rutgers University. 1966 Begins to be involved in video, performance, printmaking, and drawing. 1969–77 Art critic, *Newsweek*. 1971 Creative Artists Public Service grant from New York State Council on the Arts. 1971, 1975, and 1979 National Endowment for the Arts Fellowship. 1972 Artist-in-residence, Television Lab, WNET, New York. 1976 Fellow, Center for Advanced Visual Studies, Massachusetts Institute of Technology. 1976–present Artistic director, International Network for the Arts (nonprofit teaching organization). Teaches at ten educational institutions during this time. 1977 With Nam June Paik and Joseph Beuys creates live telecast transmitted via satellite to more than twenty-five countries, including United States, Soviet Union, and most of Europe.

Artist fellow, Deutscher Akademischer Austauschdienst, Berlin. **1981** Live satellite television and radio performance, May 16, Whitney Museum of American Art, New York, and Centre National d'Art et de Culture Georges-Pompidou, Paris. **Presently** Lives in New York. Senior writer, *Newsweek*, specializing in architecture, photography, and contemporary ideas.

Robert Doisneau

1912 Born April 14 in Gentilly, France. **1929** Receives diploma as photoengraver. **1930** Begins to work in graphic design and advertising. **1932** First commercial photojournalism article sold to *Excelsior* magazine. **1934–39** Employed as product photographer by Renault automobile corporation at Billancourt. **1939** Meets Charles Rado, founder of Rapho picture agency. Makes his first street photographs. Begins military duty. **1942** Meets Maximilien Vox, who engages him to illustrate book *Les Nouveaux Destins de l'intelligence française*. **1946** Meets Blaise Cendrars and Jacques and Pierre Prévert. Employed by Pierre Betz, publisher of *Le Point*. **1949–52** Employed by French *Vogue* magazine. **1952** Begins work with Maurice Baquet on photomusical symphony *Violoncelle-slalom*. **1956** Prix Nièpce. **1968** Photographs in Soviet Union. **1973** With François Porcile directs film *Le Paris de Robert Doisneau*. **1978** Participates with Jeanloup Sieff and Bruno Barby in film by Fernand Moscowicsz, *Trois Jours, trois photographes*. **Presently** Lives and works in France.

Maxime Du Camp

1822 Born in Paris. **1847** Writes on Brittany with Gustave Flaubert. **1848** Made Chevalier de l'Ordre de la Légion d'Honneur for participation in revolution of 1848. **1849** Learns photography from Gustave Le Gray. **1848–51** Travels with Flaubert to Middle East; produces two hundred paper negatives. Spends two months in Cairo studying pyramids and other monuments. Photographs monuments and landscapes of Nile Valley. **1852** *Egypte, Nubie, Palestine et Syrie* published by Goupil with prints by Blanquart-Evrard; earliest French travel publication illustrated with photographs. **1854–93** Writes seventeen books on various subjects, including *Bon Cours et brave gens*, 1893, reprinted five times. **1894** Dies in Baden-Baden.

Robert Frank

1924 Born November 9 in Zurich. **1942** Begins to photograph. Apprentices with Herman Eidenbenz in Basel and Michael Wolgansinger in Zurich. **1943–44** Stills photographer for Gloria Films, Zurich. **1947** Emigrates to United States. **1948** Encouraged by Alexey Brodovitch, photographs fashion for *Harper's Bazaar*. Travels in South America. **1948–55** Photographs published in *Fortune, Life, Look, McCall's*, and other mass-circulation magazines. **1949–51** Photographs in Britain, France, and Spain. **1950** Marries. **1953** Meets Edward Steichen; accompanies him to Europe to aid in selecting

photographs for exhibition *Postwar European Photographers* at Museum of Modern Art, New York. **1955** Guggenheim Fellowship. **1955–56** Takes photographs across United States that are published in *The Americans*. **1958** Collaborates on film *Pull My Daisy*, coproduced and filmed with painter Alfred Leslie, narrated by Jack Kerouac, and starring John Cassavetes. **1959** First prize, San Francisco Film Festival. **1961–75** Active in moviemaking: 1961, *The Sin of Jesus*; 1963, *O.K. End Here*; 1965–68, *Me and My Brother*; 1969, *Conversations in Vermont* and *Life Raft—Earth*; 1971, *About Me*; 1972, *Cocksucker Blues*; 1975, *Keep Busy*. **1963** Commercial fashion assignments. **1969** Divorced. Relocates to Mabou, Nova Scotia. **1975** Remarries. Teaches in California. **Presently** Lives and works in Nova Scotia.

William A. Garnett

1916 Born in Chicago. **1930s** Studies photography at Art Center School, Los Angeles. **1940–44** Head of photography and physical-evidence laboratory, Pasadena Police Department. **1944–45** Serves as cameraman, United States Army Signal Corps. **1945** After his first cross-country flight, decides to concentrate on aerial photography. **1945–58** Works in advertising and as free-lance photographer in southern California. **1953, 1956, and 1975** Guggenheim Fellowship. **1954–64** Many aerial photo essays for *Fortune* magazine. **1967** Fellow, Massachusetts Institute of Technology. **1967–68** Produces nine photo essays for *Life*; two are published. **1968–present** Teaches photography at College of Environmental Design, University of California, Berkeley. **1979–80** Photo essays for *Life*, "Earthquakes" and "Volcanoes and Cascades."

Ralph Gibson

1939 Born January 16 in Los Angeles. **1956–60** Learns fundamentals of photography as photographer's mate, United States Navy. Some work from these years included in book *Days at Sea* (1975). **1960–61** Studies painting at San Francisco Art Institute. Begins to practice yoga. **1962** Assistant to Dorothea Lange. Influenced by Henri Cartier-Bresson. Works with Robert Frank in New York. **Late 1960s** Moves to New York to assist Frank on film *Me and My Brother*. Plays guitar in rock-'n'-roll band with three artist friends, making occasional club appearances. **1969** Establishes Lustrum Press, which publishes his own work and that of other photographers. **1973 and 1975** National Endowment for the Arts Fellowship. **1977** Creative Artists Public Service grant from New York State Council on the Arts. **1979** Deutscher Akademischer Austauschdienst award, Berlin. **Presently** Lives and works in New York.

Jan Groover

1943 Born in Plainfield, N.J. **1965** B.F.A., Pratt Institute, Brooklyn, N.Y. **1965–68** High-school art instructor. **1970** M.F.A., Ohio State University, Columbus. **1970–73** Instructor, University of Hartford. Works mainly in black-and-white multipart se-

quences. **1973** Begins work in color and masters its printing methods. **1974 and 1977** Creative Artists Public Service grant from New York State Council on the Arts. **1977** Acquires 4 x 5 inch camera and photographs still lifes. **1978** National Endowment for the Arts Fellowship. **1979** First palladium prints. Guggenheim Fellowship. **Presently** Lives and works in New York.

Gerald Incandela

1952 Born in Tunis, Tunisia. **1965–69** Studies at the Lycée, Tunis. **1969** Moves to Paris; studies at Lycée Janson de Sailly. Receives baccalaureate in philosophy. **1970–73** Studies art history, University of Nanterre. Becomes French citizen. **1973–77** Travels in Europe. **1974** Begins to photograph while in London and continues to do so during his tour of the Continent. **1974–75** Makes several Super-8 movies. **1974–76** Learns fine photographic printing while employed by a commercial studio in London. **1977** Emigrates to United States. Begins to consider his work more as painting than photography; works intensively with brush-developed print techniques. Approximately forty percent of his negatives are realized while on holiday. **Presently** Lives and works in New York.

Lotte Jacobi

1896 Born August 17 in Thorn, Germany (now Toruń, Poland). **1898** Family moves to Posen. **1912–16** Studies art history and literature at academy in Posen. **1916** Marries (marriage later dissolved). **1917** Son, Jon Frank, born. **1920** Moves from Posen (which had become Polish territory in 1918) to Berlin. **1925–27** Studies photography and film technique, Bavarian State Academy of Photography. Studies art history at university in Munich. **1927** Becomes third generation to operate Jacobi Studio in Berlin, succeeding father, Sigismund Jacobi. **1930–35** Exhibits in group shows in Berlin, Paris, London, and Tokyo. **1931** Silver medal, Royal Photography Salon, Tokyo. **1932–33** Travels in Central Asia and Soviet Union. **1935** Emigrates to United States. **1935–55** Operates photography studio in New York, specializing in authors' portraits. **1938 and 1947** Photographs at Phillips Exeter Academy, Exeter, N.H. **1940** Marries Erich Reiss, publisher. **1946** Idea for cameraless photographs is inspired by Leo Katz. **1950s** Begins to experiment with photogenics, abstract photographic prints made without camera but directly printed on paper, using a miniature flashlight as source of light. **1952–53** Works at Atelier 17, New York. **1955** Moves to Deering, N.H., and operates a studio there. Studies graphic arts, art history, French horticulture, and educational television, University of New Hampshire, Durham. **1962–63** Travels in Europe; studies etching and engraving at Atelier 17, Paris, with William Stanley Hayter. **1963** Establishes art gallery in Deering, where she exhibits photographs and paintings. **1969** Visits Germany for exhibition *Erich Reiss Verlag*, Klingspor-Museum der Stadt, Offenbach. **1970–71** Helps organize Department of Photography, Currier Gallery of

Art, Manchester, N.H. **1972** Honorary curator, Currier Gallery of Art. **1974** Honorary Doctor of Fine Arts, University of New Hampshire. **1978** Honorary Doctor of Human Letters, New England College, Henniker, N.H. **Presently** Lives in Deering.

André Kertész

1894 Born July 2 in Budapest. **1912** Baccalaureate, Academy of Commerce, Budapest. **1912–14** Clerk, Budapest Stock Exchange. Begins photographing in streets and cafés. **1914–18** Serves in Austro-Hungarian army. **1915** Wounded in action. Photographs wartime events on his own. **1916** "Satiric Self-Portrait" awarded prize by *Borsszem Jankó* magazine. **1917** First published photographs appear in *Erdekes ujsag* magazine. **1918** Most of his World War I negatives destroyed. **1925** Moves to Paris. **1925–28** *Frankfurter illustrierte, Berliner illustrierte, Strassburger illustrierte, UHU* magazine, *La Nazionale de Fiorenze, Sourire,* and *The Times* (London) reproduce photographs. **1928** Buys Leica camera, which soon becomes his preferred equipment. Photographs many literary and artistic personalities. Becomes a staff photographer, *Vu* magazine. **1929** Berlin Public Library first institution to acquire his work. **1930** Contributes frequently to *Art et médecine* magazine. Silver medal, Exposition Coloniale, Paris. **1933** Marries Elisabeth Sali. **1936** Moves to New York. Meets Cartier-Bresson. **1936–37** Employed by Keystone Studios, New York. **1937–49** Assignments for *Harper's Bazaar, Vogue, Town and Country, American Magazine, Colliers, Coronet, Look,* and *Life.* **1944** Becomes United States citizen. **1949–62** Employed by Condé Nast publications, New York. **1962–present** No longer accepts commercial assignments but continues to photograph for his own satisfaction. **1963** Gold medal, Biennale Internazionale della Fotografia, Venice. **1974** Guggenheim Fellowship. **1976** Made Chevalier des Arts et des Lettres, France. **1977** Mayor's Award for Distinguished Achievement, New York. **1980** La Médaille de la Ville de Paris (Echelon Vermeil). First Annual Award, Association of International Photography Art Dealers. **1981** Mayor's Award of Honor for Arts and Culture, New York. **Presently** Lives and works in New York.

Vitaly Komar

1943 Born September 11 in Moscow. **1956–58** Attends Moscow Art School. **1962–67** Attends Stroganov Institute of Art and Design, Moscow. **Presently** Lives and works in New York.

J. Lawton

1871 Engaged by Committee on Ancient Architecture to photograph principal structures in Ceylon at Anuradhapura (ancient capital), Polonnaruwa, and Sigiriya. In *Archaeological Survey of Ceylon, Annual Report, 1911/1912* H. C. P. Bell refers to Lawton's photographs as "now completely faded and pitted, and [they] represent conditions no longer existing. Negatives were sold to various purchasers before [the]

Ceylon Archaeological Survey was initiated and are scattered past recovery.'' Lawton's photographs were published in three volumes in the early 1870s. A complete set is available at the library of the Department of Archaeology in Colombo, Sri Lanka.

Wendy Snyder MacNeil

1943 Born in Boston. **1965** B.A., Smith College. **1966–68** Special student of photography with Minor White, Massachusetts Institute of Technology. **1967** M.A.T., Harvard University. **1973–present** Assistant professor of art, Wellesley College. **1976–present** Adjunct professor, Department of Photography, Rhode Island School of Design. **1973** Guggenheim Fellowship. **1974 and 1978** National Endowment for the Arts Fellowship. **1975** Massachusetts Arts and Humanities Fellowship. **Presently** Lives and works in Lincoln, Mass.

Man Ray

1890 Born August 27 in Philadelphia. **1897** Family moves to New York. **1911** Studies with Robert Henri, Academy of Fine Arts, New York. Works as draftsman-artist for map-and-atlas publisher. Becomes acquainted with contemporary art at Alfred Stieglitz's Little Galleries of the Photo-Secession (''291''), New York. **1912** Studies life drawing, Ferrer Center, New York. **1913** Sees work of European avant-garde artists, Armory Show, New York. Becomes influenced by Cubism. Moves to Ridgefield, N.J. **1914** Marries Adon Lacroix (Donna Loupov). **1915** Acquires camera to photograph own art. Publishes single issue of *The Ridgefield Gazook*—first American Dada publication—with Alfred Kreymborg and William Carlos Williams. Meets Marcel Duchamp. Returns to New York. **1916** Exhibits *Self-Portrait*, first American Dada assemblage. Begins series of collages, *Revolving Doors*. **1917** Founding member, Society of Independent Artists. **1918** Begins series *Aerographs*, abstract airbrush paintings. **1919** In March with Henry S. Reynolds and Adolf Wolff publishes only issue of *TNT*. **1920** Divorced. Resigns from job with map publisher; endeavors to support himself by commercial photography. With Katherine Drexel and Marcel Duchamp founds Société Anonyme, first museum of contemporary art in New York. Designs first chess pieces. **1921** With Duchamp edits only issue of *New York Dada*. Moves to Paris; meets Francis Picabia, André Breton, Tristan Tzara, Paul Eluard, and others. Establishes portrait-photography business. About this time meets photographer Eugène Atget. **1921** Makes first one-of-a-kind rayographs. **1923** Makes his first film, *Le Retour à la raison* (''The Return to Reason''). Other films follow: 1926, *Emak bakia* (''Leave Me Alone''); 1928, *L'Etoile de mer* (''Star of the Sea''); 1929, *Les Mystères du château du Des* (''Mysteries of the Château of the Des''). **1929** Makes first solarized prints. **1940** Leaves France; settles in Los Angeles, where he paints and photographs. **1946** Marries Juliet Browner. **1951** Returns to Paris, where he occasionally photographs in color while continuing to paint. **1961** Gold medal, Biennale Inter-

nazionale della Fotografia, Venice. **1966** Cultural Award, Deutsche Gesellschaft für Photographie. **1976** Dies November in Paris.

Robert Mapplethorpe

1946 Born November 4 in New York. **1963–70** Studies painting and sculpture, Pratt Institute, Brooklyn, N.Y. **1968** Meets Patti Smith. **1970–72** Involved with noncommercial films. **1975** Patti Smith portrait reproduced on jacket of her record album *Horses*. **1979** Creative Artists Public Service grant from New York State Council on the Arts. **Presently** Lives and works in New York.

Aleksandr Melamid

1945 Born July 14 in Moscow. **1958–60** Attends Moscow Art School. **1962–67** Attends Stroganov Institute of Art and Design, Moscow. **Presently** Lives and works in New York.

Sheila Metzner

1939 Born in Brooklyn, N.Y. **1956–60** Studies visual communications, Pratt Institute, Brooklyn. **1962–65** Advertising director, CBS television network. **1965–68** Commercial assignments with Richard Avedon, Bob Richardson, Melvin Sokolsky, and Diane Arbus. **1966** Builds darkroom and teaches herself photography. First work, sharp-focus black and white. **1974** Begins series of soft-focus low-contrast pictures, some hand painted. **1978** Begins to work in color; negatives printed by Fresson Studio. **Presently** Lives and works in New York.

Lisette Model

1906 Born Elisa Felicie Amelie Seybert on September 10 in Vienna. **1918** Becomes friends with family of Arnold Schoenberg; studies music with him. **1922** Moves to Paris; continues music studies with Maria Freund. **1932** Relinquishes music for painting. **1936** Marries Russian painter Evsa Model. **1937** Learns principles of photography with goal of working as laboratory technician. Photographs French Riviera and Paris. **1938** Photographs in Italy; negatives are lost. Moves to New York. **1940** Works in photo lab of *P.M.* magazine. **1940–41** Photographic series of feet and of reflections in windows. **1941** Starts twelve-year association with *Harper's Bazaar*. Begins series *How Coney Island Got That Way*. **1942** Unpublished series on reformatories for *Look* magazine. **1947** Lectures at San Francisco Art Institute. **1950** Participates in symposium "What Is Modern Photography?" chaired by Edward Steichen. **1951–54 and 1958–present** Instructor in photography, New School for Social Research, New York. **1965** Guggenheim Fellowship. **1967** Creative Artists Public Service grant from New York State Council on the Arts. **1981** Honorary doctorate, New School for Social Research. **Presently** Lives in New York. Continues to photograph, teach, and contribute to American and European exhibitions.

László Moholy-Nagy

1895 Born July 20 in Bacsbarsod, Hungary. **1913** Enrolls as law student, University of Budapest. Associates with writers and musicians; contributes to avant-garde magazines. **1914** Drafted into Austro-Hungarian army and sent to Russian front. **1917** Wounded in hand; during convalescence makes crayon and watercolor portraits. With Ludwig Kassak and others organizes artists' group MA, named after Hungarian word for "today." Cofounds literary review *Jelenkor*. **1918** Discharged from army; returns to Budapest law studies. **1919** Sees reproductions of art of Malevich and El Lissitzky. With MA publishes art quarterly *Horizon*. **1920** First photograms. Moves to Berlin; makes Dada-influenced collages. **1921** Meets El Lissitzky in Düsseldorf. First visit to Paris. Contributes writings to *MA*, *De Stijl*, *Cahiers d'art*, and other publications. Briefly shares a studio with Kurt Schwitters. **1922** Marries Lucia Schulz. With Ludwig Kassak edits *Das Buch neuer Künstler*, anthology of modern poetry and art. Invited by Walter Gropius to join faculty of Bauhaus, Weimar. Attends Constructivist Conference, Weimar, organized by Theo van Doesburg. **1923** Begins Bauhaus lectures. Collaborates with Oskar Schlemmer on murals and stage design. Works in photography, light and color experiments, and typography and layout. Plans, edits, and designs the fourteen *Bauhausbücher* with Walter Gropius; also collaborates on publication *Bauhaushefte*. Describes his paintings at this time as "Constructivist," with emphasis shifting from line to colored form. **1925** Relocates with Bauhaus to Dessau. **1927** With J. J. P. Oud and Willem Pijper founds avant-garde monthly publication *i 10*. **1928** Follows Gropius in resigning from Bauhaus. Returns to Berlin; stage designer with State Opera. Designs exhibitions in Berlin, Brussels, and Paris. Continues to make photograms and documentary films. Moves into field of layout and typographical design. **1929** Separates from Lucia Moholy. Experiments with film. **1930** First monograph of his photographs published. **1931** Marries Sibyl Peech. **1934** Moves to Amsterdam. Experiments with color film and color photography. **1935** Moves to London. Works as free-lance designer, filmmaker, and photographer. Begins to experiment with "space modulators." **1937** Emigrates to Chicago to direct New Bauhaus; this closes before end of year. **1938** Founds Institute of Design, Chicago. **1939** Free-lance designer. **1941** Translates his "space modulator" work into three-dimensional sculpture. **1945** Produces many varied watercolor and ink drawings; constructs stabiles and mobiles that refract light. **1946** Dies November 24 in Chicago.

Hans Namuth

1915 Born March 17 in Essen, Germany. **1933** Moves to Paris. Learns photographic techniques from Georg Reisner; becomes free-lance photographer for *Vu* and *Life*. **1936–37** Covers Spanish civil war. **1939–40** Infantry soldier in French Foreign Legion. **1941** Emigrates to United States. **1942–45** Serves in United States Army in action in Europe. **1943** Becomes United States citizen. **1946–48** Studies at New School for Social

Research, New York, with Alexey Brodovitch and Joseph Breitenbach; works for Brodovitch and *Harper's Bazaar*. **1947** Photographs Todos Santos statues, Guatemala. **1948** Free-lance reportage photographer for *Life, Look, Fortune, Time, Newsweek, Harper's Bazaar, Art News,* and *Vogue.* Starts to photograph artists and stage and screen personalities. **1950** Meets Jackson Pollock. **1950–51** Collaborates with Paul Falkenberg on film *Jackson Pollock.* **1950s** Collaboration continues with films on Albers, Brancusi, Calder, de Kooning, Kahn, and Matisse. **1977–81** Again photographs in Guatemala. **Presently** Lives and works in New York.

Arnold Newman

1918 Born March 3 in New York. **1920s and 1930s** Raised in Atlantic City and Miami Beach. **1936–38** Studies art, University of Miami. **1938** Employed by a chain of portrait studios in Philadelphia, Baltimore, and West Palm Beach. Begins own creative work. **1939** Meets Alfred Stieglitz. **1941** First environmental portraits. **1946** Moves to New York; opens studio. Assignments for *Harper's Bazaar, Life,* and *Fortune.* Corresponds with Moholy-Nagy, who includes Newman's 1942 portrait of Mondrian in his book *Vision in Motion.* **1949** Marries Augusta Rubenstein. **1951** Photokina Award, Cologne. **1951–58** *New York Times* executives' and writers' portraits. **1954–61** Commercial assignments worldwide for *Holiday* and *Life* magazines. **1963** Gold medal, Biennale Internazionale della Fotografia, Venice. **1966** Increasing use of 35mm camera changes nature of his work. **1968** Works in France and England on special photography for films. Teaches advanced class, Cooper Union for the Advancement of Science and Art, New York. **1970–71** Assignments for *Travel and Leisure* magazine. **1975** American Society of Magazine Photographers Life Achievement in Photography award. **1977** Subject of nationally distributed television film, *The Image Makers — The Environment of Arnold Newman,* produced by Nebraska Educational Television. **1978** Commissioned by National Portrait Gallery, London, to photograph in England. **1981** Honorary Doctor of Fine Arts, University of Miami. Lectures in *Masters of Photography* series sponsored by Smithsonian Institution, Washington, D.C. **Presently** Lives and works in New York.

Paul Outerbridge, Jr.

1896 Born August 15 in New York. **1906** Attends elementary school in New York and in Pottstown, Pa. **1914** Attends Cutler School, New York. **1915** Attends Art Students League, New York; concentrates on anatomy and aesthetics. **1916** Assists Rollo Peters in stage design. Establishes studio in Greenwich Village. **1917** Joins Royal Flying Corps and later United States Army. Assigned to Oregon; begins documentary photography of objects and events in aircraft-construction facility. **1921** Marriage (later dissolved) coincides with growing preoccupation with and appreciation of "feminine beauty." Takes up photography; attends Clarence H. White School of Photography,

New York. Attracted to the nude and to concrete abstractions. **1922** Published in *Vanity Fair* and *Harper's Bazaar*. Communicates with Stieglitz. Studies sculpture with Archipenko; photographs his work. **1925** Moves to Paris; meets Man Ray, Abbott, Duchamp, Brancusi, Picasso, Picabia, Baron de Meyer, Braque, and other artists. **1926** Photographs for Paris *Vogue*. His style incompatible with Steichen's; leaves to free-lance for magazines other than Condé Nast publications. **1927** Establishes studio in Paris with Mason Siegal. Makes many unconventional pictures of Siegal's war dummies wearing bizarre clothing. Is prominent figure in artistic avant-garde. **1928** Metropolitan Museum of Art, New York, acquires ten photographs, the second body of photographs acquired by the Museum as works of art (the first being the work of Stieglitz). Makes films in Berlin and London. **1929** Returns to New York. Intense interest in color processes. **1930** Establishes studio outside New York. Experiments with carbro process. Begins ink drawings. **1937** Directs successful studio specializing in color. Moves to Hollywood and then to Laguna Beach, where he sets up small studio. **1940** Publishes *Photography in Color*, in which he writes about his work with the nude. **1945** Marries Lois Weir, fashion designer; enters partnership with her in women's fashions. Closes his studio. **1947** Travels in United States, Mexico, and South America doing picture stories for magazines. **1955** Begins to write "In Color" column for *U.S. Camera*. **1956** Lung cancer diagnosed. **1958** Dies October 17 in California.

Kenneth Pelka

1949 Born December 6 in New York. **1971** B.A. in mathematics and philosophy, C. W. Post College, Greenvale, N.Y. **1975–76** Attends Visual Studies Workshop, Rochester, N.Y. **1977–78** Teaches photography, Buffalo, N.Y. **1977–79** Director, community programs, Cepa photo gallery, Buffalo. **1978** M.F.A. in photography, State University of New York at Buffalo. Works on *Portrait of Buffalo*, extensive documentation of the city, for Cepa gallery with CETA (Comprehensive Employment Training Act) grant. **1979** Instructor of photography, Medaille College, Buffalo. **Presently** Lives and works in New York.

Irving Penn

1917 Born June 16 in Plainfield, N.J. **1934–38** Studies design with Alexey Brodovitch, Philadelphia Museum School of Industrial Art. **1938–39** First drawings published in *Harper's Bazaar*. **1938–41** Works as graphic artist in New York. **1942** Spends year painting in Mexico. **1943–44** Designs and photographs for *Vogue* magazine. **1946–present** Works with Alexander Lieberman for Condé Nast publications. **1952–present** Also works as free-lance advertising photographer; pursues personal creative projects.

Rosamond Wolff Purcell

1942 Born in Boston. **1964** B.A., Boston University. **1969** Begins to photograph. In-

formal training from husband, Dennis Purcell; taught view-camera technique by Kipton Kumler and advanced darkroom technique by John Weiss. Works with Polaroid materials and found glass plates and other Victorian ephemera. **1976** Assignment from Polaroid Corporation to photograph children. Directs workshop, Photographers' Gallery, London. **1976–78** Assignments to illustrate poetry, psychology, and drama books. **1977** Conducts workshops, Massachusetts Institute of Technology and Delaware Art Museum. **1981** Produces location stills for film *Ghost Story*. **Presently** Lives and works in Boston.

Albert Renger-Patzsch

1897 Born June 22 in Würzburg, Germany. (Raised in Essen and in Thuringia region.) **1907–1908** Begins to photograph. Graduates from Kreuzschule, Dresden, in classical subjects. **1916–18** Military duty. **1918** Studies chemistry, Dresden Technical College. **1920** Becomes director of picture collection, Folkwang Archives, Hagen. **1925** Settles in Bad Harzburg, where his first exhibition is held. **1928** Relocates to Essen. Laboratory and photography studio of Museum Folkwang placed at his disposal; in return, he produces documentary photographs for museum. Publishes *Die Welt ist Schön* ("The World Is Beautiful"). **1933** Appointed director, Department of Pictorial Photography, Folkwangschule, where he also briefly teaches. **1944** Home and many negatives destroyed in war. Moves to Wamel, Westphalia. **1957** David Octavius Hill prize, Gesellschaft Deutsche Lichtbildner, Essen. **1960** Award, Deutsche Gesellschaft für Photographie. **1965** Award for skilled craftsmanship, North Rhine–Westphalia government. **1966** Dies September 27 in Wamel.

August Sander

1876 Born November 17 in Herdorf, Siegerland, Germany. **1889** Apprenticed in iron mine in Herdorf. **1892** Meets industrial photographer Friedrich Schmeck of Siegen. Uncle helps him buy first camera, and father helps him build darkroom. Starts to photograph as part-time job. **1896–97** Military service at Trier. Works as barracks photographer for local photographer. **1898–1901** Travels as commercial photographer. **1901** Moves to Linz, Austria; works at Greif photography studio. **1902** Marries Anna Seitenmacher. Buys Greif studio; becomes partner with Franz Stukenberg. **1903** Son Erich born. **1904** Buys out Stukenberg. **1906** First solo exhibition, Linz, includes work printed by pigment bromoil, by gravure, and in color. Fourth prize, international portrait competition, Halle, Germany. Son Günther born. **1910** Moves to Cologne. Works first as manager for Blumberg and Hermann photographic portrait studio, then opens his own in Lindenthal, a suburb. Starts to photograph peasants; this develops into project *Menschen des 20. Jahrhunderts* ("Man of the Twentieth Century"). **1911** Daughter, Sigrid, born. Moves to larger studio. **1914** Kunstgewerbe-Museum, Berlin, purchases six of his prints. **1914–18** Military service. Continues to photograph.

Wife runs studio. Emanuel Bachmann, lecturer in architecture, Cologne Werkschule, hires Sander to photograph architecture. **1919** Photographs peasants and occupation troops in Westerwald and takes first students. Changes style, stops retouching, and prints on glossy paper. **1921** Becomes friendly with painter Franz Wilhelm Seiwert; is influenced by others in the arts, including Gottfried Brockmann, Otto Dix, Jankel Adler, and Wassily Kandinsky. **1927** Exhibits first photographs of *Menschen des 20. Jahrhunderts* at Cologne Kunstverein. **1929** *Antlitz der Zeit* ("Face of Our Time") published. Also photographs architecture. **1931** Six talks, "The Nature and Development of Photography," for West German radio (WDR) in Cologne. **1933** Assists son Erich in producing anti-Nazi literature; Erich is imprisoned. *Antlitz der Zeit* seized by Gestapo; plates destroyed. **1935–39** Photographs landscapes and nature studies almost exclusively. **1939–45** Resumes work on *Menschen des 20. Jahrhunderts*. Studio destroyed in air raid; negatives survive. **1944** Moves to Kuchhausen, Westerwald. Erich dies in prison at Siegburg. **1951** Reprints old negatives and makes new images to complete *Menschen des 20. Jahrhunderts*. **1957** Wife dies. **1960** Order of Merit, Federal Republic of Germany. **1963** Suffers stroke. **1964** Dies in Cologne.

Ludwig Schorer

1930s Active Germany. Works for Auriga Verlag. No other information available in standard references.

George Seeley

1880 Born in Stockbridge, Mass. **About 1885–96** Attends Williams Academy, Stockbridge. Receives pinhole camera from uncle and begins to photograph. **1897–1902** Studies drawing and painting at Massachusetts Normal Art School. Does not photograph during this time. **1902** Visits studio of F. Holland Day, who rekindles his interest in photography. Acquires 8 x 10 inch camera. Returns to Stockbridge. **1902–1904** Becomes Supervisor of Art, Stockbridge public schools. Makes his first serious photographs. **1903** First prize, genre class, *Photo Era* competition. **1904** Alvin Langdon Coburn introduces him to Alfred Stieglitz, who invites him to become a fellow of the Photo-Secession. **1905** Stockbridge correspondent for *Springfield Republican* newspaper, writing articles of general interest, including coverage of art exhibitions. Fourteen prints accepted by American Photographic Salon. **1906–1910** Nineteen photographs reproduced in *Camera Work*, Nos. 15, 20, and 29. **1910** Twenty-three prints exhibited at Albright Art Gallery, Buffalo, N.Y.; *Golden October* purchased for one hundred dollars. **1913** Baron de Meyer requests some of Seeley's lantern slides for lecture on pictorial photography. **1916** Group of Clarence H. White's students visits Seeley's studio in Stockbridge. **1917** Selection of his photographs reproduced in *Country Life in America*. **1920** Father dies; family leaves house where George was raised. This coincides with his reduced activity in photography. **1920s and 1930s**

Becomes interested in ornithology and painting; is involved with Biological Survey of Washington. **1940s** Toward end of life becomes recognized as still-life painter. **1955** Dies in Stockbridge.

Stephen Shore

1947 Born October 8 in New York. **1953** Receives darkroom kit. **1956** First uses 35mm camera; takes first color photographs. **1957** Obtains copy of *American Photographs* by Walker Evans. **1963–65** Frequent visitor to Heliography Gallery, New York. **1964 and 1971** Makes films. **1965–67** Photographs Andy Warhol. **1970** Participates in Minor White's workshop. **1972** First "on the road" photographs. **1973** Solo exhibition at Metropolitan Museum of Art, New York. **1974 and 1979** National Endowment for the Arts Fellowship. **1975** Guggenheim Fellowship. **1976** Metropolitan Museum of Art publishes limited-edition portfolio of twelve of his photographs. **1977** Photographs Monet's gardens at Giverny for Metropolitan Museum of Art. **1980** Special Fellowship, American Academy in Rome. Marries Ginger Cremer Seippel. Moves from New York to Bozeman, Mont., where he lives and works presently.

Arthur Siegel

1913 Born in Detroit. **1927** Begins to photograph. **1930s** Majors in sociology, University of Michigan and Wayne State University. Begins experimental documentary photography; member of Detroit Camera Club. **1937** Receives scholarship, New Bauhaus; relocates to Chicago. **1940s** Works at Office of War Information. Later serves in Air Corps. **1946** Organizes graduate and undergraduate curriculum in photography, Institute of Design, Chicago. **Late 1940s** Experiments with cameraless photography and 35mm color photography. Completes *In Search of Myself*, series on Chicago's State Street. **1950s** Writes periodic articles for *American Photography* and *Modern Photography*. **1960** Begins full-time free-lance photography. **1967** Resumes teaching at Illinois Institute of Technology (which has absorbed Institute of Design), where Aaron Siskind heads Department of Photography. **1971** Succeeds Siskind. Produces new series of photograms he calls lucidograms. **1978** Dies in Chicago.

Eve Sonneman

1946 Born in Chicago. **1967** B.F.A., University of Illinois. **1969** M.F.A., University of New Mexico. **1969–74** Makes black-and-white diptychs, then black-and-white quadrants, and finally color diptychs. **1970–present** Teaching posts include Cooper Union for the Advancement of Science and Art, New York; Rice University, Houston; City University of New York; and School of Visual Arts, New York. Photographs appear in *Esquire, Life, The New York Times Magazine,* and other publications. **1971 and 1978** National Endowment for the Arts Fellowship. **1973–80** Films shown at Whitney Museum of American Art, New York; University of Rochester; Art Institute of

Chicago; and Michigan Film Festival, Ann Arbor. **1976–80** Films appear on New York cable television. **1977 and 1978** Grants from Polaroid Corporation for experiments with Polavision. **Presently** Lives and works in New York.

Kate Steinitz

1889 Born Kate Trauman on August 2 in Beuthen, Germany (now Bytom, Poland). **1899** Family relocates to Berlin. **1901** First visit to museum: "From that day on there was nothing more important in my life than art." **1908** Starts art studies with Käthe Kollwitz. **1909–1911** Studies with Heinrich Wölfflin. **1913** Lives in Paris; studies at Sorbonne and elsewhere. Marries Dr. Ernst Steinitz. **1914** Daughter Ilse born. **1918** Moves to Hanover, where husband is military physician. Meets Kurt Schwitters. **1918–36** Works as artist and writer. Sets up Aposs (Active Paradox Oppose Sentimentality Sensitive) Verlag. Collaborates with Schwitters and other artists on books, opera librettos, and festivals. Acquires large part of her personal art collection. **1924–33** Writes many articles on books, art, theater, and spectacle under own name and pseudonyms Annette C. Nobody, Elizabeth Hill, and Mia Meyer. **1932–33** Takes photography class during winter term at Technische Hochschule, Hanover. **1932–34** Photographs for Ullstein Verlag publications. **1936** Moves to New York. **1936–42** Assists husband in medical practice. Works as free-lance artist; continues to photograph and to study art. **1939** Arranges *Great American* art exhibition, New York World's Fair. **1942** After death of husband, moves to California, where daughter lives. **1943** At urging of Schwitters, meets Dr. Elmer Belt. **1944** Becomes United States citizen. **1945** Becomes librarian of Elmer Belt Library of Vinciana. **1961** Named honorary curator, Elmer Belt Library of Vinciana, on its donation to University of California, Los Angeles. **1975** Dies April 7 in Los Angeles.

Alfred Stieglitz

1864 Born January 1 in Hoboken, N.J. **1871** Family moves to New York, where, with exception of European study, travel, and summers spent at Lake George, he lives until his death. **1876** First visit to Lake George. **1881–82** Attends Realgymnasium, Karlsruhe, Germany. **1882–90** Attends Berlin Polytechnic Institute and University of Berlin; enrolls in mechanical-engineering classes. **1883** Studies concentrate on photography, photochemistry, and related subjects. Makes first photographs. **1885–86** Begins to write for photography magazines. **1886** Honorable mention, *Amateur Photographer* (London) competition. **1887** Vacation in Italy results in his first important body of photographs. First prize, *Amateur Photographer* (London) "Holiday-Work" competition, awarded by Dr. Peter Henry Emerson. English and German periodicals reproduce his photographs. **1888** Sends prints to exhibitions. Work reviewed by Dr. Emerson and by Stieglitz's teacher, Dr. H. W. Vogel. **1889–1910** Photographs, experiments, and exhibits; wins more than 150 medals and awards in worldwide exhibitions.

1890 Returns to United States. Enters photoengraving business. 1891 Joins Society of Amateur Photographers of New York. 1892 Extensive use of hand camera. 1893 Marries Emmeline Obermeyer. 1893–96 Editor, *American Amateur Photographer*. 1894 Elected to membership in Linked Ring. 1896 Merger of Society of Amateur Photographers with New York Camera Club to form Camera Club of New York. Resigns as editor, *American Amateur Photographer*. 1897 Founding editor, *Camera Notes*, official publication of Camera Club of New York. 1898 Begins to collect photographs. 1902 Resigns from *Camera Notes*. Establishes Photo-Secession movement and its publication *Camera Work*. Organizes exhibition of Photo-Secessionists' work, National Arts Club, New York. 1903 First number of *Camera Work* published. 1905 Opens Little Galleries of the Photo-Secession, 291 Fifth Avenue, New York; gallery becomes known as "291." Elected honorary fellow, Royal Photographic Society of Great Britain. 1907 Works with autochromes while in Europe with Edward Steichen and Frank Eugene. 1908 Arranges first United States exhibition of European modernists at Little Galleries of the Photo-Secession. 1910 Organizes *International Exhibition of Pictorial Photography* at Albright Art Gallery, Buffalo, N.Y. 1913 One-man exhibition of his photographs coincides with Armory Show. 1915–16 Publishes magazine *291*. 1917 Closes "291" gallery. Publishes last number of *Camera Work*. Makes first photographs of Georgia O'Keeffe. From now until his death spends nearly every summer at Lake George, where he photographs. 1917–25 Directs exhibitions of American artists at various commercial galleries. 1919 Donates his library to Metropolitan Museum of Art, New York. **Early 1920s** Marriage to Emmeline ends. 1922–23 Publishes *MSS*. 1924 Progress medal, Royal Photographic Society, for publication of *Camera Work*. Marries Georgia O'Keeffe. 1925 Includes own work in *Seven Americans*, exhibition organized by him at Anderson Galleries, New York. 1925–29 Opens Intimate Gallery, New York. 1928 Metropolitan Museum of Art purchases twenty-two Stieglitz photographs. 1929–46 Directs An American Place gallery, New York. 1933 Donates several hundred photographs by three dozen friends to Metropolitan Museum of Art. 1937 Career as practicing photographer ends. 1940 Honorary fellowship, Photographic Society of America. 1946 Dies July 13 in New York.

Karl Struss

1886 Born in New York. 1899 Already serious about photography. 1903–1914 Works full-time in father's bonnet-wire factory. 1908 Attends Clarence H. White's photography course at Columbia University; studies with White until 1912. 1909 Travels extensively in Europe recording landscapes, cityscapes, and genre scenes in soft-focus romantic manner. Invents a single-element soft-focus lens. 1910 Works with autochrome process. 1912 Elected to membership in Photo-Secession. Assists Baron de Meyer with printing. Has eight prints reproduced in *Camera Work*, No. 38. 1914 Leaves father's factory. Works for Bermuda Government Tourist Board taking photo-

graphs. Takes over White's New York studio. Works commercially making portraits and taking photographs for Metropolitan Opera. Joins Air Corps; works with aerial photography and then secret infrared film and night photography. **1916** With Clarence H. White and Edward R. Dickson organizes Pictorial Photographers of America. **1919** Moves to Hollywood to work as cinematographer; first assignment, shooting production stills for Cecil B. De Mille. **1924** Films *Ben Hur*, which uses technicolor sequences. **1927** *Sunrise* wins first Academy Award for Cinematography. **1940** *The Great Dictator*. **1952** *Limelight*. **1950s** In Italy experiments with wide-screen lenses, 3-D film, and television. **1959** Grand Prix, Cannes Film Festival. **1960–70** Works in television commercials. **1977** Rediscovery of his still photographs. **1981** Dies December 16 in Santa Monica, Cal.

Edmund Teske

1911 Born March 7 in Chicago. **1918** Begins to photograph. **1922** Studies music. **1923** Learns darkroom technique from Mabel A. Morehouse. **1929** Employed as wrapper in department store. Meets Nathan Lerner, who becomes lifelong friend. **1931** Attends evening art classes. Fraternizes with established Chicago photographers; assists Ferdinand de Gelder. Makes negatives that recur in later work, primarily of mother, sister, and friends. **1932** Protégé of Ida Lustgarten, concert pianist. **1934–36** Employed by A. George Miller at Photography Inc.; uses studio facilities for own work. Sees Edward Weston's work at Art Institute of Chicago; becomes acquainted with the work of Edward Steichen, Man Ray, and Anton Bruehl through Condé Nast publications. Learns technique of solarization by accident; produces his first solarized images. **1936** Meets Alfred Stieglitz and Georgia O'Keeffe in New York. Meets Frank Lloyd Wright at Taliesin in Wisconsin. Establishes the first photography workshop there. Enrolls in Taliesin Fellowship. **1937** Returns to Chicago; begins sequence photographs *Portrait of My City*. Commissioned by Frank Lloyd Wright to photograph his work in Illinois and Wisconsin. **1938** Teaches at New Bauhaus with László Moholy-Nagy. Assists Katherine Kuh in her Chicago gallery. Meets Ansel Adams. **1939–40** Employed by Works Progress Administration, Chicago. Travels in eastern states. Meets Roy Stryker, Paul Strand, and Leo Hurwitz. Assists Berenice Abbott in New York. Starts montage portrait of Frank Lloyd Wright. **1941–43** Involved in aerial mapping. **1943** At Frank Lloyd Wright's Taliesin West in Arizona. Moves to Los Angeles; works for Paramount Studios still-photography department. Becomes friend of and assistant to Aline Barnsdall. Establishes friendships with Man Ray, John and James Whitney, Hazel Guggenheim McKinley, Richard De Mille, and other artists; meets D.W. Griffith. **1945** Introduced to Hindu mythology and symbolism. **1946** Begins work on *Song of Dust*, which incorporates work already completed on *Portrait of My City*. Becomes friendly with Will Geer and joins his acting group. Works briefly in Douglas Aircraft photography studio. **1955** Acts in *Pilgrimage Play*. Meets John Saxon; photographs

exclusively for him. **1956** Acts in film *Lust for Life*. **1958** Develops technique combining chemical toning with solarization, named by Steichen duotone solarization. **1962** Teaches at Chouinard Art Institute, Los Angeles. **1965–70** Visiting professor, University of California, Los Angeles. **1972** Completes Frank Lloyd Wright montage. **1975** National Endowment for the Arts Fellowship. **1977** Completes *Song of Dust*. **1979** Visiting professor, Department of Photography, California State University, Los Angeles. **Presently** Lives and works in Los Angeles.

Jerry Uelsmann

1934 Born in Detroit. **1950** Begins to photograph. **1953** Studies under Minor White and Ralph Hattersley, Rochester Institute of Technology. **1957** B.F.A. First published photographs appear in *Photography Annual, 1957: A Selection of the World's Greatest Photographs by the Editors of Popular Photography*. **1958** M.S. in audiovisual communications, Indiana University. **1960** M.F.A., Indiana University, directed by Henry Holmes Smith. Becomes instructor in art, University of Florida, Gainesville. **1962** Founding member, Society for Photographic Education, Chicago. Multiple printing becomes foremost technique in his work. **1965** Delivers paper, "Post-Visualization," to Society for Photographic Education. **1967** Guggenheim Fellowship. **1968** National lecture tour. **1969** Becomes tenured professor, University of Florida. **1972** National Endowment for the Arts Fellowship. **1973** Made fellow of Royal Photographic Society of Great Britain. Medal, City of Arles, France. **1979** Visiting professor, College of Art, Nihon University, Tokyo. **Presently** Lives and works in Gainesville, Fla.

Doris Ulmann

1884 Born May 29 in New York. **1900–1903** Studies with Lewis Hine, Ethical Culture School. Marries Dr. Charles H. Jaeger, surgeon and photographer. **1914** Studies psychology and law, Columbia University. Studies with Clarence H. White, Teachers College, Columbia University; later attends and lectures at Clarence H. White School of Photography, New York, where she meets Margaret Bourke-White, Ralph Steiner, and Laura Gilpin. **1918** Adopts photography as profession; becomes member of Pictorial Photographers of America. Works predominantly in portraiture. Specializes in portraits of talented professionals—scientists, doctors, lawyers, and writers—for reproduction and publication. **1925** Divorced. Begins to photograph rural people, particularly Dunkard, Mennonite, and Shaker settlements in Virginia, Pennsylvania, New York, and New England. **Late 1920s** Travels in Appalachia, South Carolina, and Louisiana with John Jacob Niles, writer and folk singer. **1929–30** In South Carolina photographs Gullah people of Lang Syne plantation, owned by Julia Peterkin; in collaboration with her later produces book *Roll, Jordan, Roll*. **1933** Collaborates with Allen Henderson Eaton photographing the rural handicrafts movement. **1934** Dies August 4 in New York.

Carleton E. Watkins

1829 Born November 11 in Oneonta, N.Y. **1851–52** Moves to San Francisco. **About 1854** Starts employment with Robert Vance, daguerreotypist. **1855–61** Photographs New Idrea and New Almaden mines and Mission Santa Clara. **1859** Photographs Mariposa–Bear Valley area for James Hutchings. **1861** First listed in San Francisco directory as "daguerrean operator" at 425 Montgomery. Acquires mammoth-view camera; makes his first series of mammoth-plate Yosemite views. **1863** Photographs favorably reviewed by Oliver Wendell Holmes. Exhibits at Goupil's Gallery, New York. **1864** Photographs Yosemite for J. D. Whitney Geological Survey of California. **1866** Photographs in Yosemite again for Whitney Survey. **1867** Renames his 425 Montgomery studio Yosemite Art Gallery. Issues his first copyrighted photographs. Photographs in Oregon and Columbia River area. **1868** Medal, Paris Exposition. **1870** Photographs Mount Shasta–Mount Lassen area with United States Geological Survey directed by Clarence King. **1871** Photographs North Bloomfield Gravel Mines, Nevada County, Cal., for possible buyers. **1874–75** Because of financial difficulties, loses gallery and many negatives to I. W. Taber. **1876** Photographs Comstock Lode and Virginia City, Nev. **1876–79** Taber listed as owner of Yosemite Art Gallery, but Watkins still associated with it. **1880** Watkins parts company with Taber. Marries Frances Sneed. Photographs along Southern Pacific lines to Tucson, Ariz. **1880s** Photographs Golden Gate and Feather River land claims in southern California. **1881–87** Yosemite Art Gallery reestablished, with W. H. Lawrence as owner and Watkins as manager. **About 1890** Photographs Northwest as far as British Columbia. Also photographs Bakersfield area for Kern County Land Company; Anaconda Copper Mines; and Butte, Mont. **1890s** Eyesight begins to fail. **1906** Earthquake and fire destroy contents of studio, including negatives; family moves to Capay Valley, Cal. **1910** Committed to California State Hospital for the Insane, Napa. **1916** Dies June 23 in Napa.

Weegee (Arthur Fellig)

1899 Born in Austria. **1909** Emigrates to United States. **1923–35** Darkroom assistant, Acme News Services. **1935** Acquires Speed Graphic camera. **1936–45** Free-lance photographer concentrating on human situations, resulting in book *Naked City*. Photographs published in *Vogue, Holiday, Life, Look,* and *Fortune.* **1940–44** Staff photographer for *P.M.* magazine. **1944** Lectures at Museum of Modern Art, New

York. **1948–58** Employed in Hollywood as photo consultant and bit-part actor, often playing small character roles based on *Naked City*. Later plays lead in several Grade B movies. **1955** Included in *The Family of Man*, Museum of Modern Art, New York. **1958–68** Photographs series on Greenwich Village. Turns to manipulative and trick photography. Lectures and makes publicity photographs for businesses across country. **1959** Invited to Soviet Union as consultant on photography. Lectures and exhibits in Russian schools. **1968** Dies December 26 in New York.

John A. Whipple

1822 Born in Grafton, Mass. **1839–40** Starts to daguerreotype after reading of Daguerre's process; improves own apparatus and makes own light-sensitive chemicals. **1840–44** Employed in Boston by company manufacturing daguerreotype chemicals; leaves as toxic vapors affect his health. **1844** With assistance of W. B. Jones develops practical process for making photographs on paper with glass negatives. **1844–47** Partnership in daguerrean studio with Albert Litch. **1846–60** Works with microphotography. **1848** Uses steam power in his photography establishment. **1849** Patents crayon daguerreotype process. **1850–51** Collaborates with William C. Bond, director, Harvard College observatory, to make first successful daguerreotypes of moon and stars using refracting telescope. Also makes daguerreotypes of microorganisms. Patents his process for albumen glass negatives. Starts to make photographic reproductions of sculpture and other art objects. **1851** Medal, Crystal Palace, London. **1852** First advertises crystallotypes. Works with James Wallace Black to perfect quality and permanence of his photographic work. **1853** Licenses crystallotype process for fifty dollars. Takes students for same fee; Black teaches them. Sells rights to process in New England and Philadelphia. Starts to work with collodion glass negatives. **1854** Silver medal, New York Industrial Fair, for crystallotypes. *Photographic Art Journal* begins mounting one of his crystallotype prints as frontispiece in each issue, including crystallotypes of his daguerreotypes of the moon. **1856** Forms partnership with Black. **1857–60** Whipple and Black work with astronomer George Phillips Bond; make more than two hundred photographs of stars, using glass negatives and paper prints. **1859–74** Operates his photography gallery alone; period of greatest creativity. **1863** Nighttime photographs of Boston Common, using electric arc and 90-second exposure. **1865** First lists himself as photographer rather than daguerreotypist. **1874** Gives up photography to publish religious material. **1891** Dies in Boston.

Index of Photographers

Plate numbers are in italics. Other numbers refer to pages on which substantive discussions of the plates or photographers appear.

Becher, Bernd and Hilla *49*, 110–11, 148

Berghash, Mark W. *55*, 123, 148–49

Black, James Wallace *16, 62*, 43–45, 137–39, 149

Blossfeldt, Karl *54*, 118–19, 149

Boubat, Edouard *35*, 78–79, 150

Bourke-White, Margaret *7, 8, 23, 27*, 150

Brassaï *9, 34, 36, 52*, 26–27, 78–79, 82–83, 114–15, 150–51

Callahan, Harry *2, 9*, 151

Cartier-Bresson, Henri *3*, 16–17, 151–52

Clift, William *14, 59*, 38–39, 131–33, 152–53

Cohen, Mark *39*, 87–89, 153

Coplans, John *26*, 60–61, 153

Davis, Douglas *56*, 122–23, 153–54

Doisneau, Robert *20*, 48–49, 154

Du Camp, Maxime *21*, 52–53, 154

Frank, Robert *58*, 126–27, 154–55

Garnett, William A. *17*, 44–45, 155

Gibson, Ralph *38*, 87–89, 155

Groover, Jan *48*, 104–05, 155–56

Incandela, Gerald *61*, 131–33 , 156

Jacobi, Lotte *18*, 45, 156–57

Kertész, André *4, 19, 31, 32*, 16–17, 48–49, 70–71, 74–75, 157

Komar, Vitaly *56*, 122–23, 157

Lawton, J. *30*, 71, 157–58

MacNeil, Wendy Snyder *25*, 60–61, 158

Man Ray *10*, 30–31, 34, 158–59

Mapplethorpe, Robert *28*, 65–67, 159

Melamid, Aleksandr *56*, 122–23, 159

Metzner, Sheila *45*, 100–101, 159

Model, Lisette *57*, 126–27, 159

Moholy-Nagy, László *24*, 56–57, 160

Namuth, Hans *33*, 74–75, 160–61

Newman, Arnold *23*, 57, 161

Outerbridge, Paul, Jr. *27*, 65–67, 161–62

Pelka, Kenneth *40*, 89, 162

Penn, Irving *29*, 65–67, 162

Purcell, Rosamond Wolff *43*, 96–97, 162–63

Renger-Patzsch, Albert *11, 41, 42*, 31, 92–93, 163

Sander, August *22, 50*, 52–53, 110–11, 163–64

Schorer, Ludwig *12*, 34–35, 164

Seeley, George *46*, 100–101, 164–65

Shore, Stephen *60*, 131–33, 165

Siegel, Arthur *6*, 22–23, 165

Sonneman, Eve *47*, 104–05, 165–66

Steinitz, Kate *13*, 34–35, 166

Stieglitz, Alfred *1*, 9, 166–67

Struss, Karl *64*, 139, 167–68

Teske, Edmund *44*, 96–97, 168–69

Uelsmann, Jerry *15*, 38–39, 169

Ulmann, Doris *51*, 114–15, 169

Watkins, Carleton E. *63*, 137–39, 170

Weegee *5, 37*, 21–22, 82–83, 170–71

Whipple, John A. *53*, 118–19, 171

Reproduction transparencies by
Sheldan Collins, Laurie Heller, and Alexander Mikhailovich,
Photograph Studio, The Metropolitan Museum of Art
·

Composition in Monotype Walbaum by
Michael and Winifred Bixler, Boston, Massachusetts
·

Printing by Rapoport Printing Corp., New York
·

Binding by Sendor Bindery, Inc., New York
·

Design by Eleanor Morris Caponigro

Library of Congress Cataloging in Publication Data

Naef, Weston J., 1942–
 Counterparts : form and emotion in photographs.

 "Book . . . published in connection with the
exhibition . . . at the Metropolitan Museum of Art,
New York, from February 26, 1982 to May 9, 1982"—
Verso of t.p.
 Bibliography: p.
 Includes index.
 1. Photography, Artistic—Exhibitions. I. Mor-
gan, Joan, 1929– . II. Metropolitan Museum
of Art (New York, N.Y.) III. Title.
TR646.U6N4837 779'.074'01471 82-2143
ISBN 0-87099-299-6 AACR2
ISBN 0-525-10768-1 (Dutton)